Seaside Holidays in the Past

Allan Brodie, Andrew Sargent and Gary Winter

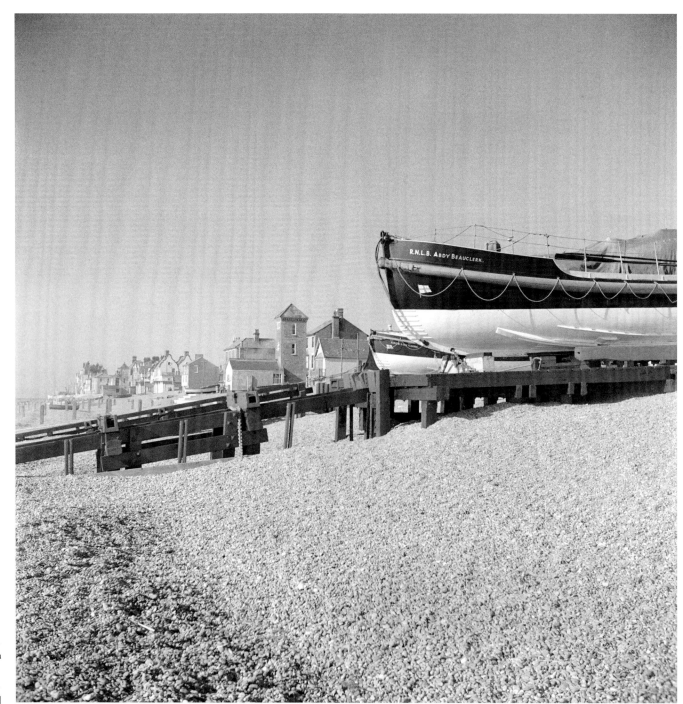

LIFEBOATS, ALDEBURGH, SUFFOLK

This photograph is a reminder that the sea is not always a safe playground. [Hallam Ashley, AA98/11262]

Seaside Holidays in the Past

Allan Brodie, Andrew Sargent and Gary Winter

ENGLISH HERITAGE

Published by English Heritage, 23 Savile Row, London W1S 2ET, www.english-heritage.org.uk

English Heritage is the Government's statutory adviser on all aspects of the historic environment.

© English Heritage 2005

All images, unless otherwise specified, are © English Heritage.NMR, © Crown copyright.NMR or reproduced by permission of English Heritage.NMR. The collection references or photographers' names and the negative numbers for NMR images are noted in square brackets in the captions. Dates of photographs are given where known. Every effort has been made to trace copyright holders and we apologise in advance for any unintentional omissions, which we would be pleased to correct in any subsequent edition of the book. Application for the reproduction of images should be made to the National Monuments Record.

First published 2005

ISBN 1 85074 931 0

Product code 51060

British Library Cataloguing in Publication Data

A CIP catalogue record for this book is available from the British Library.

Edited and brought to publication by René Rodgers, Publishing, English Heritage

Cover design by Walker Jansseune

Page layout by Mark Simmons

Printed in Belgium by Snoeck-Ducaju & Zoon

Acknowledgements

This book is part of a series designed to bring some of the riches of the National Monuments Record archive to a wider public. The authors would like to thank their many colleagues in the NMR whose contributions made this volume possible, in particular: Caroline Craggs, Anna Eavis, Ian Leith, Andrew Maybury, Jonathan Proudman, Alyson Rogers, Tony Rumsey, Ian Savage, Kirsty Scorer, Neil Stevenson, Emma Whinton and Nigel Wilkins. Publication was managed by René Rodgers of English Heritage Publishing.

Mrs Howarth-Loomes was helpful regarding the use of photographs from the collection of her late husband, Bernard Howarth-Loomes. Roger Billington of Butlins Archives kindly supplied the picture on p 17.

We are grateful for permission to reproduce the following material: the extract from Pretty Halcyon Days by Ogden Nash (*Candy is Dandy: The Best of Ogden Nash,* Andre Deutsch, 1945) courtesy of Carlton Publishing Group (p 37) and the extract from Holiday Memory by Dylan Thomas (*Collected Poems,* Dent, 1952) courtesy of David Higham Associates (p 109).

Contents

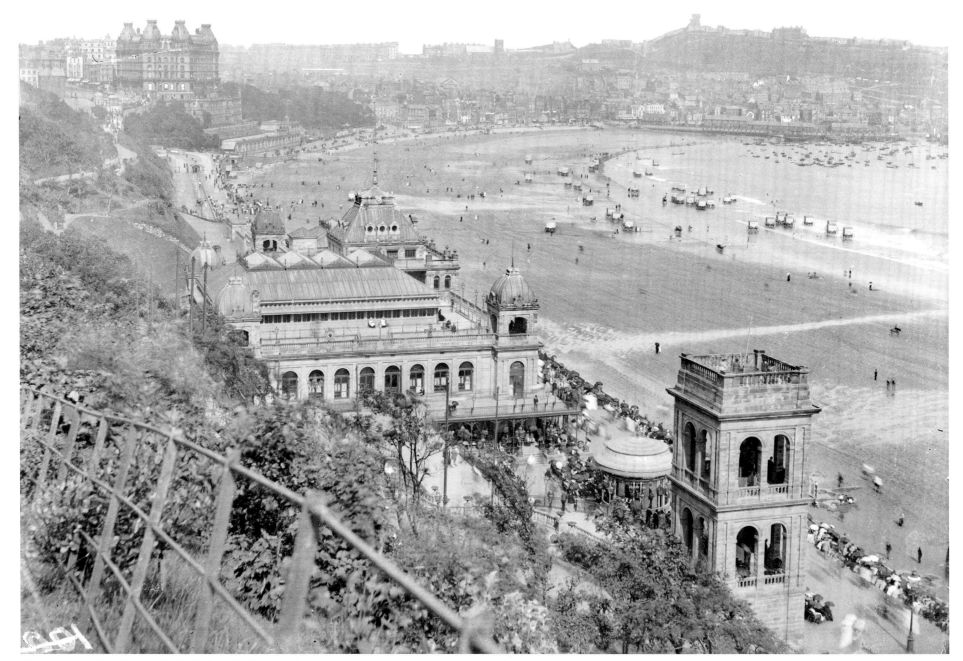

SCARBOROUGH, NORTH YORKSHIRE, 22 AUGUST 1897

Scarborough's reputation as a resort was built first upon its medicinal spring waters. The new spa buildings were completed in 1880 and contained baths, an assembly room and a theatre. From this viewpoint in the South Cliff Gardens, the South Bay curves like an amphitheatre, with the spa in the foreground, the Grand Hotel in the middle distance, and the old town and harbour backed by the castle on its promontory. A number of bathing machines are in use at the water's edge. [LMS, CC76/00420]

The English seaside

The seaside is a special place with its own distinctive sounds, smells, tastes and sights. It is fish and chips mingled with the sharp salty fragrance of a fresh breeze and the simple ditties of amusement machines breaking through the crash of waves. It is flashing neon, sunburn and bustling beaches. We all remember our holidays and dream of our next trip to the seaside!

We are drawn to the seaside by the sand and the sea, and therefore usually sit with our backs to the buildings. It is easy to overlook the fact that these towns are an assemblage of historic buildings mostly from the last 250 years, buildings that have had to adapt to changing tastes in leisure. 2005 is the Year of the Sea, a date chosen to mark two centuries since Nelson's victory at Trafalgar. This book celebrates the seaside resort, the closest that most of us will get to heroic ocean-going adventures.

The images in this book are drawn from the NMR's extensive collection of historic photographs. Since the mid-19th century, photographers – like holidaymakers – have been drawn to the seaside, setting up studios to service the needs and whims of visitors. Alongside their main business of studio portraiture, photographers were captivated by the lively activities they witnessed on the beach and along the promenade. In the mid-19th century, when photography was in its infancy, it required long exposures. Therefore, the earliest seaside photographs tend to be devoid of all but the most static people.

Photography has crystallised our image of the seaside holiday, but for over a century before its invention our Georgian forebears had been enjoying the sea. Bathing at spas and drinking the mineral waters have been popular for centuries, but it was not until the late 17th century that

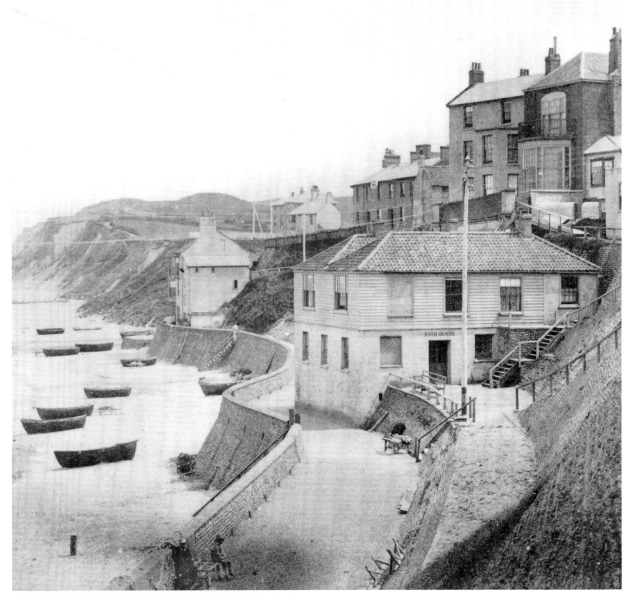

BATHHOUSE, CROMER, NORFOLK
In the 18th and early 19th centuries a number of fashionable health resorts developed at the seaside, comparable to inland spas such as Bath. Originally bathing was principally for medical reasons rather than for pleasure. For those who did not wish to expose themselves to the dangers of the sea, indoor bathing in seawater baths was an option. This early bathhouse on the seafront has now been converted into a house. [Howarth-Loomes, BB85/02189A]

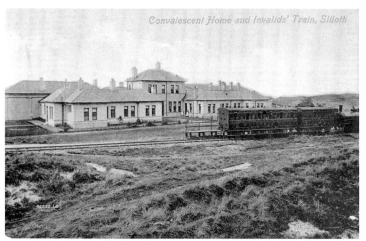

CUMBERLAND & WESTMORLAND CONVALESCENT INSTITUTION, SILLOTH, CUMBRIA

Sea bathing and sea air were believed to be part of the cure for numerous medical complaints. Built by public subscription in 1862, this nursing home at Silloth provided convalescence and sea bathing on the bracing Cumbrian coast. The buildings are set low among the dunes and face directly onto the sea. A spur from the railway line to Silloth allowed special 'invalids' trains' to run right to the home. [BB90/09470]

medical writers began to promote the sea as an enormous cold water bath. Since its discovery in 1626 the spa at Scarborough had drawn visitors from the gentry of northern England, and with the prompting of medical writers the connection between the sea and improved health was made explicit in the early 18th century. This link has continued to the present day. Many convalescent and retirement homes are still located at the seaside where the brisk, fresh air has been felt to have therapeutic value. The suntan has been a symbol of prosperity and good health since the 1920s.

Sea bathing by members of fashionable society was mentioned in August 1732 when the Duchess of Manchester and other ladies entered the sea at Scarborough. In 1735 there were references to sea bathing at Brighton, and at Margate a 1736 newspaper advertisement for baths indicates that bathing was being practised as a commercial venture. These new facilities for bathing were created in small towns with long histories. Margate and Weymouth were ports with harbours while Brighton had a declining fishing industry with boats launched from the beach. In most early resorts the original economic basis continued while the town developed its leisure functions. In fact, the working life of the town proved a compelling attraction for visitors curious to see people at work. Today, holidaymakers still enjoy the sights and sounds of a vibrant harbour. Watching the fishing fleet or a lifeboat put to sea or admiring a lighthouse can still form part of the modern holiday.

The seaside became an essential part of England's social scene in the late 18th century and for a resort to prosper it had to attract the highest class of visitors. In Jane Austen's *Persuasion* (1818) the fashionable young people 'were all wild to see Lyme [Regis]'. Austen notes that in the season the bay is 'animated' with bathing machines and

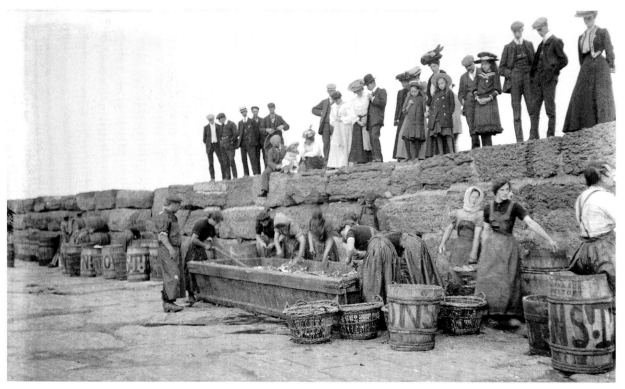

PROCESSING THE CATCH, 1896–1920

Many visitors to resorts look for a change in the pace of life and for local colour. Fishing harbours provide plenty of opportunity to absorb distinctive local sights, sounds and smells. This photograph is almost certainly taken in Scarborough. The contrast between the working women who gut the fish and pack them into barrels and the group of formally dressed tourists watching them is striking. This work was undertaken by Scottish fisher girls who followed the herring as they migrated southwards, finding work at successive harbours. [Alfred Newton & Son, BB98/05780]

'company'. She concludes: 'a very strange stranger it must be, who does not see charms in the immediate environs of Lyme'. The presence of a member of the Royal Family was a great coup. The Prince of Wales, later George IV, made regular visits to Weymouth at the end of the 18th and the beginning of the 19th centuries, which stimulated the rapid growth of the town, especially along the seafront. Brighton also benefited from the presence of the Prince of Wales, culminating in his decision to rebuild the Marine Pavilion (later known as the Royal Pavilion) as the exotic confection at the heart of the resort. It established this 'exotic' style as a recurring theme in 19th-century seaside architecture, especially on the seafront. Queen Victoria turned her back on Brighton, preferring the peace of Osborne House on the Isle of Wight.

By the middle of the 18th century, seaside towns were beginning to acquire a range of facilities. Providing baths and bathing machines was necessary to meet the health needs of visitors, but these holidaymakers also expected to have facilities for a range of uplifting and enjoyable activities. They spent time in libraries, assembly rooms and coffee houses, and in the evenings attended dances, played cards and visited the theatre. At first these facilities were makeshift and basic, but they were gradually replaced with better, larger purpose-built buildings. Housing also developed slowly. In the early resorts visitors had to lodge in the homes of working people, but gradually purpose-built houses were constructed with rooms to let during the season. Once it was realised that the seaside was not a short-term fad, people were willing to invest in larger projects and, by the late 18th century, terraces and squares were being built as accommodation for visitors.

The small, vernacular buildings that dominated the original historic towns were now joined by new, larger buildings erected in imitation of the most fashionable models

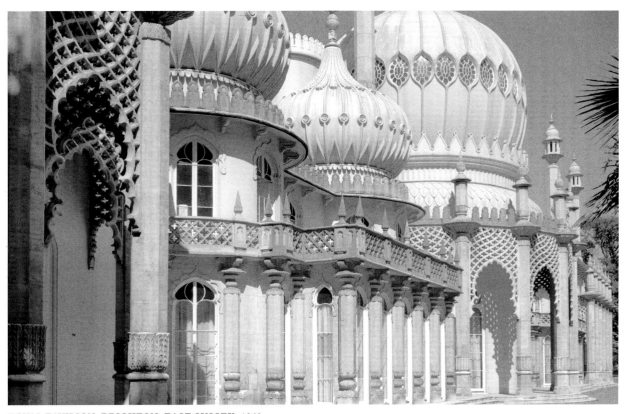

ROYAL PAVILION, BRIGHTON, EAST SUSSEX, 1960s
The Royal Family, along with the upper echelons of society, flocked to the seaside in the 1770s and 1780s. In 1786 the Prince of Wales (later George IV) rented a 'superior farmhouse' in Brighton. The house was enlarged and, between 1815 and 1823, John Nash transformed it in an 'Indian' style into the sumptuous and ornate palace we see today. The town flourished as a result of this royal association and the seaside became an established part of the social calendar. [Eric de Maré, AA98/04128]

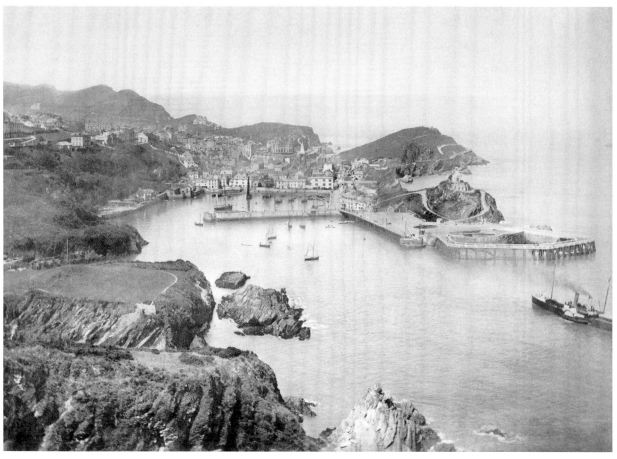

ILFRACOMBE, DEVON

Ilfracombe is a picturesque haven on the remote and rugged north Devon coast. During the season there was a regular steamer service to Bristol, Hayle, Lynmouth, Padstow and Swansea. Ilfracombe combined a working harbour with natural grandeur and bathing facilities, and its remoteness ensured that it remained 'unspoiled'. The medieval chapel of St Nicholas on the promontory overlooking the harbour served as a lighthouse at one time. [BB86/07971]

from the nearest large city and London. In the late 18th or early 19th century individual houses and long terraces were predominantly built in a relatively strict, plain Georgian style, but public facilities such as assembly rooms and libraries, were often designed using more decorative styles.

As most resort construction was on land that had not previously been developed, builders had a relatively free hand in the layout of the new parts of these seaside towns. They employed the fashionable forms of the period, creating regular grids of streets with squares and terraces, and later crescents. On the shoreline buildings were orientated to face the sea, rather than being built perpendicular to it to avoid harsh weather. By the early 19th century resorts had been sufficiently successful to inspire people to invest large sums of money with a reasonable prospect of making a profit. Huge town-planning schemes, such as Kemp Town in Brighton or the foundation of St Leonard's beside Hastings, proved that investment could be profitable. However, substantial but failed speculations at Bognor Regis and Herne Bay showed that success was not inevitable.

In the early 19th century the architecture of new developments became more elaborate. At the top end of the scale, developments in Brighton echoed Nash's palatial façades at Regent's Park. The rather dour Georgian houses of the 18th century began to be made more decorative. Bay windows and balconies, and sometimes both, were added to previously severe façades. These allowed more access to sunlight and fresh air as well as improving the view of the sea.

Suitable transport links were vital if a resort was to succeed, especially in the period before the arrival of railways. Good roads with fast stagecoaches allowed wealthy visitors to reach resorts. Hoys – small, single-mast trading vessels – transported large numbers of people from London along the Thames to the north Kent resorts.

The introduction of steam-powered ships in 1815 led to a dramatic increase in the number of holidaymakers. They also allowed people to stay in a resort and travel back to London to attend to business. Later in the century families could stay in Margate or Ramsgate while the husband worked in London during the week and commuted for the weekend. The freedom bestowed on the middle classes by the steamship anticipated the opportunities that the railways would begin to offer everyone.

The first significant railways arrived at the seaside in the 1840s. They allowed growing numbers of people now living in industrial cities a brief taste of the leisure once restricted to the wealthiest strata of society. Stagecoaches and steamers transported thousands of visitors to resorts, but railways brought tens of thousands. In 1837 stagecoaches brought around 50,000 travellers to Brighton, but in 1850 – in one week – 73,000 people arrived by train. The change in resorts can be illustrated at Weymouth. In 1800 it was the leading resort for genteel visitors from Bath, but by the 1890s 21,000 workers from the Great Western Railway works at Swindon were visiting the resort on their annual trip.

In 1871 an Act of Parliament created bank holidays, the first nationwide opportunity for day trips to the seaside. However, apart from bank holidays, most people's free time was restricted to part of Saturday and Sunday. This brought them into direct conflict with church groups striving to preserve the sanctity of the Sabbath. The arguments of sabbatarians could not eclipse the lure of the seaside, but in a concession to them some organisers of trips included religious worship as part of the package. The Lancashire & Yorkshire Railway offered 'Sea Bathing for the Working Classes' on Sundays and promised that 'Parties availing themselves of these trains will be enabled to bathe and refresh themselves in ample time to attend a Place of Worship.'

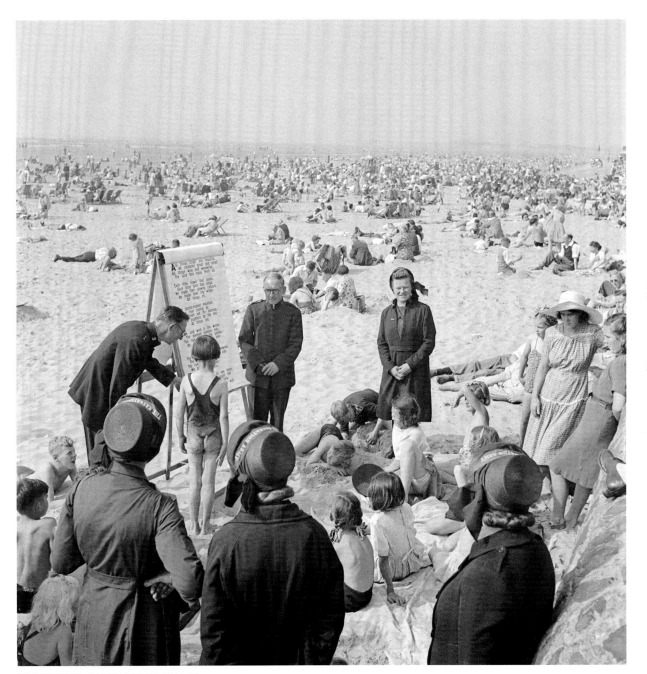

BLACKPOOL, LANCASHIRE, 1946–55
Beach missions were a regular feature of holiday resorts. Here the Salvation Army runs a beach mission for children. The song on the board is that children's favourite, *All Things Bright and Beautiful*. Behind them the beach is thronged with holidaymakers. [John Gay, AA047908]

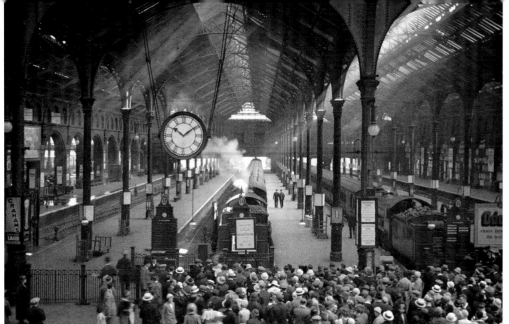

LIVERPOOL STREET STATION, LONDON
It was the railways that really opened up the seaside as mass holiday resorts, especially for day trippers. Here a crowd of passengers in their holiday best wait to board a train bound for Felixstowe, one of a string of resorts that benefited from being within easy reach of the East End. The family on the left have their suitcases so will be staying for a few days. [AA78/02492]

BLACKPOOL, LANCASHIRE, 1946–55
Holidaymakers wearily return home with their luggage, trudging from the Promenade towards Talbot Road Station on the London & North Western Railway. The Church of the Sacred Heart makes a strange contrast with the futuristic decorations that adorn the post carrying the illuminations. [John Gay, AA047931]

At some resorts beach missions gathered congregations around them on the sands and meeting points for worship are still found on some seafronts.

People went to resorts with their families and friends, but many also went on organised trips. On 5 July 1841 Thomas Cook, a Baptist woodturner with an interest in the temperance movement, organised his first trip, from Leicester to a temperance fête in Loughborough. Enlightened employers were also important providers of excursion trips. From 1865 Bass began to arrange family day trips to the seaside, and in 1903 office staff at Bournville had a hectic day trip to Weston-super-Mare, including lunch, dinner, a boat trip and a ride on a charabanc – all of which had to be fitted in after they had completed their paperwork at the factory. As well as work-related excursions, political and religious groups organised trips. In 1919 the annual Joy Day and demonstration of the Lancashire and Cheshire Miners' Federation brought 100,000 miners and their families on 135 trains to Blackpool.

The arrival of railways brought increased numbers of visitors to resorts and had a major impact on their development. The layout of Victorian resort towns followed similar themes and forms to those established in the previous century but the scale of the development was now huge. Vast amounts of middle- and working-class housing was built, behind a thin, seafront veneer of taller, more expensive terraced houses that provided lodgings, and later hotels for the more prosperous visitors.

Buildings in resorts followed the contemporary fashions of the 19th century, as they had in the 18th century. However, while most buildings in Victorian resorts were broadly similar in appearance to those in major inland towns there were often two major differences. Firstly, resorts seem to contain a higher number of large houses than in comparable inland towns, as the owners were able to let rooms to visitors and make

additional income. Secondly, houses at the seaside were also likely to be more lavishly decorated with sculptural details, ironwork and bay windows. The same exuberance was also applied to visitor facilities such as piers and theatres, where the exoticism of the Royal Pavilion in Brighton provided a constant inspiration for architects.

In the 18th century the seaside resort had followed many of the practices of inland spas and provided similar facilities. However, during the 19th century it developed in new ways. The strictures of Georgian society were replaced by tensions created by adhering to the rules of mass bathing from the beach. The rolled-up suit trousers of Victorian fathers replaced the finery of the Georgian gentleman and bathing was supplanted by swimming, though bathing machines survived throughout the 19th century. Resorts had to adapt to the demands of vast numbers of new tourists. The facilities of Georgian resorts were relatively small scale and exclusive, created for a limited number of select visitors. Assembly rooms declined gradually during the second half of the 19th century. Circulating libraries continued to serve a restricted clientele until the end of the century but theatres became more popular, frequently leading to their reconstruction.

Victorian resorts needed entertainments that could cater for the thousands of new tourists. Visitors sought increasingly exciting technological thrills. New types of activities appeared requiring new architectural solutions. For instance, piers evolved from plain landing stages in the 1820s to structures that allowed fashionable promenades and, by the end of the 19th century, pavilions and kiosks were added to create elaborate pleasure piers. Cliff lifts were invented to transport visitors from the seafront to their clifftop lodgings but they also served as a novelty ride for holidaymakers.

By the end of the 19th century Victorian holidaymakers could indulge in a bewildering range of activities. On the

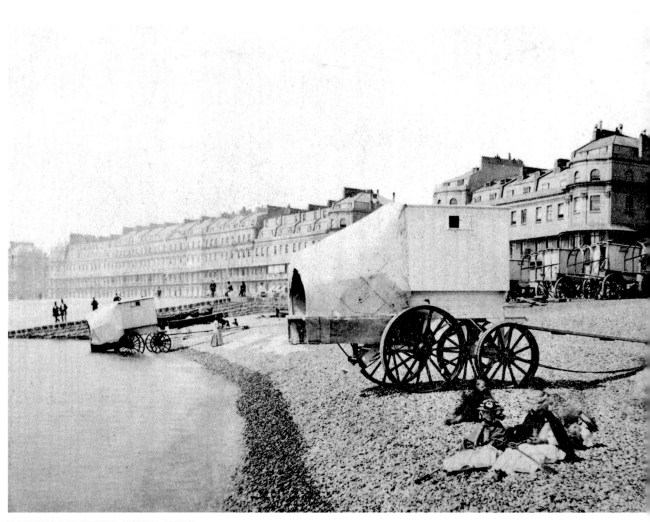

BATHING MACHINES, DOVER, KENT
The canvas hood of the bathing machine was reputed to have been invented by Benjamin Beale around 1750. It was folded out to allow the bather to enter the water and bathe in complete privacy. However, not all resorts seem to have adopted this feature. The machine was often towed into the sea by a horse, though these examples at Dover were winched up and down the beach. In the background, the terraced houses of Waterloo Crescent were built in the 1830s to provide lodgings for visitors. [BB88/03995]

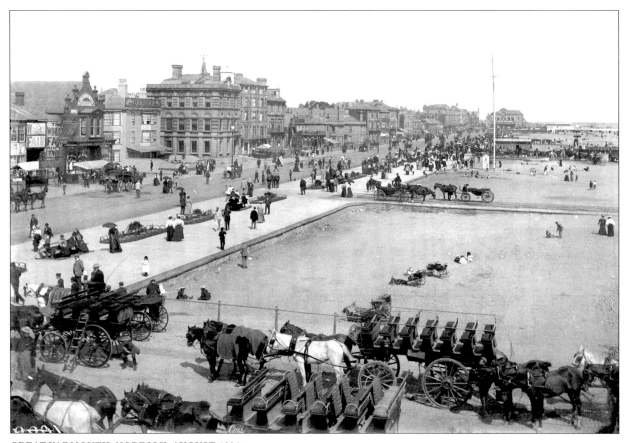

GREAT YARMOUTH, NORFOLK, AUGUST 1896
Horse-drawn coaches carried large numbers of visitors in the days before the internal combustion engine. These charabancs, drawn up just off the promenade, may have brought parties of day visitors to Great Yarmouth or be waiting for sightseeing tours, while another laden charabanc is setting off along the promenade. Further along the beach two elegant landaus contrast with the more basic transport used by most visitors. On the beach goat carts provide rides for children, a variation on the donkey ride. [LMS, CC76/00460]

beach they could enjoy donkey rides and beach entertainers including Punch & Judy shows, minstrels and pierrots. Stalls on the promenade grew up in a haphazard fashion to house fortune-tellers, amusements and a wide range of food and drink. Towers, carousels and primitive rollercoasters began to redefine the form of at least part of the seafront. Parks were created to contain a range of sports facilities including golf, tennis and bowling. As well as theatres, numerous music halls, circuses, aquaria, pavilions, bandstands, ballrooms and winter gardens were built during the 19th century. At the beginning of the 20th century kursaals – buildings housing a range of indoor leisure activities – were established in some resorts, and the first surviving cinemas at the seaside appear in the years immediately before World War I.

The main theme of the late 19th century seaside was the extension of disposable time and income to new classes of visitor and this phenomenon gathered pace during the first part of the 20th century. Charabancs, coaches and cars allowed visitors to reach resorts more often and began to open up areas of the coast to mass tourism for the first time. Improved methods of transport were important but, as in the 19th century, this would have had little impact without increased income and the time to enjoy it. In 1938 the Holidays with Pay Act created the first statutory right to paid holidays but, due to World War II, its impact was not felt until the late 1940s.

New types of settlements appeared on the coast between the wars. The bungalow town developed at Canvey Island, Shoreham-by-Sea, Peacehaven and Jaywick. The 'Costa Geriatrica' was another creation of the mid-20th century when the once separate, small communities of the Sussex coast merged into a long suburban sprawl, occupied by a large number of retired people. Holiday camps, invented at the end of the 19th century, began to attract large numbers of visitors in the 1930s, enticed by the offer of accommodation and entertainment in a single, affordable

package. In the post-war era chalet and caravan camps have created entire settlements on virgin stretches of coastline.

Between the wars some Art Deco buildings, usually cinemas, were built in the heart of resorts and examples of Modernist housing can be seen at what was the edge of the town at that date. Some of the best, radical, modern architecture is found at the seaside; the De La Warr Pavilion at Bexhill-on-Sea, the Midland Hotel at Morecambe and a small housing estate at Frinton-on-Sea are notable examples. However, most inter-war and post-war development in seaside resorts is rather plain suburbia, indistinguishable from the suburbs of any large town or city.

Seaside towns bear the imprint of generations of changing fashions in entertainment and visitor accommodation. They also provide tangible testimony to the threats that have faced these islands. In some resorts, especially on the south coast of England, there are the remains of forts built by Henry VIII, martello towers from the struggle against Napoleon and the Palmerston forts of the mid-19th century. During World War I a handful of east and south coast resorts were hit by naval bombardment, Zeppelins and Gotha bombers. Seaside towns, again mainly in the south-east, were scarred by World War II: towns were depopulated and buildings destroyed or damaged; sections of piers were blown up to prevent their use by invading troops; beaches were turned into minefields; and seafronts were strewn with anti-invasion defences, including pillboxes, concrete blocks and barbed wire. An article published in *The Times* on 3 August 1943 described the impact that the war had on one seaside town:

From being a bright and well-kept background to cheerful holidaymaking, Margate has become damaged and shabby... Half the property in the borough has been damaged to a greater or

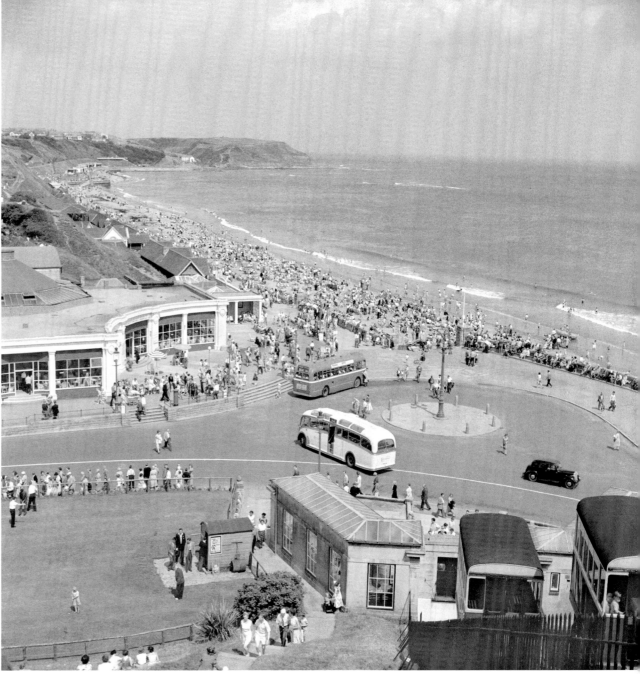

NORTH BAY, SCARBOROUGH, NORTH YORKSHIRE, 1950s
Coach travel opened up more resorts to day trippers and these coaches are just two of many that have brought visitors to Scarborough that day. A lone private car, from an era before universal car ownership, does not hint at the problem traffic was to become. In the foreground is the later of Scarborough's two cliff railways, built in 1881. [Hallam Ashley, AA98/18184]

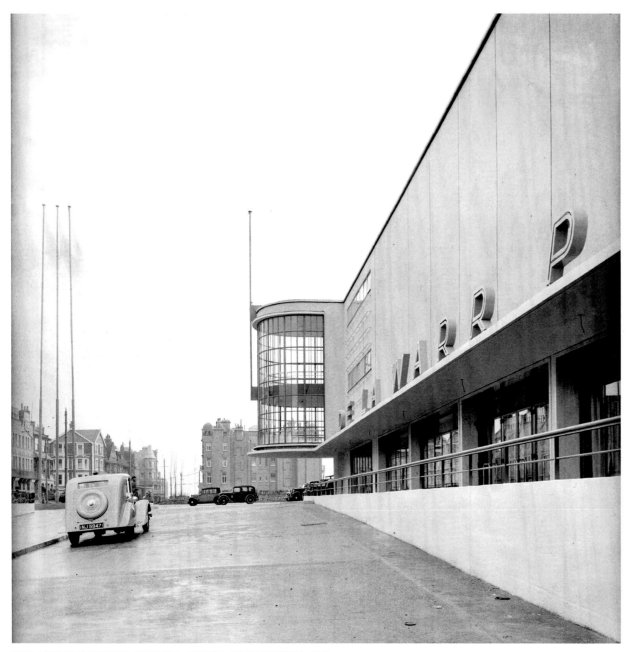

DE LA WARR PAVILION, BEXHILL-ON-SEA, EAST SUSSEX, 1937
The De La Warr Pavilion was part of the development of Bexhill as a seaside resort by Earl De La Warr, landowner and mayor. This Modernist building by Mendelsohn & Chermayeff won an architectural competition and was completed in 1936. The Pavilion provided a theatre, ballroom, restaurant and reading room. Tea could be taken on its terraces and balconies. [H Felton, CC47/02374]

lesser extent... But worse even than the damage done by bombs is that due to premises being left empty and unattended through interruption of the town's peace-time function of a holiday resort.

After the war, seaside resorts seem to have recovered relatively quickly. A war-weary population flocked back to the coast to relax on reopened beaches and, by the 1950s, many resorts were as busy as during the inter-war period. However, many of the large hotels that had been common before the war closed and were either converted into flats or demolished. Instead, people preferred to stay in seafront or backstreet bed and breakfasts or in caravans and camp sites.

Since World War II the largest architectural additions to resorts have been blocks of flats. The earliest substantial blocks of flats were built in the 1930s, with San Remo Towers at Bournemouth and Embassy Court in Brighton being notable examples in contrasting styles. Most post-war developments have not been as architecturally distinguished, catering for a retired market interested in comfort rather than architecture. While flats make a more or less positive contribution to the seaside resort, many late 20th-century buildings only aspire to be cheap and cheerful. They are often little more than simple boxes with vivid, applied decoration, designed to house large numbers of fruit machines and arcade games. However, the harsh geometric forms of modern aquaria provide a new focal point on many beaches.

The 20th century saw a huge increase in the types of entertainment available and a liberalisation of behaviour on and off the beach. Some of the entertainments established in the previous two centuries survive but have been dramatically transformed. Theatres have been converted into cinemas, bingo halls and discotheques. The esplanade is now often dominated by large amusement arcades, and funfairs

have increased in size and in terms of the thrill they provide. In the 19th century holidaymakers wore their normal clothes at the seaside, but during the 20th century a wide range of leisurewear developed, including increasingly skimpy bathing costumes. Some holidaymakers have gone a stage further, casting off all their clothing in an attempt to reconnect with nature. Today there are nine official naturist beaches in England and dozens where naturism is tolerated.

By the late 1960s a decline in the number of people taking their holidays at the seaside had begun. Many resorts were felt to be old-fashioned and unpleasant places to visit. Decaying infrastructure, poor weather and even fighting Mods and Rockers all contributed to the negative image of many resorts. The growth of air transport allowed cheap foreign travel, leading to the creation of resorts – especially on the Mediterranean – catering for English tastes. In recent years English seaside resorts have also had greater domestic competition from other types of holiday and leisure activities, such as activity holidays, cultural tourism including heritage sites, city breaks and theme parks. In response, Butlins has consolidated its operations on three sites where it has invested in large, modern, undercover facilities.

In the late 20th century the future for seaside towns looked bleak. Headline figures suggested a near fatal decline in their fortunes that could not be arrested. However, increasing affluence in the 1980s and 1990s led to a growing market for short breaks and activities such as hen and stag nights. These have helped to offset the decline in longer-term visitors, but for resorts to prosper they have had to adopt a range of new strategies to guarantee their future. At the heart of these is the desire to make resorts pleasant places to live and work, and therefore places that will attract visitors. New employers are being drawn to seaside towns, guaranteeing employment all year round.

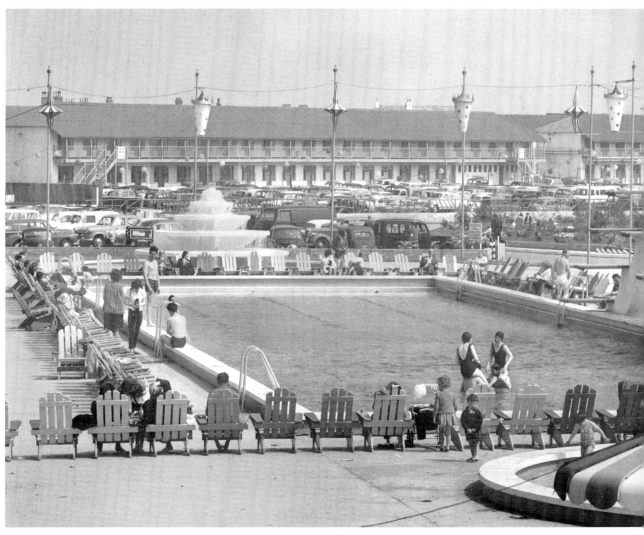

BUTLINS HOLIDAY CAMP, BOGNOR REGIS, WEST SUSSEX, 1960s
Billy Butlin's seventh holiday camp opened at Bognor Regis on Saturday 2 July 1960. It could cater for 5,000 holidaymakers from an intended catchment area of London and the Home Counties. Butlin had had a presence in Bognor since 1930, when he opened an amusement park there. The heated outdoor pool, located between the perimeter fence and the reception building, was one of the original camp constructions and was an important focal point for outdoor rest and recreation. The standard rectangular design was later remodelled into an irregular-shaped fun pool. [ER 25/1; Courtesy of Butlins Archive]

UNION STREET, RYDE, ISLE OF WIGHT, OCTOBER 1969

'Less than a century back Ryde was but a small fishing village, but within the last 50 years it has rapidly risen into a thriving and prosperous town, and now ranks as one of the most pleasant bathing places on the S. coast' (*The National Gazetteer of Great Britain and Ireland*, 1868). Yet this does not look like a holiday resort. Union Street, with its usual complement of shops and other commercial premises, could be found in any town in the country. The sea at the end of the road comes as something of a surprise. This highlights the fact that Ryde, in common with many other resorts, has a large permanent population and must provide services for all its residents. [BB69/07258]

Resorts are beginning to try to diversify to meet the tastes of a wide range of potential tourists. Cultural tourism is being exploited at the seaside; for example St Ives, with its long artistic associations and a branch of the Tate Gallery, appeals to visitors throughout the year. Margate is trying to follow a similar path by encouraging small businesses to open in a cultural quarter in the old town, in anticipation of the construction of the Turner Centre. Padstow has enjoyed a recent boom through tourists wishing to visit Rick Stein's restaurants as well as the picturesque harbour and town. Other resorts are exploiting their natural assets. Newquay styles itself as the surf capital of Europe and Bournemouth has considered creating an artificial reef to attract surfers as well as to please its large student population. Since the 19th century local government and businesses in resorts have recognised that to create a prosperous town it was necessary to lengthen the season. This was done initially by providing winter gardens that offered a warm, pleasant interior, whatever the weather. Since World War II many towns have invested in conference centres to capture some of the income from lucrative political and business conferences. Large resorts such as Brighton, Bournemouth and Blackpool continue to thrive and are still drawing visitors all year round. Some small resorts, filling a distinct niche in the holiday market, are also successful. However, most resorts are quiet except for a few months during the summer.

The seaside resort is still a fun place. The donkey arrived on the beach around 200 years ago and remains an abiding symbol of the joys of the seaside. Today people have more time, more disposable income and the means to get to the seaside whenever they wish. However, with more choice at home and abroad, the seaside has increasingly become a place for short breaks and second holidays. Irrespective of the challenges facing resorts in the 21st century, the seaside still has a special place in everyone's heart.

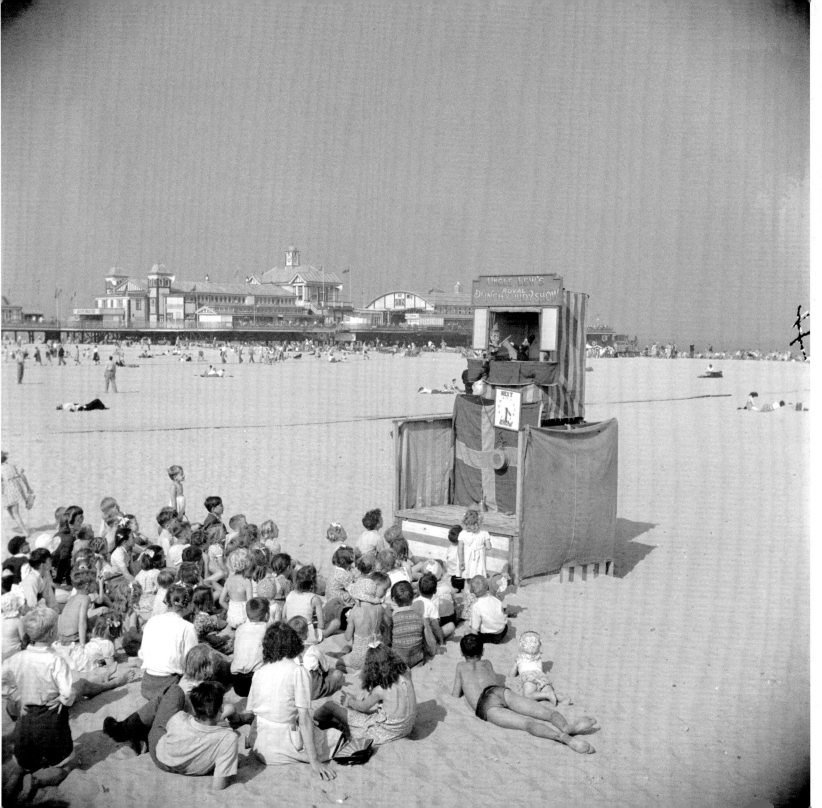

A group of children sit on the sand, captivated by Uncle Lew's Royal Punch & Judy Show. In the background is the Britannia Pier, with its pier-head pavilion and ballroom. [Hallam Ashley, AA98/10838]

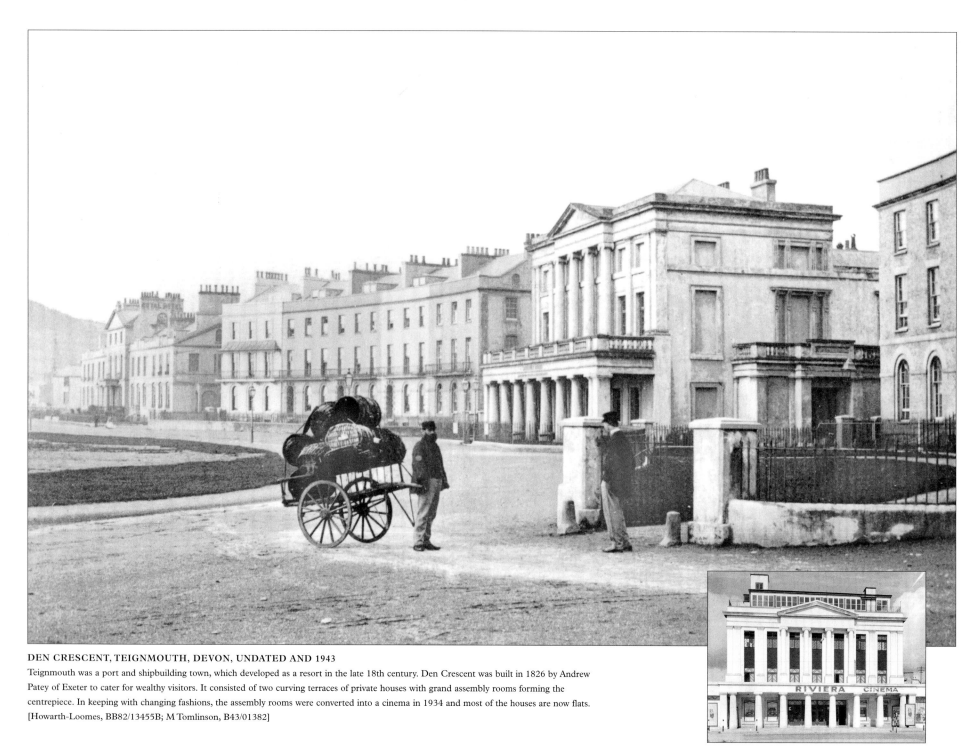

DEN CRESCENT, TEIGNMOUTH, DEVON, UNDATED AND 1943

Teignmouth was a port and shipbuilding town, which developed as a resort in the late 18th century. Den Crescent was built in 1826 by Andrew Patey of Exeter to cater for wealthy visitors. It consisted of two curving terraces of private houses with grand assembly rooms forming the centrepiece. In keeping with changing fashions, the assembly rooms were converted into a cinema in 1934 and most of the houses are now flats.
[Howarth-Loomes, BB82/13455B; M Tomlinson, B43/01382]

Board and lodging

I immediately began to make a more diligent enquiry with respect to lodgings... but to no avail. Every pot-bellied Grocer,
& dirty linendraper bespeaks his lodgings from year to year & they are therefore pre-engaged throughout the year...
There are no lodgings to be had at Sutton – every dirty cottage runs over.

Letter from George Clayton Tennyson, 1813

This was the challenge that faced Tennyson in his search for lodgings in Mablethorpe, Lincolnshire. Visitors came to resorts for weeks during the summer and therefore wanted to rent a house or rooms in a house for the duration of their stay. Initially this meant staying in any house they could find, but by the end of the 18th century long terraces of houses were being built to accommodate visitors. In the 19th century a wide range of villas were built for wealthy people in retirement, for successful businessmen and for prosperous visitors to rent.

Inns and hotels were suitable for people passing through or for short stays, but until the 19th century they were not the luxurious, grand establishments that still dominate some resorts like Scarborough. Victorian visitors were treated to highly decorative exteriors and magnificent interiors in which to relax, dine and play. In the inter-war years a small number of new hotels were built in the fashionable Art Deco style, providing the most modern facilities for people who might know of the pleasures of the sun of the Mediterranean. For the masses, the holiday camp and the caravan began to offer greater numbers of people an opportunity to stay at the seaside. Today large parts of the coastline, especially on the south and east coast, are dominated by caravan sites, while a range of holiday camp companies offer affordable family holidays.

The Leas Promenade, Folkestone. 3295. W. & Co. Ltd.

THE LEAS, SANDGATE, FOLKESTONE, KENT, 1890–1910
The Leas was laid out in the mid-19th century for the Earl of Radnor using designs prepared by Decimus Burton. It was part of a large concerted development of this part of Folkestone as a resort. This terrace is in a prime site on the clifftop and was built as houses and lodging houses. It is five stories tall with a canopied balcony running along the length of the façade at first-floor level. Despite the long shadows which suggest the early evening, several pedestrians on the promenade shade themselves under parasols. [W & Co, OP00557]

HESKETH CRESCENT, TORQUAY, DEVON
Hesketh Crescent would not look out of place in a Georgian town such as Bath. Location is everything, sited as it is high on the cliff with an uninterrupted view of Tor Bay. The Crescent was built in 1846–8 by J & W Harvey for Sir Laurence Palk and represents a significant investment in Torquay. It consists of a central hotel flanked by fashionable and well-appointed houses that provided lodgings for visitors. [Howarth-Loomes, BB82/13455A]

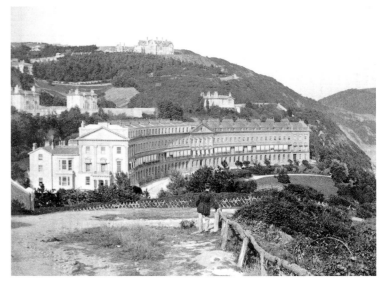

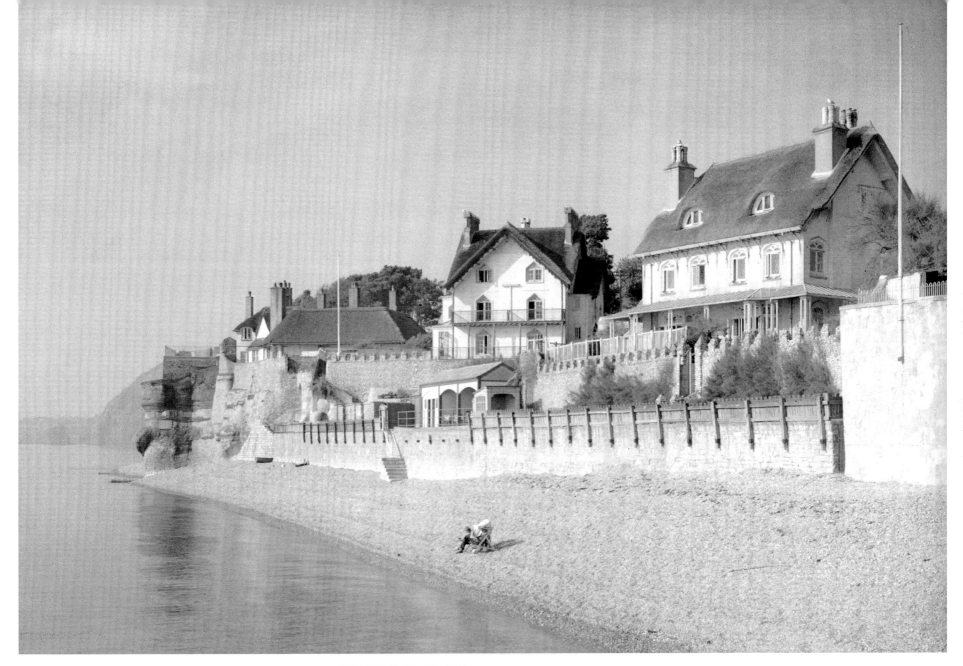

SIDMOUTH, DEVON, 1947

Sidmouth began to develop as a seaside resort in the last years of the 18th century. It has always been a select spot and enjoyed royal patronage in 1819–20 when the Duke and Duchess of Kent took Woolbrook Glen (subsequently renamed The Royal Glen) with their infant daughter Princess Victoria. A grand crescent and fashionable terraces were built by the early 19th century to accommodate the town's wealthy visitors. However, many preferred houses of the more romantic *cottage orné* style – combining delicate Regency ironwork, Gothic details and thatched roofs – exemplified by these quirky examples on the seafront at the end of the Esplanade. [M Tomlinson, BB47/01659]

GRAND HOTEL, SCARBOROUGH, NORTH YORKSHIRE

The Grand Hotel, seen from the South Bay, is towering and imposing. It rises 13 stories, the lower 4 being built into St Nicholas's Cliff. Its style is vaguely that of a French château and the domed roof at each corner creates a distinctive profile. Designed by Cuthbert Brodrick and completed in 1867, it was one of the largest hotels in England. In the foreground, bathing machines are lined up on the beach. [Howarth-Loomes, BB69/05669A]

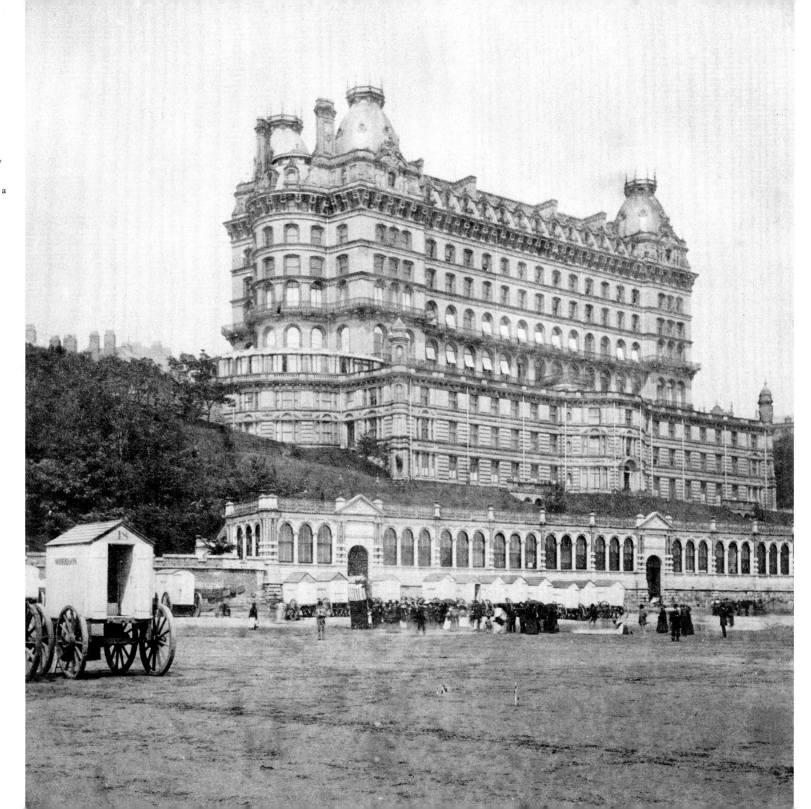

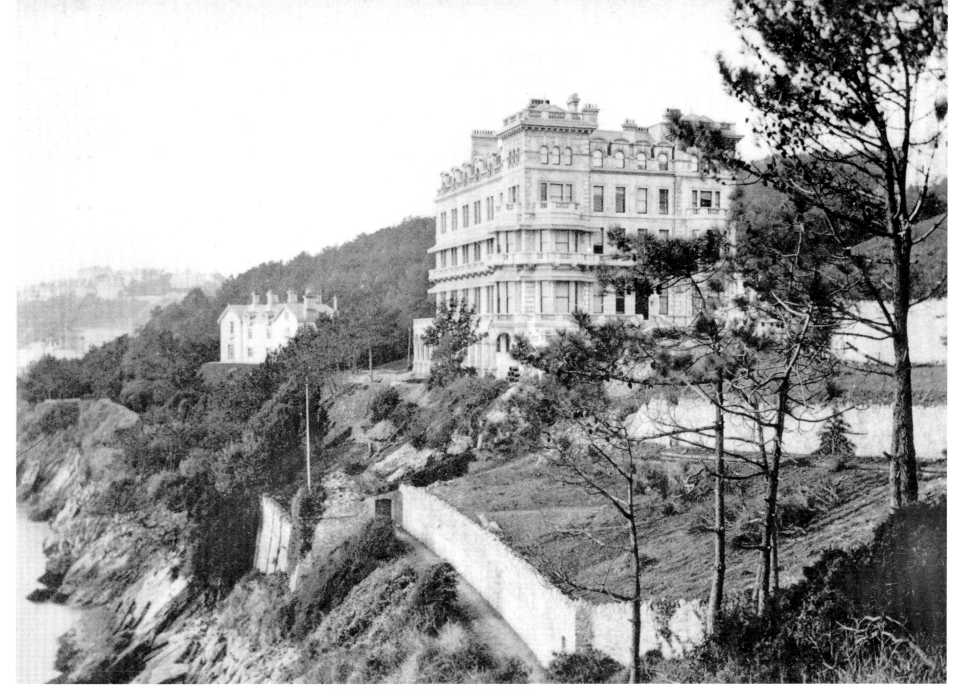

IMPERIAL HOTEL, TORQUAY, DEVON

Tor Bay (Torquay, Paignton and Brixham) styles itself 'the English Riviera' and its mild climate has long attracted visitors. The Imperial Hotel in Park Hill Road was begun in 1863 and was the first major hotel in Torquay. It is sited spectacularly in its own extensive grounds overlooking Tor Bay. At this date sea air rather than beach access was considered the more important factor. A gate gives onto a clifftop walk. [Howarth-Loomes, BB82/13453B]

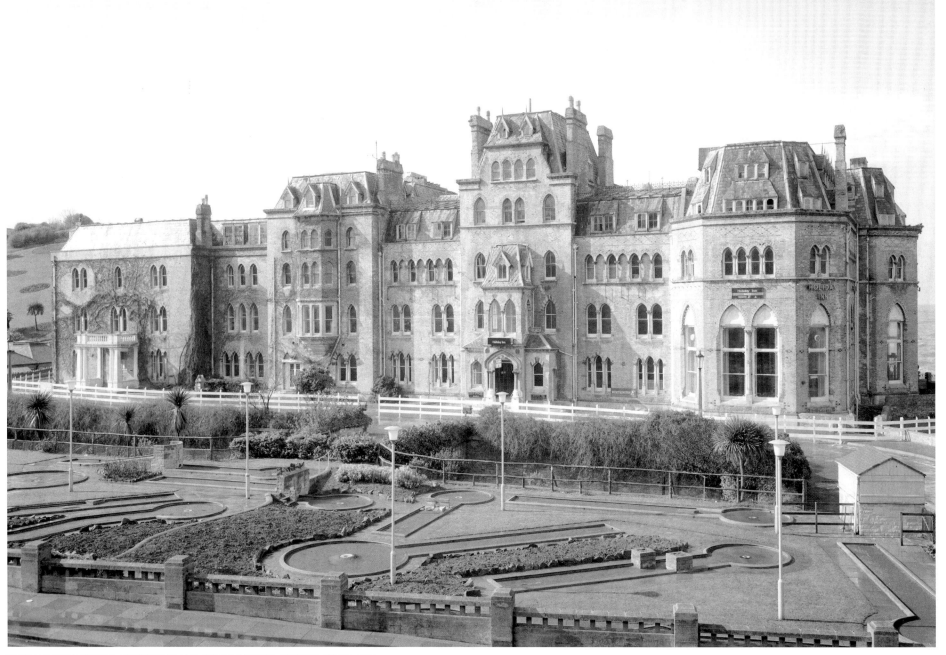

ILFRACOMBE HOTEL, WILDER ROAD, ILFRACOMBE, DEVON, APRIL 1975
Before the arrival of the railway in 1874, Ilfracombe was visited by small numbers of holidaymakers and the Gothic Ilfracombe Hotel was built on a grand scale in 1867–71 to accommodate this growing band. In the late 19th century the hotel advertised ornamental grounds and tennis courts as well as a variety of private sea and indoor bathing facilities. It ended its days as council offices and was demolished in the 1970s, though its laundry has survived and is used as a museum. [BB75/02479]

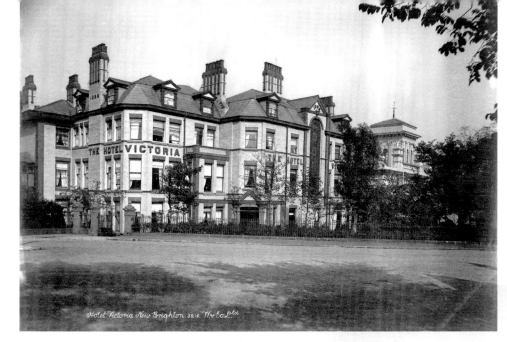

HOTEL VICTORIA, NEW BRIGHTON, MERSEYSIDE, 1890–1910

New Brighton developed primarily as a resort for day trippers from Liverpool, but some visitors wanted to stay for a longer holiday. The Hotel Victoria is an unostentatious building in yellow brick. Its one feature, the long window to the right of the main entrance, may light the principal staircase. It displays two building dates of 1892 and 1895 and so pre-dates the opening of New Brighton Tower.
[W & Co, OP00590]

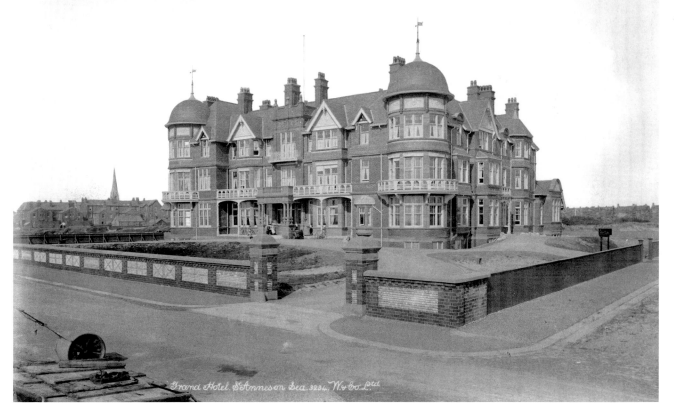

GRAND HOTEL, ST ANNE'S-ON-SEA, LYTHAM ST ANNE'S, LANCASHIRE, 1906–10

Lytham St Anne's remains a quieter and more genteel neighbour to Blackpool. The Grand Hotel on the South Promenade was built in 1906 to designs by F W Catterall. It is visually eclectic in style, with a mixture of building materials, unusual corner drums with domed caps and decorative first-floor balconies giving views towards the sea.
[W & Co, OP00444]

CLIFTONVILLE HOTEL, MARGATE, KENT, 1914
This large hotel on the clifftop was in a prime location, overlooking
Newgate Promenade. The rooms on the main front had balconies and a
sea view. Since World War II most of these large seaside hotels have closed,
been converted into flats or unfortunately been demolished. The
Cliftonville was demolished in 1962. [Bedford Lemere, BL 22782/A]

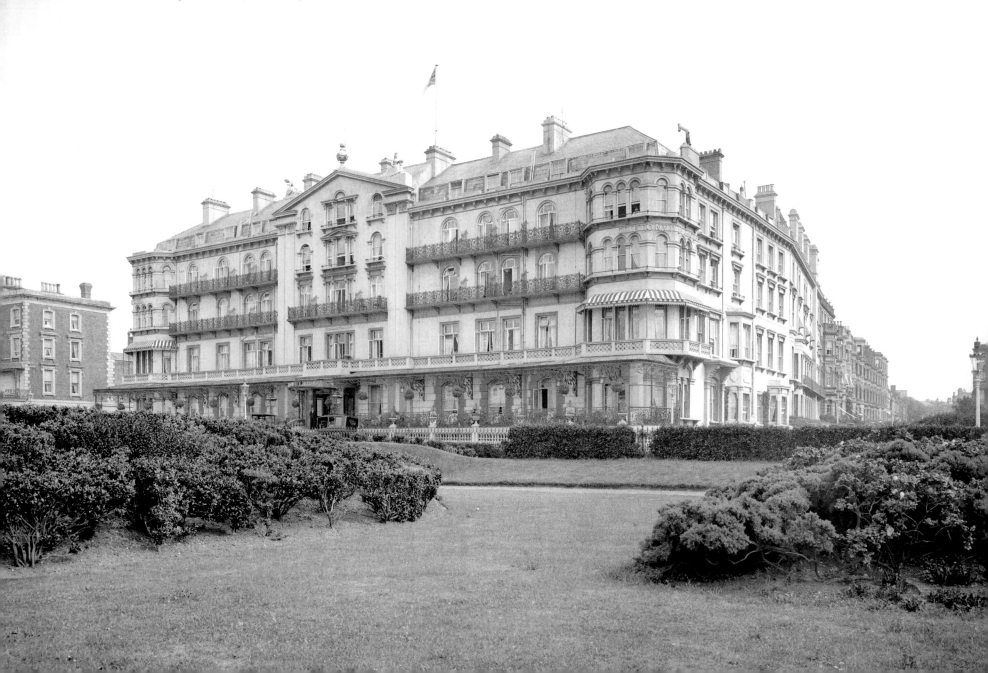

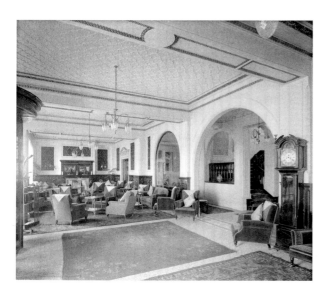

CLIFTONVILLE HOTEL, MARGATE, KENT, 1914

The Cliftonville Hotel was a high class establishment, as the furnishings and decoration of the entrance hall lounge and garden lounge testify. The entrance hall lounge seems formal and heavy, with antimacassars protecting the upholstery. In contrast, the garden lounge appears light and airy. A wrought-iron hammerbeam roof, potted palms, hanging baskets, wicker furniture and Indian side tables combine to create a relaxed, exotic atmosphere. Interior views of this date are comparatively unusual. For these promotional photographs people have been excluded and the scene has been carefully posed for best effect. [Bedford Lemere, BL22783, BL22784]

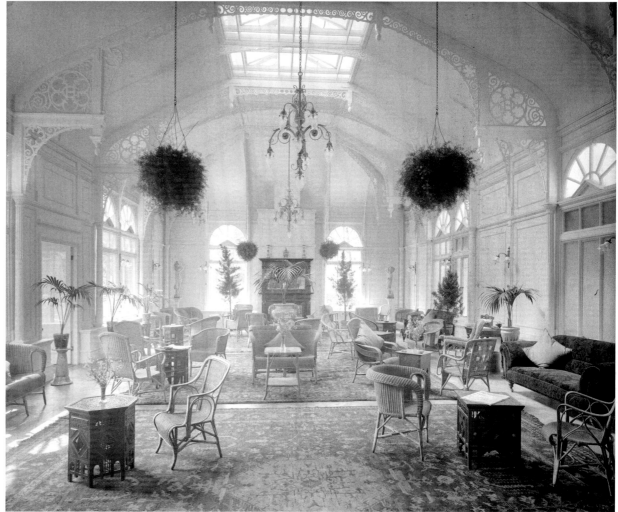

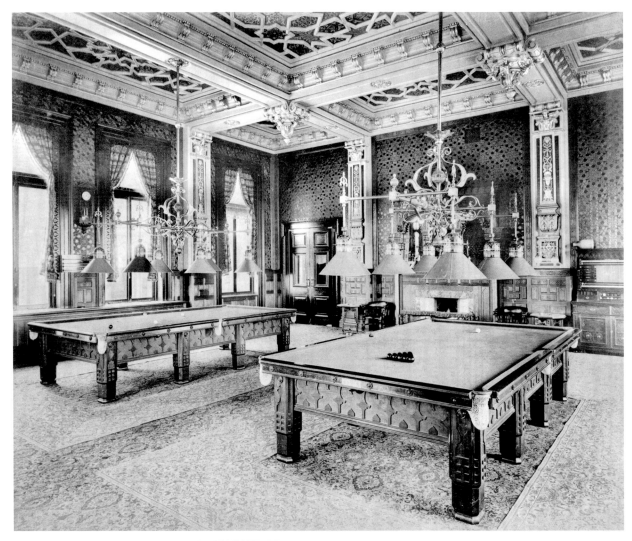

HOTEL METROPOLE, WEST LEAS, FOLKESTONE, KENT
The larger hotels had to provide the facilities their wealthy patrons would enjoy at home or at their club. For that reason most had smoking rooms and billiard rooms, both exclusively male preserves. The decor is heavy, formal and ornate. [Bedford Lemere, BB86/00250]

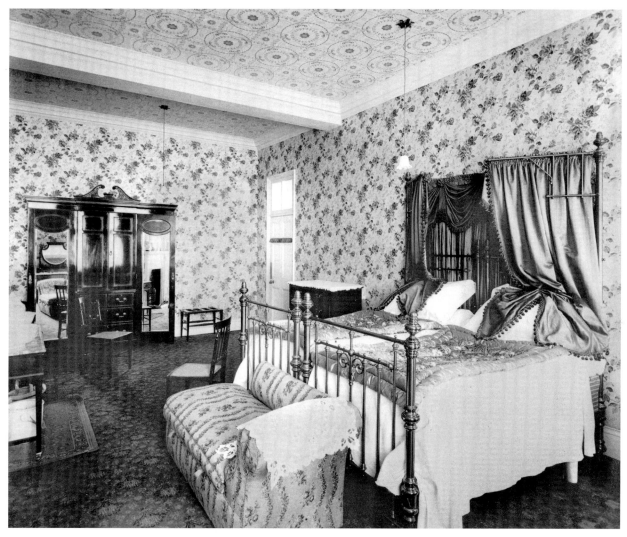

HOTEL METROPOLE, WEST LEAS, FOLKESTONE, KENT

Photographs of hotel bedrooms are rarer than views of public rooms. Two single beds are pushed together with a single curtain at the head to exclude draughts – a rather odd compromise to modern eyes. A washstand is provided opposite the bed as individual rooms did not have running water. Guests were also provided with a wardrobe and a small sofa. The wallpaper and ceiling are highly patterned and there are no pictures hanging on the wall. [Bedford Lemere, BB86/00244]

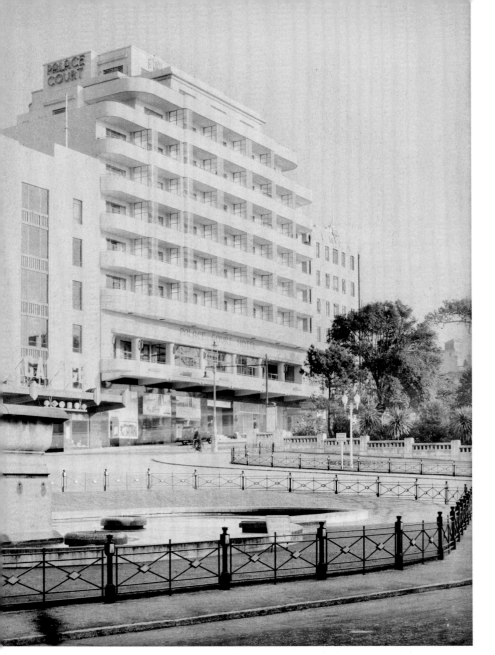

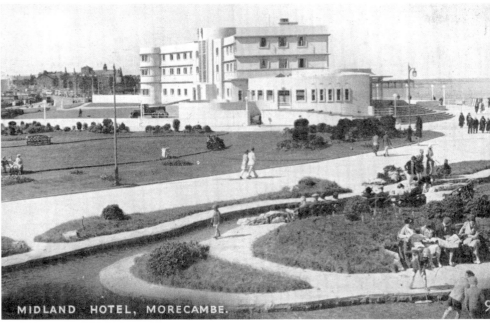

MIDLAND HOTEL, MORECAMBE, LANCASHIRE, 1950
This postcard is postmarked 8 June 1951. The Midland Hotel stands on the seafront, fitting into the sweep of the promenade. It was built for the London, Midland & Scottish Railway by the architect Oliver Hill and opened in 1933. It was a very contemporary building in a modern style. Its striking appearance is due in part to its curving façade, asymmetrical design and its use of strong, white painted surfaces. When the railways were nationalised in 1948, it was among the many former railway hotels which were sold off. The promenade gardens in the foreground were a pleasant place for parents to sit and read while their children played. [Nigel Temple, PC10615]

PALACE COURT HOTEL, WESTOVER ROAD, BOURNEMOUTH, DORSET, 1935
The Palace Court Hotel, built by A J Seal & Partners in 1935 in the Modernist style, is in the centre of town, just a short walk from the seafront. The building incorporates a row of shops at street level with the hotel above. It also advertises service flats and a residential club. In that surprising juxtaposition of wealth and poverty that can occur on a crowded town site, the YMCA hostel is on one side and a garage on the other. The gardens in front of the hotel contain a fountain and a notice gives the time from which it will be illuminated that evening. [H Felton, CC47/00984]

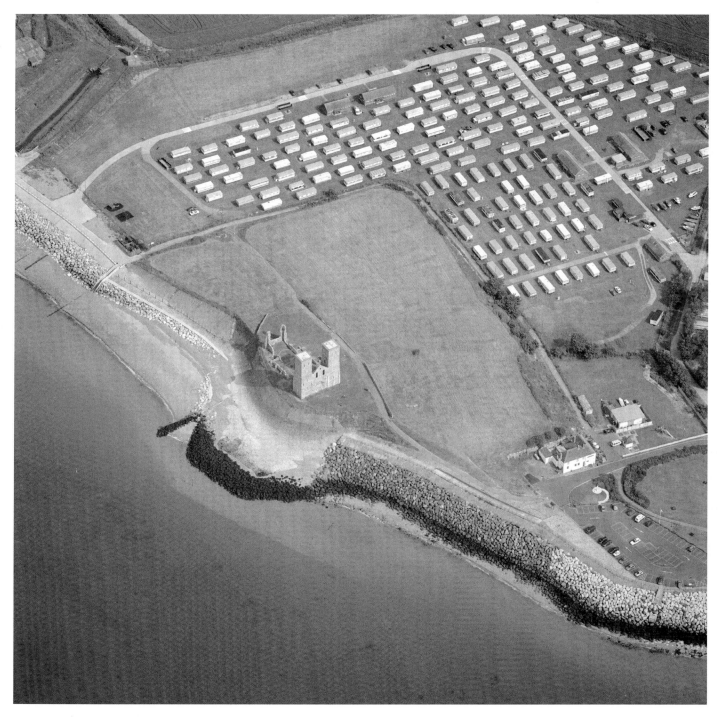

RECULVER, KENT, JANUARY 2001
Reculver lies on the north Kent coast between Herne Bay and Margate. The twin medieval towers at the west end of the former abbey church dominate the view. This coast has suffered badly from erosion, and the church, which is Saxon in origin, stands near what was the centre of a Roman fort. The church had been abandoned by 1809, but the towers were retained as a landmark for shipping and the sea defences were strengthened. Today this ancient site is hemmed in on two sides by static caravans. This scene is repeated everywhere around England's coast where caravan parks provide comfortable but affordable holiday homes for thousands of visitors. [D Grady, NMR 21314/11]

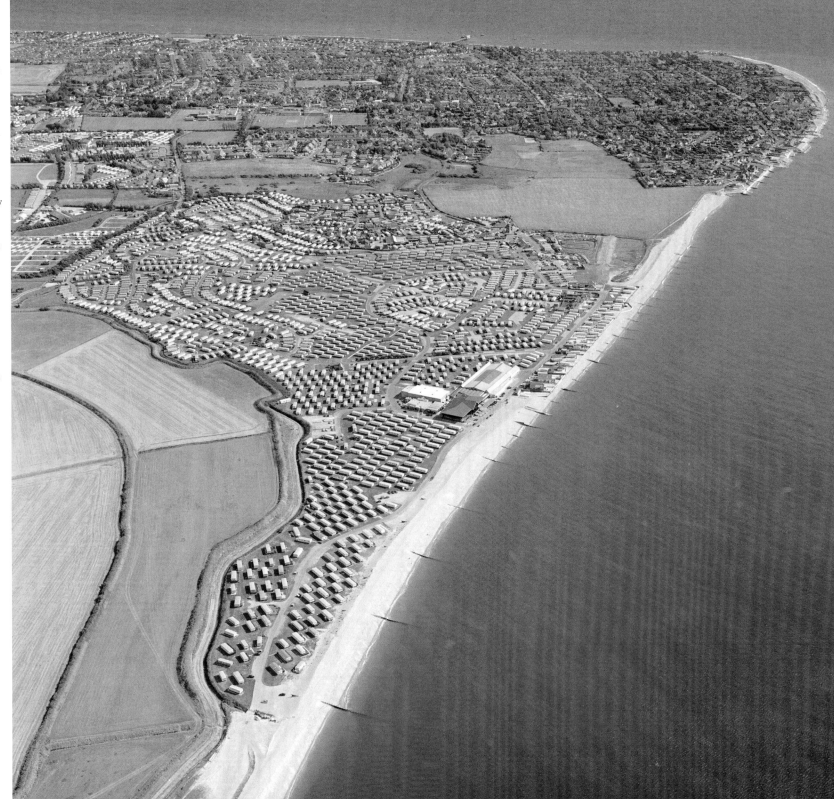

SELSEY, WEST SUSSEX, AUGUST 2002
Until 1809 Selsey was an island surrounded by marshland. The small settlement grew in popularity as a quiet retreat in the 1930s, though it lost its rail link in 1935. Since about 1960 it has developed as a popular resort and today the West Sands Holiday Centre can accommodate over 12,000 people per week during the height of the season. This view looks towards Selsey Bill, with the town facing the east shore and the caravan park on the west shore. The camp's central facilities can be seen near the centre of the photograph, but the beach is still the main attraction.
[D Grady, NMR 21819/16]

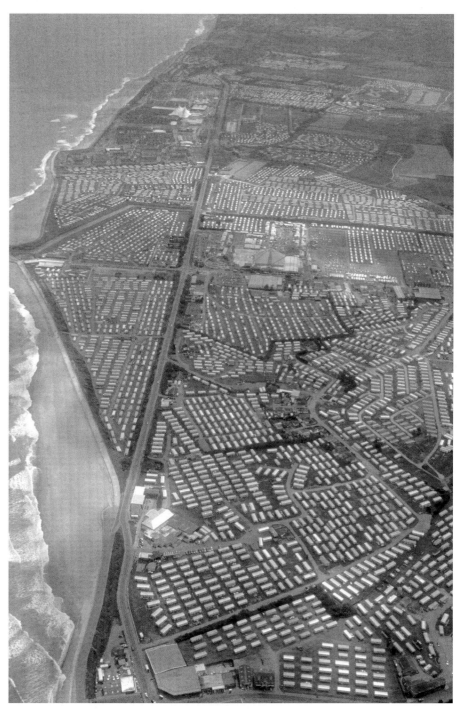

BUTLINS, INGOLDMELLS, NEAR SKEGNESS, LINCOLNSHIRE, JUNE 2000
At the top of this aerial photograph is one of the three large holiday centres around the coast still operated by Butlins. In the middle is the large amusement park. The rest of the photograph is dominated by private caravans and chalets. This section of the Lincolnshire coast is reputed to have more caravans than any other stretch of coastline. [D Macleod, NMR 17471/15]

BLACKPOOL, LANCASHIRE, 1946–55
Blackpool is the busiest resort in England and the beach is usually crowded. A man in a suit ignores the bustle and dozes on the sands, with Blackpool Tower fixing the location. [John Gay, AA047910]

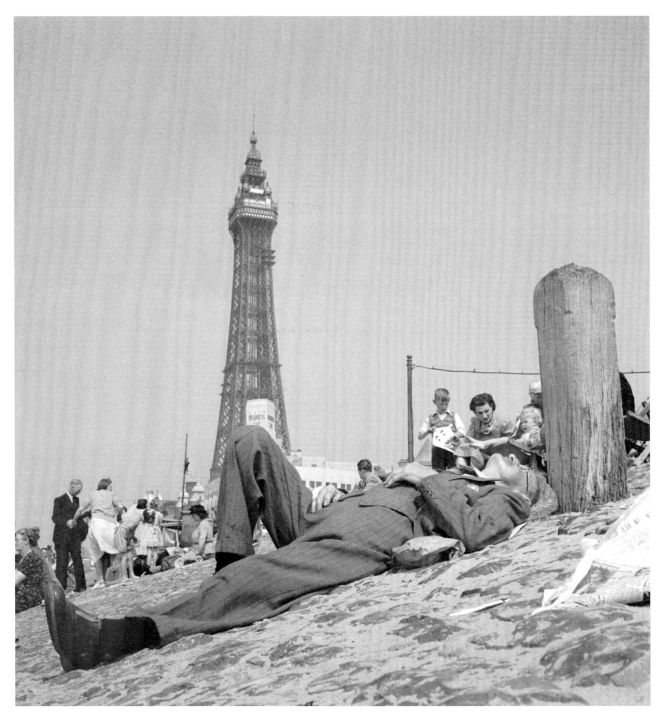

On the beach

How pleasant to sit on the beach,
On the beach, on the sand, in the sun,
With ocean galore within reach,
And nothing at all to be done!

Ogden Nash, *Pretty Halcyon Days*, 1945

The beach, that unique space between the sea and the land, never fully exposed nor completely submerged, has been the most significant component of the English seaside resort since the early 18th century. The beach, be it of sand or pebble, has been the stage upon which generations of English holidaymakers have played out their fantasies. Whether it is a secluded cove or a broad thoroughfare, it is where you truly feel that you are at the seaside.

The beach is the focal point of the English seaside resort. It is where the young and the old are happy to spend hours playing or resting. Since the first visitors journeyed to the seaside, beaches have served a multitude of uses, both active and passive. They have been a bathing place, promenade, racetrack, art gallery, theatre, concert hall, market place, sun lounge, playground, fairground, place of worship and site of scientific interest. They are one of the few shared environments where work coexists with play. The beach is also a subject for artists and poets who have been inspired by its rich textures and colours and by the sensations it evokes.

Some beaches remain remote and seemingly untouched by human hand, unmarked by groynes and rubbish bins. Most though are accessible to all and, as a result of by-laws and regulations, are probably the cleanest and safest they have been since the first Georgian bathers ventured onto them. A trip to the seaside would not be complete without time spent on the beach – preferably with socks and shoes off and trousers rolled up.

BATHHOUSE, GREAT YARMOUTH, NORFOLK

A seawater bath was one of the first facilities built in Great Yarmouth in 1759. The baths in this photograph were built in the 19th century when the resort was well established and needed larger facilities. The photograph also shows donkey rides being provided on the beach, a practice that began in the early 19th century. [Howarth-Loomes (W T Fisher), BB83/04754]

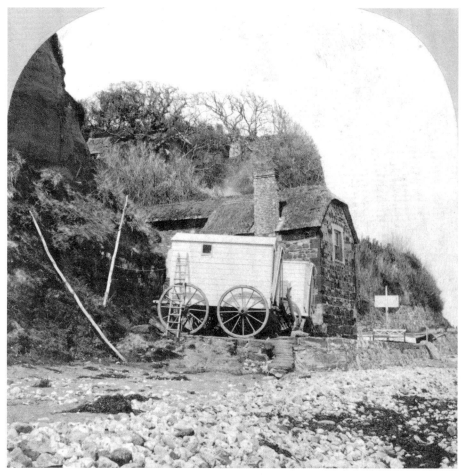

BATHING MACHINES AT WHITBY, NORTH YORKSHIRE AND SHANKLIN, ISLE OF WIGHT

Sea bathing is obviously one of the unique attractions of coastal resorts and bathing machines were an important part of this experience. They were in use at Scarborough and Margate from the 1730s to convey bathers into the sea. Their purpose was to protect both the bather's modesty and public decency, and a folding canvas hood allowed the bather to enter the water and bathe in complete privacy. The machines at Shanklin stand outside Fisherman's Cottage, premises of James Sampson, Bathing Machine Proprietor, and would probably have been towed down to the sea by horses. Those at Whitby are in the harbour where they are presumably being stored out of season. [Howarth-Loomes, BB85/02155B, BB70/01558]

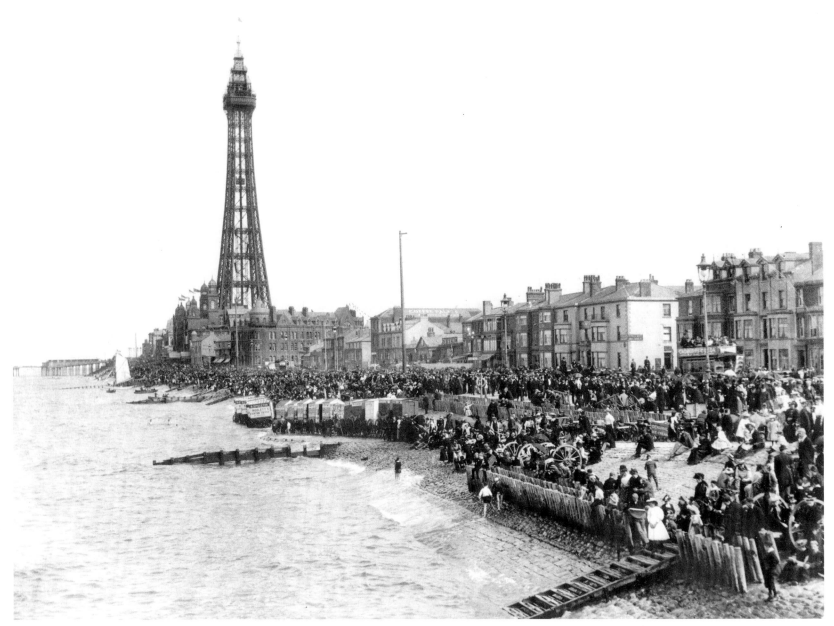

BLACKPOOL, LANCASHIRE, 20 AUGUST 1895

The Promenade at Blackpool is crowded as holidaymakers wait for the tide to go out, though a few brave souls are swimming. A row of bathing machines drawn up on the cobbles advertise Stead and Simpson's Boots and Noblett's Everton Toffee. In the distance is the North Pier, Blackpool's first pier, built by Eugenius Birch in 1862–3. Soaring over the scene is the iconic Blackpool Tower. Modelled on the Eiffel Tower, it was opened on Whit Monday 1894 and proved an immediate popular hit. [LMS, BB88/00109]

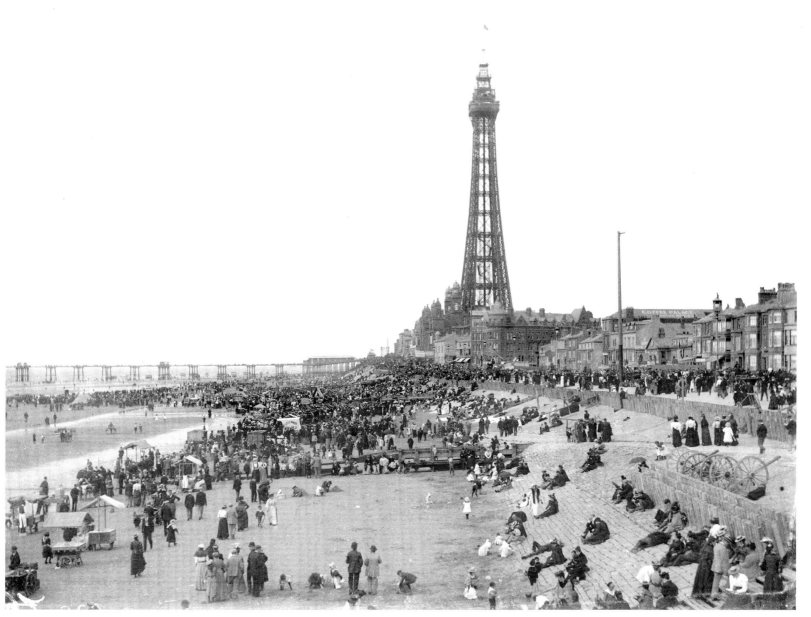

BLACKPOOL, LANCASHIRE, 20 AUGUST 1895

This is the same scene later in the day. The tide has gone out and the holidaymakers – who in the previous photograph were penned back on the Promenade – have spilled onto the sand. Others are down by the sea where bathing machines offer some privacy from the crowds. Along its length the beach is dotted with stalls selling ice cream, food and seaside gifts. [LMS, CC79/00488]

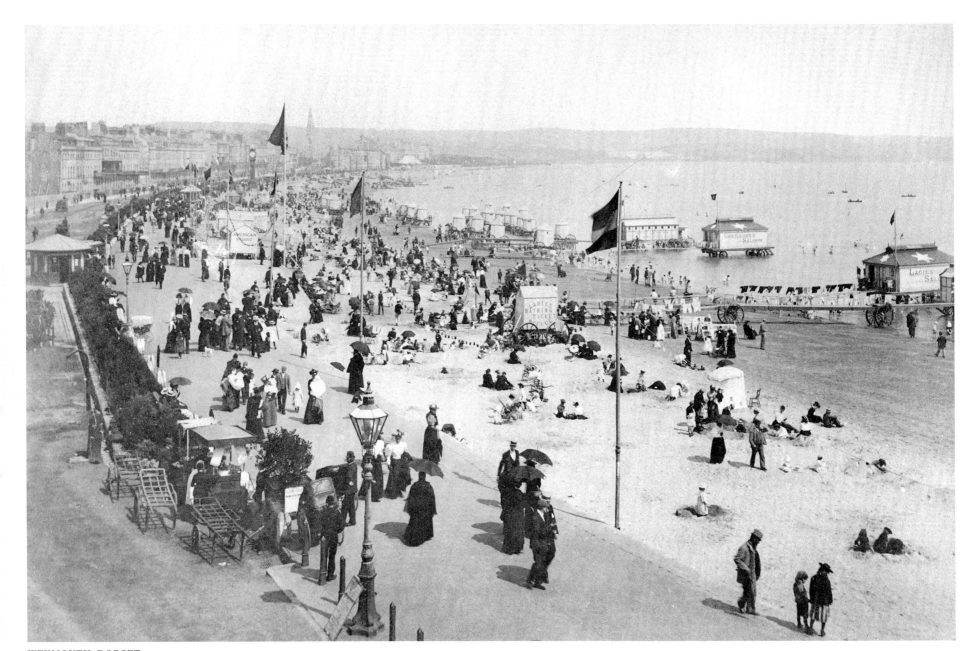

WEYMOUTH, DORSET

A busy day on the seafront: ladies with parasols take their exercise, while more informal family groups relax on the sand. Organised bathing is much in evidence and segregation of the sexes appears to be the rule. The ladies' bathing ticket office makes use of an old bathing machine and there are separate ladies' and gentlemen's saloons. Further along the beach some unusual hexagonal bathing machines stand at the water's edge. Was the American Studio, a hut towards the left of the photograph, perhaps a beach photographer? [BB88/02329]

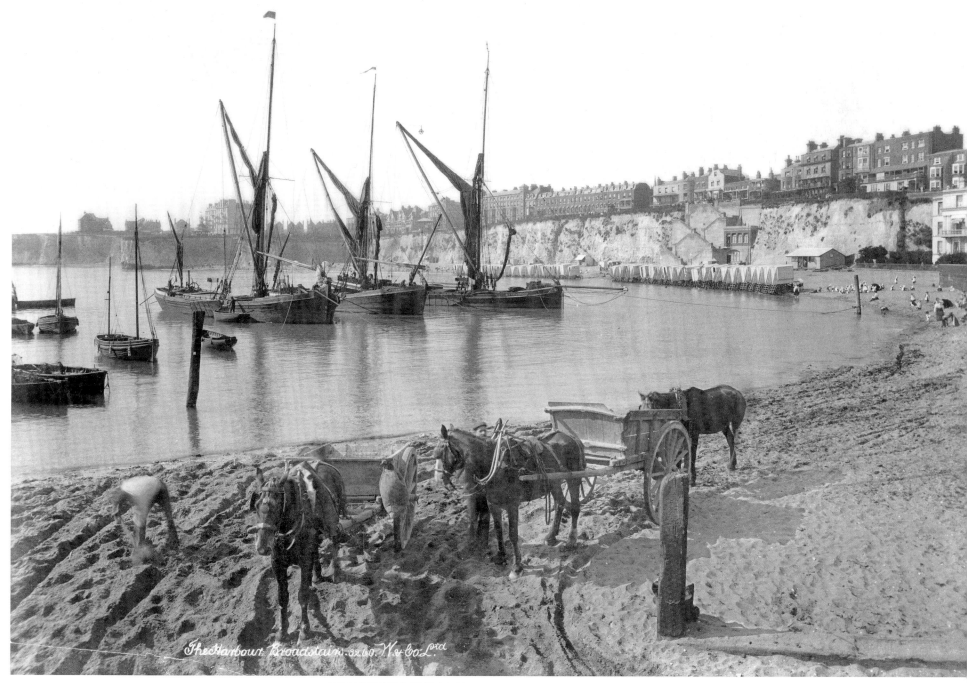

BROADSTAIRS, KENT, 1890–1910

The sandy Viking Bay, backed by tall chalk cliffs, provides an attractive holiday setting. A curve of bathing machines lines the water's edge and a tearoom is built against the cliff face, while a zigzag staircase gives access up the cliff to the town. The bay doubles as a harbour, with a variety of boats providing local colour. In the foreground a man appears to be quarrying sand, an industry that must have conflicted with the holiday trade. [W & Co, OP00508]

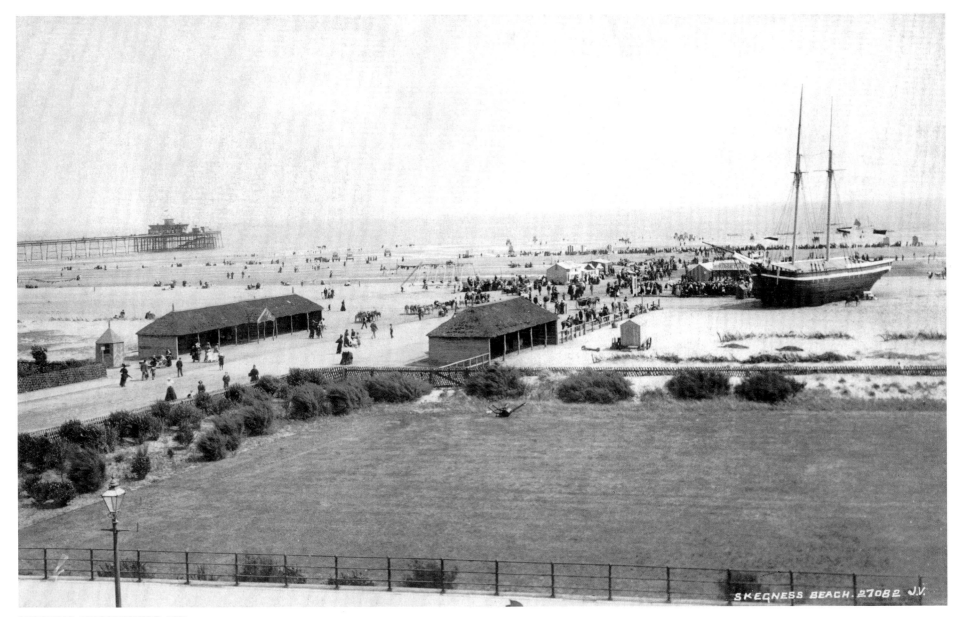

SKEGNESS BEACH. 27082 J.V.

SKEGNESS, LINCOLNSHIRE, 1903

This photograph bears the inscription 'Spent the day here 10th September 1903. J. M. Ponton'. The crowds congregate around a run of stalls, amusement booths and a swingboat ride, with a two-masted ship drawn up on the beach alongside. The open-fronted buildings in the foreground are stables for the horses that pulled the bathing machines and for the inevitable donkeys. Bathers and bathing machines are at the sea edge in the distance. Skegness pier, to the left of the photograph, ends with a pier pavilion. Built in 1880–1, it was the winning design from a competition and is over 1,800ft long. [OP03555]

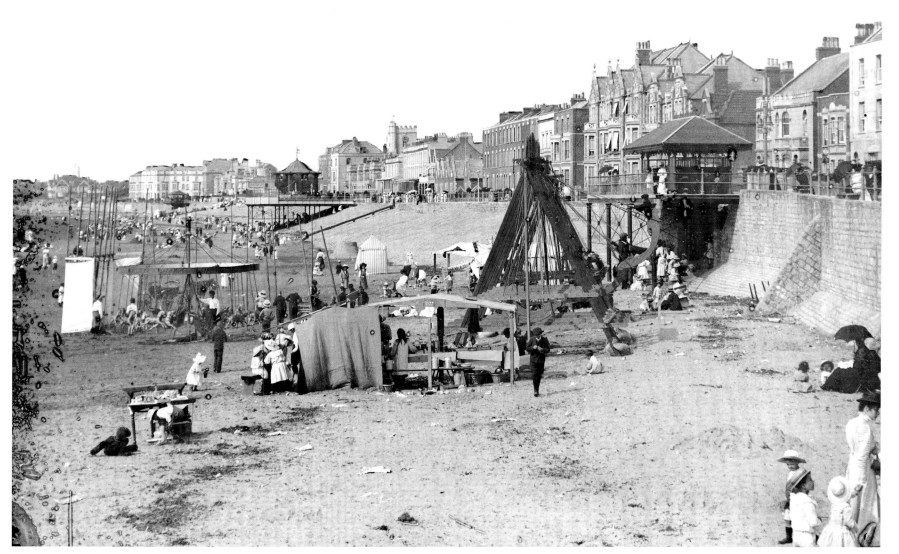

BURNHAM-ON-SEA, SOMERSET, AUGUST 1909

A children's funfair has set up on the sand, with swingboats, a carousel and a stall. The promenade had recently been enhanced, with new shelters projecting out over the beach. The bandstand was built to commemorate the coronation of Edward VII in 1901, though it was demolished in 1911 to make way for a grander pavilion. [LMS, CC76/00329]

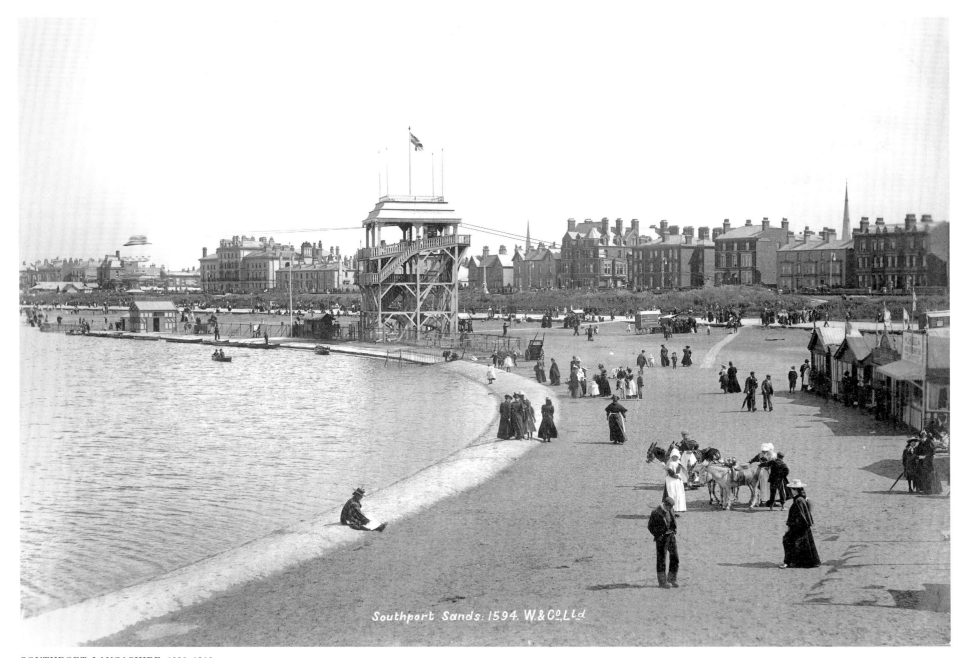

Southport Sands: 1594. W.& C⁰.L.ᵗᵈ

SOUTHPORT, LANCASHIRE, 1890–1910

A variety of attractions can be seen in this view of Southport beach. The small tower is one of a pair at either end of an aerial ride across the boating lake; the towers were demolished in 1911 as an eyesore following objections from residents. To the right a row of stalls sell food and gifts, while a group of donkeys offer rides to children. Donkey rides have been a popular seaside activity since the early 19th century. [W & Co, OP00610]

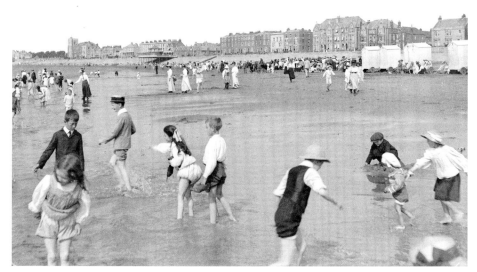

BURNHAM-ON-SEA, SOMERSET, AUGUST 1909
Edwardian children benefit from the increased informality of the early years of the 20th century and roll up their trousers or tuck in their skirts in order to paddle in the sea – though their clothing is still very formal by today's standards. Their parents are also less formally dressed when compared with the fashions of the late 19th century. The bathing machines appear to be functioning as little more than static changing huts and as a prop for a bicycle. [LMS, CC76/00331]

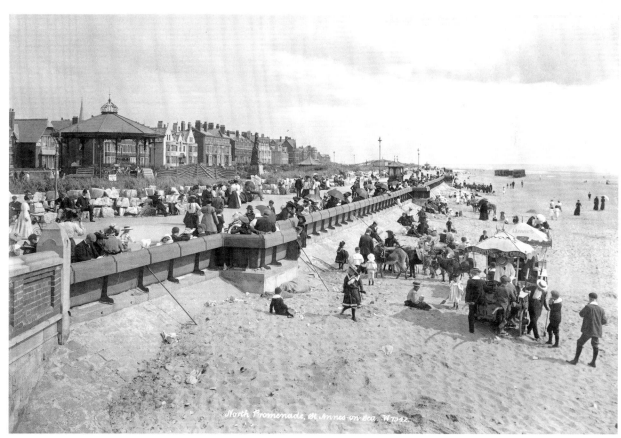

ST ANNE'S-ON-SEA, LYTHAM ST ANNE'S, LANCASHIRE, 1890–1910
Holidaymakers stroll on the North Promenade, which is lined with seating and has been laid out with gardens, a bandstand and shelters. Over the sea wall, stalls sell ice cream and the traditional donkeys give rides for children. [W & Co, OP00445]

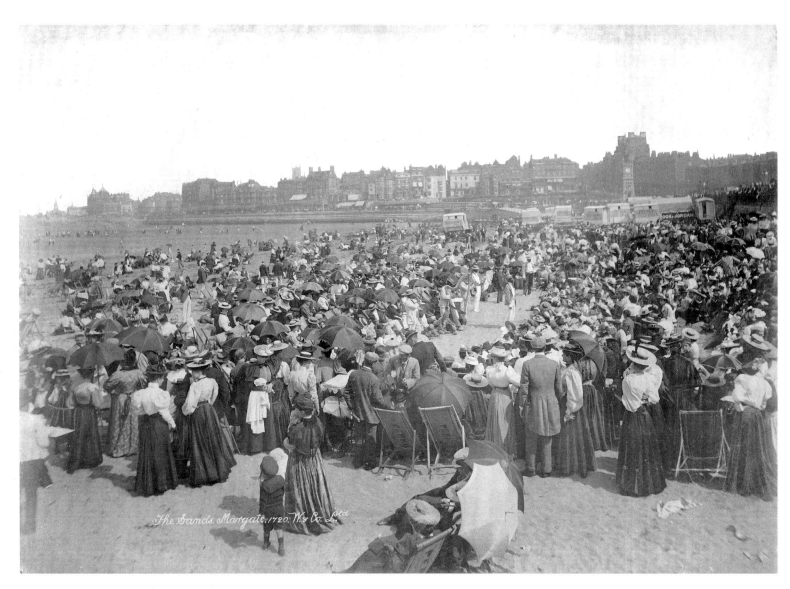

The Sands. Margate. 1720. W. & Co. Ltd

MARGATE, KENT, 1890–1910
Travelling entertainers have long
been a feature of coastal resorts.
Here a large crowd has gathered to
watch an impromptu performance
by a troupe of 'black-and-white'
minstrels. At the time they were a
popular form of entertainment and
would have provided a song, dance
and comedy routine. Deck chairs
were in use at this date and several
of the women in the audience carry
parasols to protect themselves from
the sun. [W & Co, OP00621]

NORTH BEACH, GREAT YARMOUTH, NORFOLK,
SEPTEMBER 1904
Cultural and popular entertainments were part of the package offered
by resorts in order to attract visitors. This open-air theatre has been
set up on the beach, perhaps by a touring company. With its festoon
of white lights, it no doubt provided an atmospheric setting on fine
evenings. This high vantage was provided by Warwick's Revolving
Tower (*see* p 120). [LMS, CC76/00466]

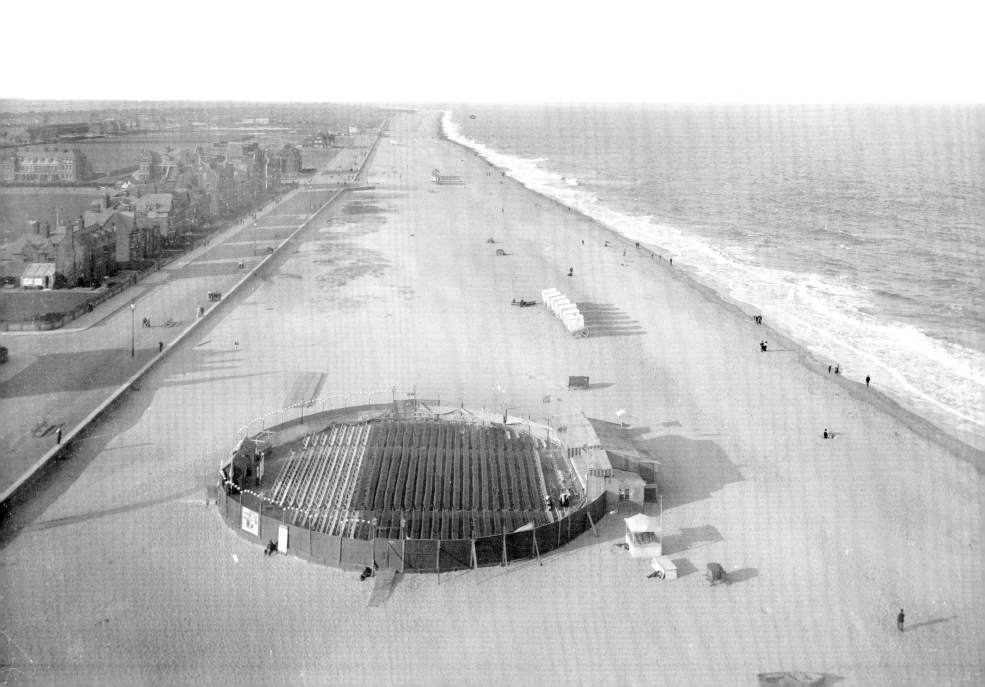

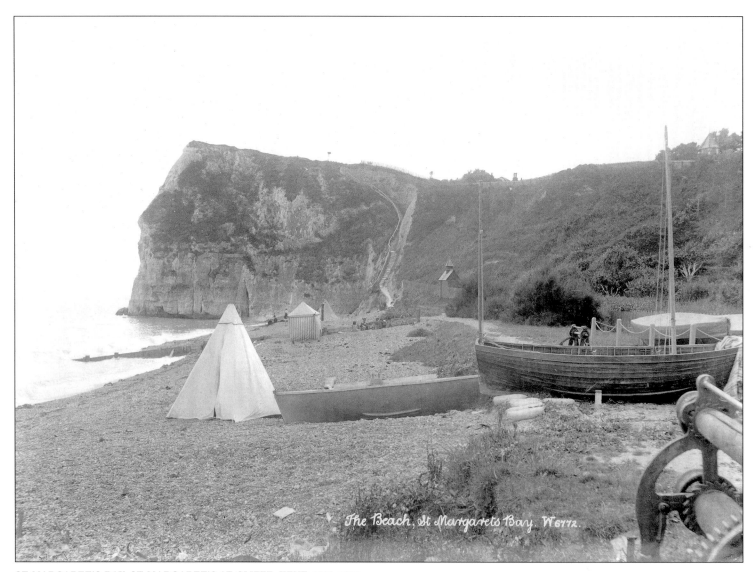

The Beach, St Margarets Bay. W6772.

ST MARGARET'S BAY, ST MARGARET'S AT CLIFFE, KENT, 1890–1910

Holidaymakers in search of unspoiled beauty have pitched their tents on this quiet and secluded beach, which they share with small boats. The headland of Ness Point provides a backdrop to the peaceful scene. St Margaret's was a small resort on the east Kent coast. The old fishing village was set back from the sea, though modern settlement has developed at the top of the cliff. Many of the seafront buildings were severely damaged during commando training in World War II. [W & Co, OP00672]

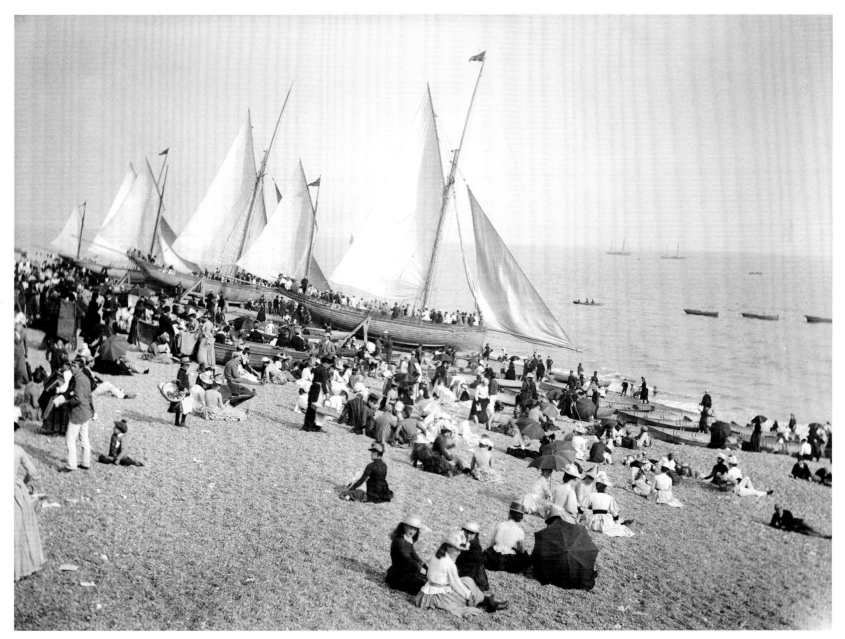

HASTINGS, EAST SUSSEX

Hastings was a fishing port, which became popular for bathing in the late 18th century. The first guide to the resort was published in 1794. This photograph captured the beach on a busy summer's afternoon. Visitors sit on the shingle in family groups to enjoy the sea view. Many of the gentlemen wear blazers and caps while the ladies sport ornate hats. 'Trips around the bay' and fishing trips were both popular pastimes and the three Skylarks offering sea trips here are filling up. The one nearest the camera advertises that it will sail at 10am. Rowing boats are for hire down by the shore for those who prefer to be their own captain. [BB68/09473]

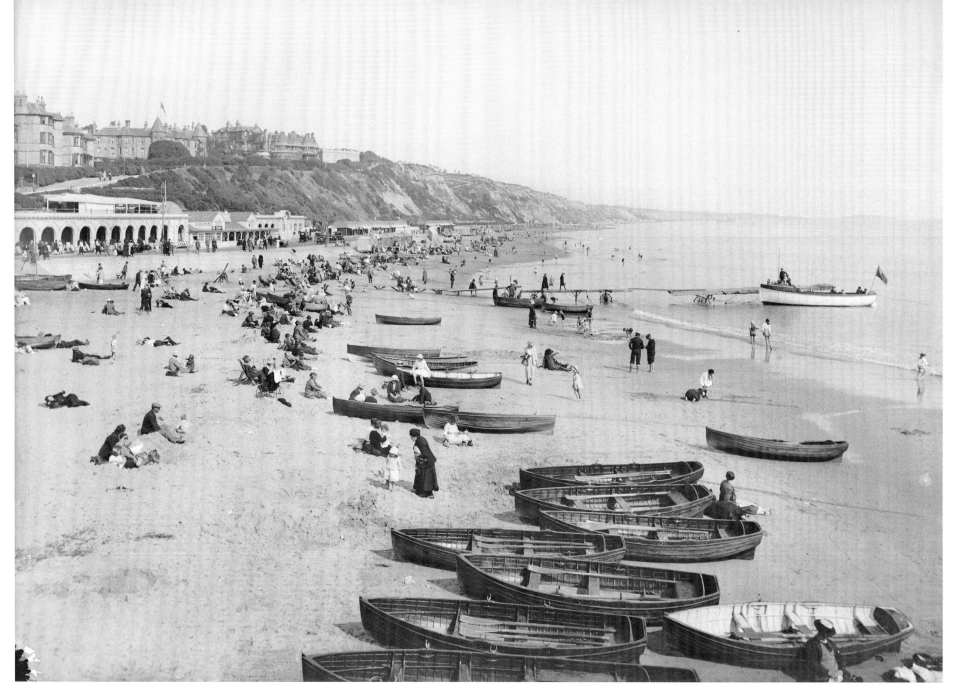

EAST CLIFF, BOURNEMOUTH, DORSET, SEPTEMBER 1921

The rowing boats in the foreground are probably for hire, while a motorised Skylark boat offers trips around the bay. The mobile jetty could be adjusted with the tide. Bathing huts and bathing machines stretch into the distance at the base of the cliff, while the East Beach Café provides for other needs. Guest houses and hotels line East Cliff Promenade, commanding spectacular sea views. [LMS, CC76/00279]

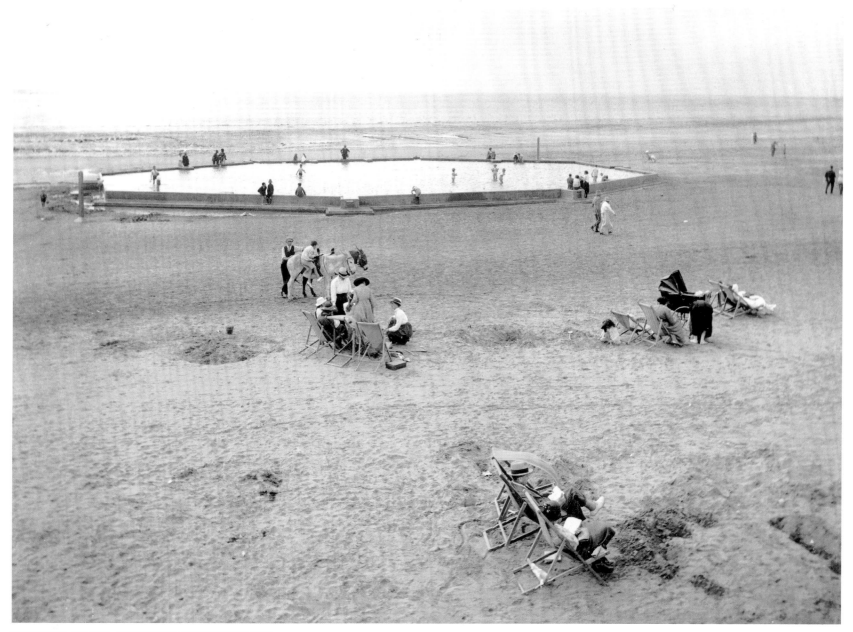

BURNHAM-ON-SEA, SOMERSET, SEPTEMBER 1921

The season is almost over and the beach is emptying. A sea-filled paddling pool provides a safe environment for children, while the ubiquitous donkeys are available for hire. Those other mainstays – the bucket and spade – are also present. With the children provided for, the adults take the opportunity to read a good book. They have sensibly positioned their deck chairs with their backs to the wind, an all-too-familiar accompaniment to days at the English seaside. The paddling pool, built in 1921, was given by Mr & Mrs J B Braithwaite in thanks for the safe return of their five sons from World War I. [LMS, CC76/00404]

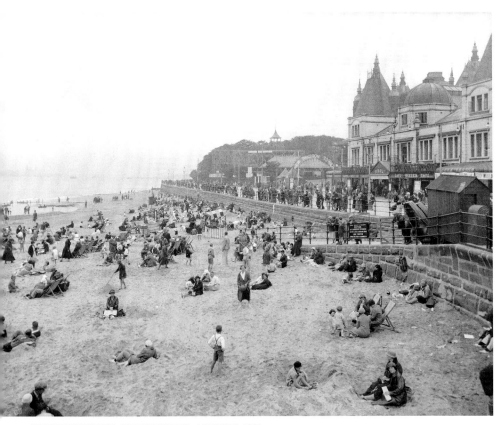

NEW BRIGHTON, MERSEYSIDE, AUGUST 1933
New Brighton offered sand, sea and amusements to day trippers from Liverpool. It may be a chilly day as coats are being worn, but Tower Promenade and the beach are still busy. Stalls on the beach serve food and there appears to be a Punch & Judy show. The fashion seems to be to scoop hollows in the sand and to sit in them, while a notice warns of the dangers of being cut off by the tide. The extensive Tower Gardens – 35 acres of amusements, sports facilities and gardens – surround the entertainment complex at the foot of the Tower. On the promenade a row of shops, cafés and the Tivoli Theatre cater for visitors. The buildings of Liverpool are hazily silhouetted across the Mersey. [LMS, CC80/00451]

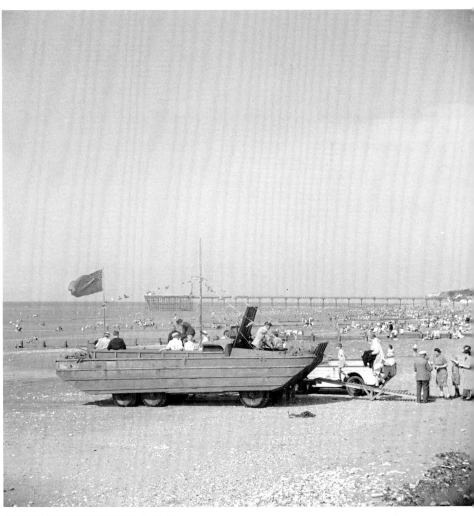

HUNSTANTON, NORFOLK, 1945–50
In the years following World War II England was still experiencing rationing and many things were difficult to come by. At Hunstanton someone clearly rose to the challenge and made the most of what was to hand. An ex-army DUKW amphibious vehicle is being used to add interest to the well-established 'trip around the bay'. Hunstanton Pier can be seen in the background. This graceful structure was built in 1870–1 and was originally 830ft long. [Hallam Ashley, AA98/17564]

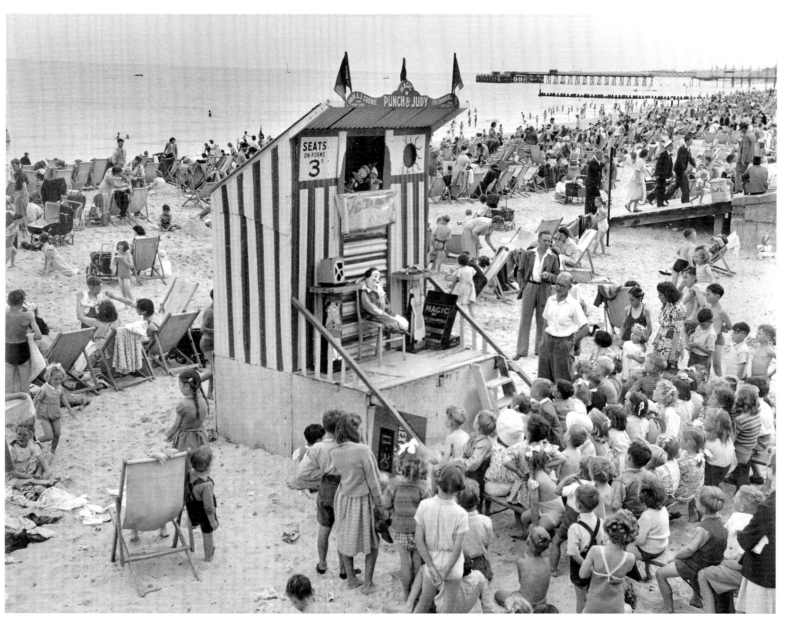

LOWESTOFT, SUFFOLK, AUGUST 1949

Punch & Judy has been performed in England since at least the 17th century, making the transition from popular adult to children's entertainment. These children have paid 3d (less than 1½p) to watch a Punch & Judy show on Lowestoft beach. The Claremont Pier, built in 1902–3, is visible in the background. The centre section of the pier was removed in World War II as a defence measure and the temporary post-war repair can just be seen in this photograph. Like many piers, its future is uncertain. [Hallam Ashley, OP00075]

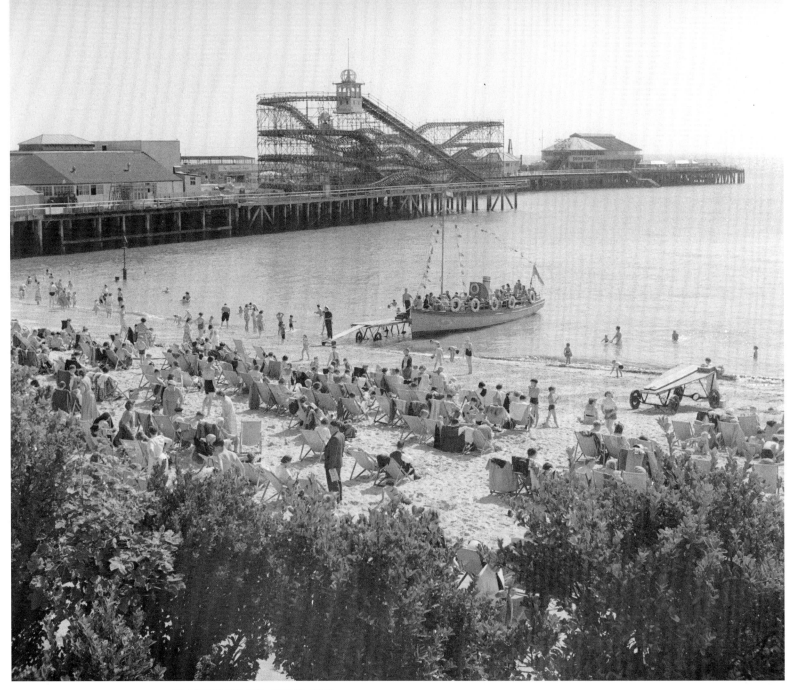

CLACTON-ON-SEA, ESSEX, 1953

Clacton Pier incorporates a large fairground at the landward end, which included a rollercoaster when this photograph was taken. The pier-head pavilion, originally built as a concert hall, has been renamed the Jolly Roger and advertises 'Show Time'. In the foreground, lines of deck chairs are set out for sun worshippers, while a small launch offers short sea trips. [Hallam Ashley, AA98/17446]

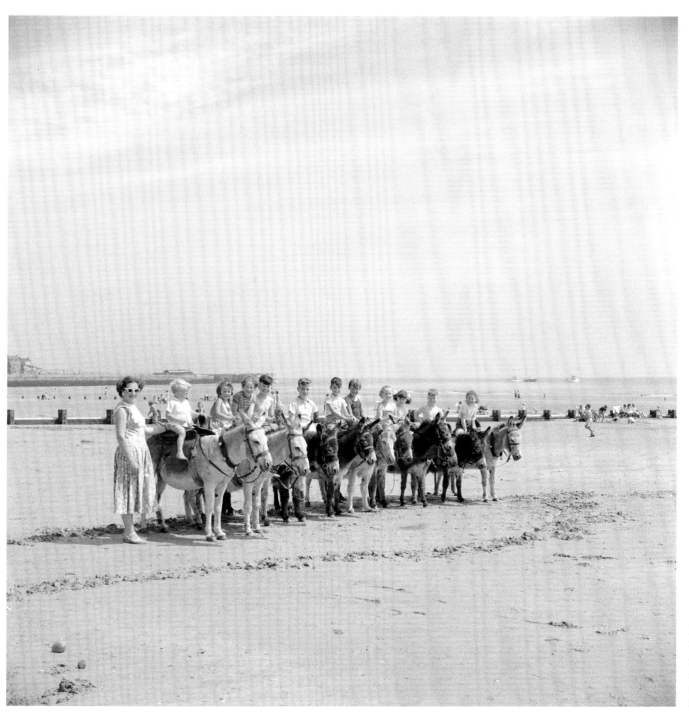

BRIDLINGTON, EAST YORKSHIRE, 1945–1980
Donkeys have been found on the beach for at least 200
years. Children continue to enjoy donkey rides – and these
donkeys do not appear to be dissatisfied with their lot
either. The youngster at the end is discreetly supported by
his mother. [Hallam Ashley, AA99/00354]

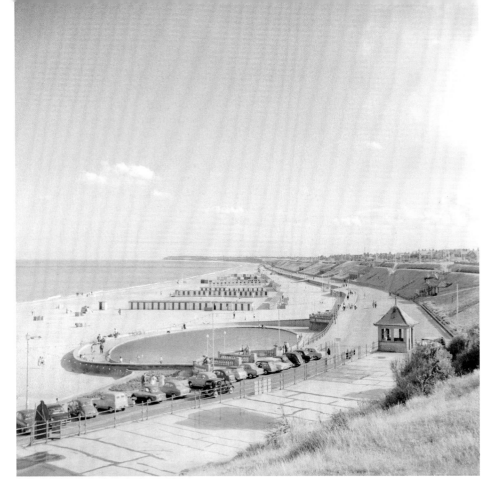

GORLESTON-ON-SEA, NEAR GREAT YARMOUTH, NORFOLK, JULY 1961
The long sandy beach and Lower Esplanade provide the basic ingredients for a seaside holiday. In the foreground a pool provides safe bathing for children. Beyond, lines of beach huts for hire give a base for a day on the beach and privacy for changing. The beach is backed by Gorleston Cliffs topped by the Upper Esplanade, which offers bowls, tennis and putting. Numerous access points have been cut through the cliffs. [Hallam Ashley, AA99/00326]

SEA PALLING, NEAR STALHAM, NORFOLK, 1945–52
Sea Palling is, by contrast, an undeveloped settlement on the north-east Norfolk coast. The road seems simply to disappear into the sand dunes and the sea beyond. The village itself appears to have little to offer the visitor apart from refreshments in one form or another. There is a restaurant, a pub and an ice cream van parked at the entrance to the beach, while the village store does a brisk trade in ice cream and cakes (though possibly not shoe polish). Accommodation can be found at the pub and the caravan park (entrance on the right). This photograph appears to have been taken before the great flood on the night of 31 January 1953, when several buildings were destroyed and seven people were killed. Following the disaster improvements to sea defences were made at a number of resorts on the east coast.
[Hallam Ashley, AA98/09281]

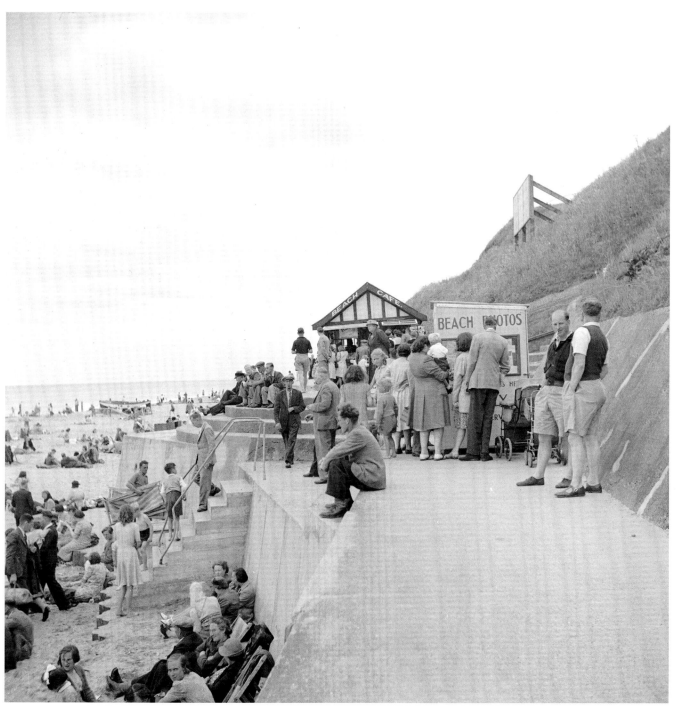

MUNDESLEY, NORFOLK, 1950s

Photograph albums are filled with portraits taken by beach photographers who made a precarious living by snapping holidaymakers on spec as souvenirs. As they were behind the camera, few pictures of these 'catchers of memories' were ever taken. This view is unusual as it includes the studio-cum-darkroom of one such photographer where recent pictures displayed on the wall are attracting attention from passers-by. The unattractive concrete promenade is a reminder that the Norfolk coast is vulnerable to erosion by the North Sea. [Hallam Ashley, AA98/17520]

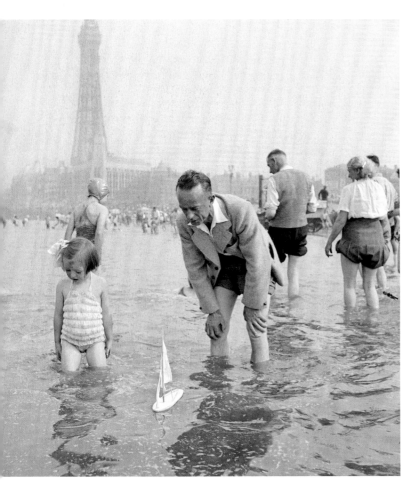

BLACKPOOL, LANCASHIRE, 1946–55
A father and daughter paddle in the sea and sail a model yacht, though the girl seems to be losing interest. [John Gay, AA047926]

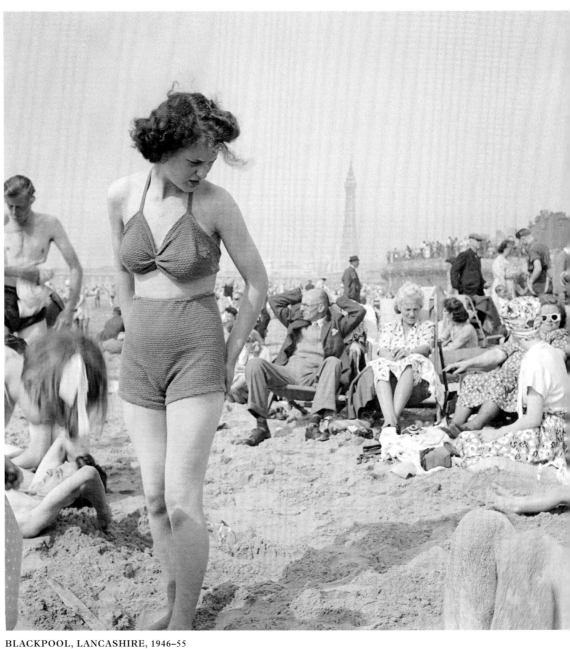

BLACKPOOL, LANCASHIRE, 1946–55
A young woman in a knitted two-piece bathing costume stands on the beach amidst the crowds. The style of dress of the three ladies seated behind her is a complete contrast. [John Gay, AA047917]

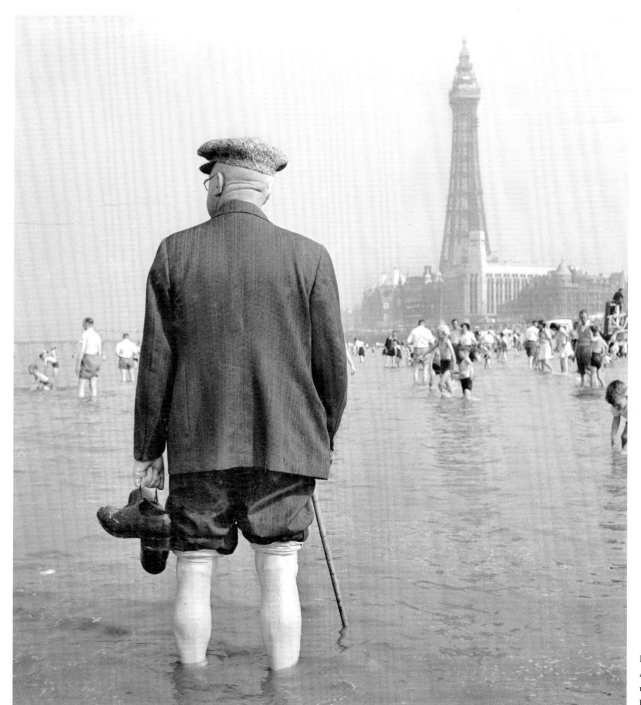

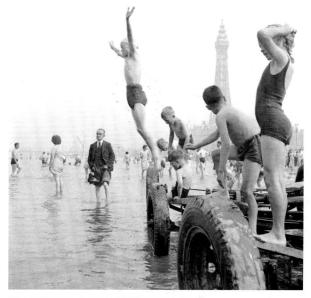

BLACKPOOL, LANCASHIRE, 1946–55
Two generations enjoy the seaside experience in different ways. Children in swimming costumes jump into the sea from a boat trailer while an older man paddles with his trousers rolled up, carrying his boots. [John Gay, AA047925]

BLACKPOOL, LANCASHIRE, 1946–55
An elderly man enjoys a paddle in the sea. He has rolled up his suit trousers, but still wears his flat cap and carries his shoes and walking stick. [John Gay, AA047928]

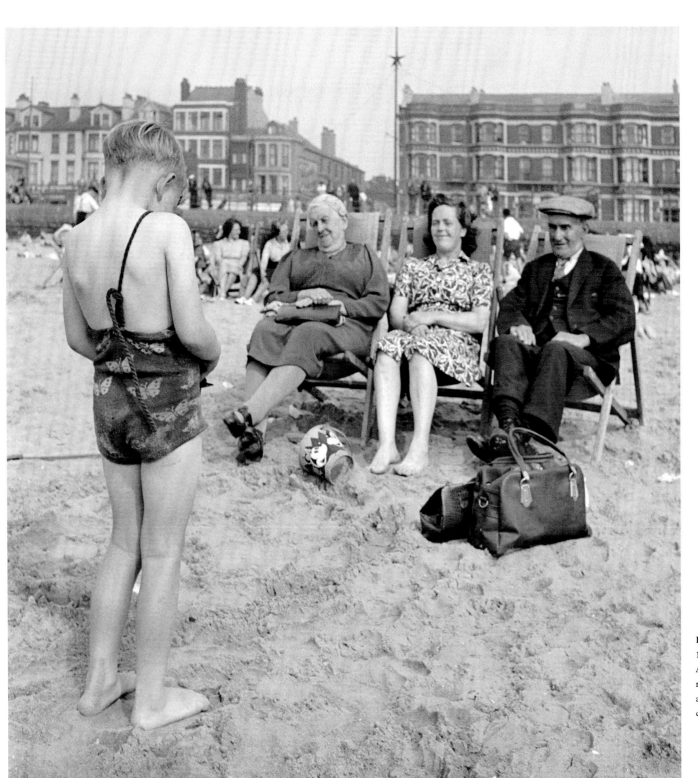

BLACKPOOL, LANCASHIRE,
1946–55
A child turns beach photographer,
recording a day out with his mother
and grandparents who are sitting in
deck chairs. [John Gay, AA047919]

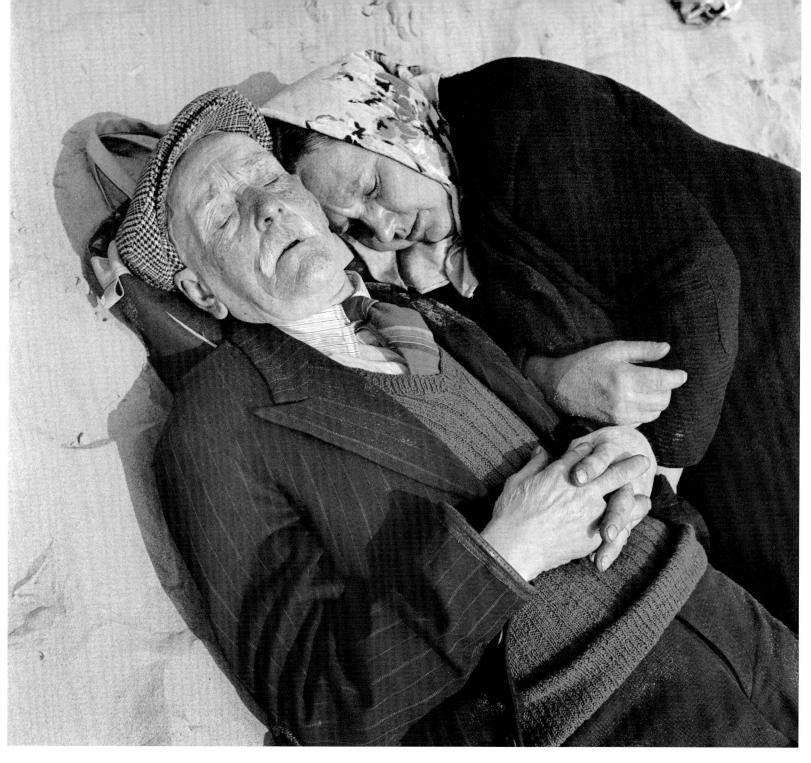

**BLACKPOOL,
LANCASHIRE, 1946–55**
An elderly couple take
40 winks on the beach,
oblivious to the interest
of the photographer.
[John Gay, AA047921]

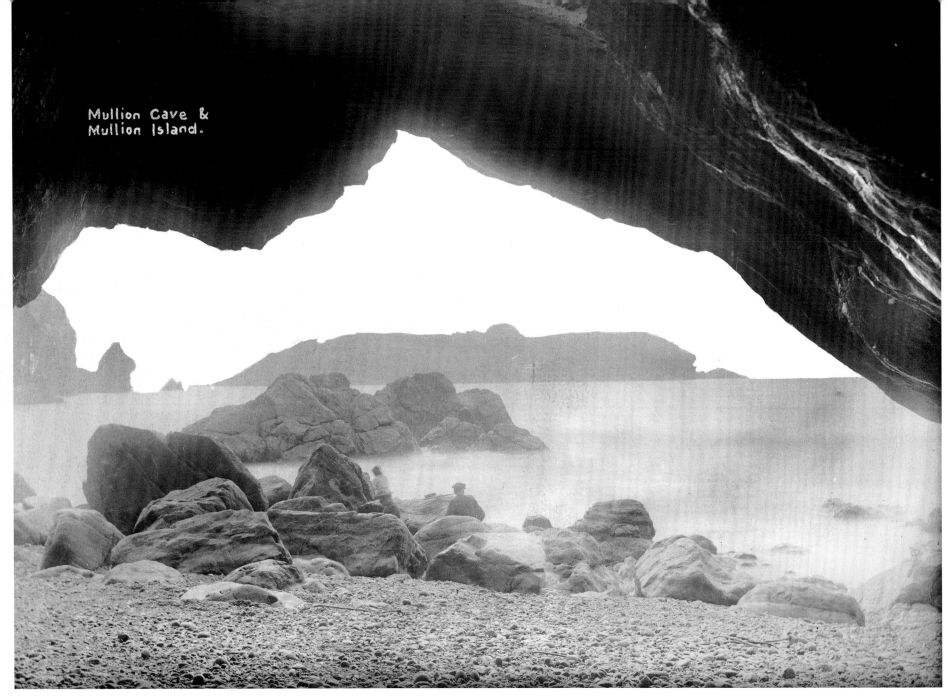

Mullion Cave &
Mullion Island.

MULLION COVE, CORNWALL

The pleasures of Blackpool do not appeal to all tastes. Some holidaymakers favour remote, isolated spots and natural beauty rather than crowds and mass entertainment. The Cornish coast offers many such places. Mullion Cove on the Lizard peninsula, with its cave and island, holds a considerable attraction. The picturesque fishing harbour of Mullion Cove is just around the bay. [Alfred Newton & Son, BB98/06127]

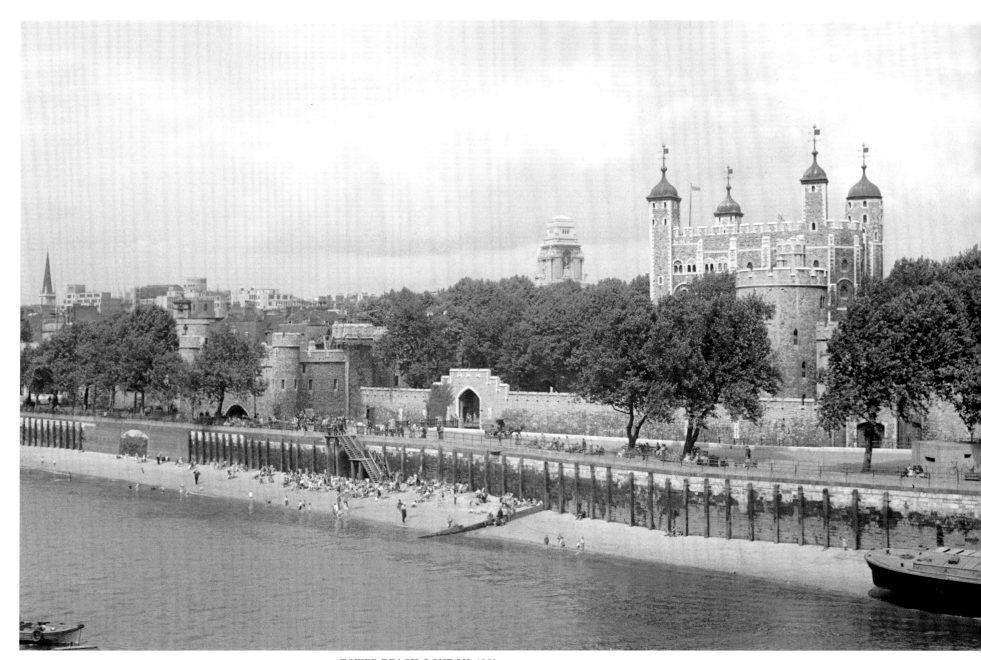

TOWER BEACH, LONDON, 1950s

Many of the poor children of East London could not afford seaside holidays, so a beach was created on the Thames next to the Tower of London. Barge loads of sand were dumped on the muddy foreshore and the beach was opened in 1934. At this time London was still a major port and pollution was surely a problem. However, it remained popular after World War II, only declining as holidays became more affordable. [S W Rawlings, AA001193]

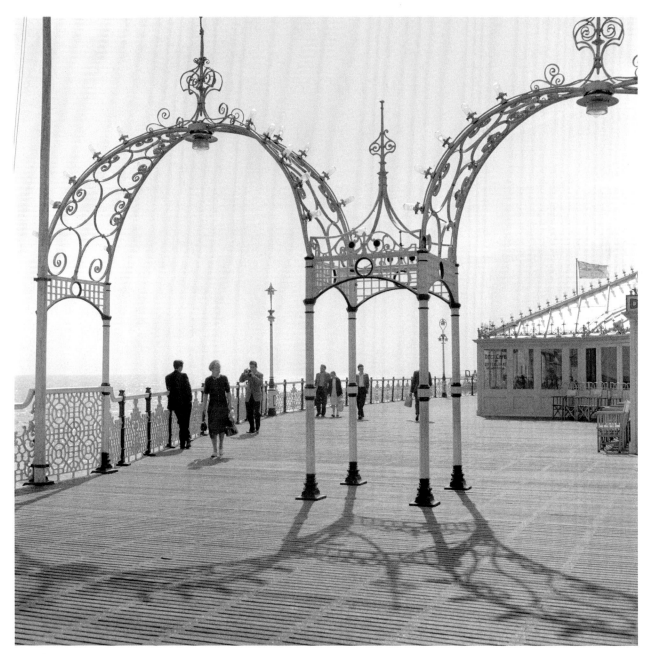

PALACE PIER, BRIGHTON, EAST SUSSEX, 1960s
Holidaymakers stroll on the Palace Pier on a very quiet day, presumably out of season. The motif of three decorative arches is repeated along the pier, echoing the finial-topped domes of the nearby Royal Pavilion. The pier was designed by Richard St George Moore and opened in 1899. It had a pier-head theatre (since demolished) and a Winter Garden was added in the centre of the pier in 1910. [Eric de Maré, AA98/04151]

Walking on water

The entire superstructure rests upon clusters of iron piles, vertically fixed in the ground by means of screws. The clusters are placed at intervals of 60ft, and resting upon them are the main girders, constructed of wrought iron, and in lengths of 72ft… The tops of the girders are converted into continuous sitting accommodation for between 3,000 and 4,000 people.

'Opening of a New Pier at Blackpool', *Building News*, 29 May 1863

Piers – from Ryde (1813–14) to Southwold (rebuilt 1999–2002) – have been *the* iconic architectural symbol of the seaside resort. Initially erected as landing stages for passengers and goods, piers were soon used as promenades by visitors to the resorts. The early piers, with no grand pavilions or amusements, gave visitors the opportunity to walk out over the sea where the air was healthiest and where they also provided unique views of the resort.

Resort developers soon realised the value of piers as visitor attractions. New, larger, longer piers were designed to house a multitude of facilities. The engineer Eugenius Birch (1818–84) was the most prolific of the Victorian pleasure pier designers, being responsible for 14 piers. He pioneered the use of Alexander Mitchell's patent screw-pile method of construction, which involved screwing cast-iron columns into the seabed for stability.

The five decades from the 1860s to the 1900s witnessed the greatest pier-building activity and often resulted in some resorts having more than one pleasure pier. Blackpool had three by 1892–3, each with its own distinct character. Pier architecture and design often included ornate detailing. Elegant domes and ironwork were shaped to invoke a kind of Eastern exoticism and a range of maritime motifs were incorporated into benches, shelters and booths.

Piers came to house a host of amusements, from simple mutoscopes (What the Butler Saw machines) to whole funfairs. Other pier entertainments included theatres, roller-skating rinks, bathing pools and even zoos. Many of the nation's most popular entertainers have performed 'at the end of the pier' and some artists can still draw large audiences during the summer season.

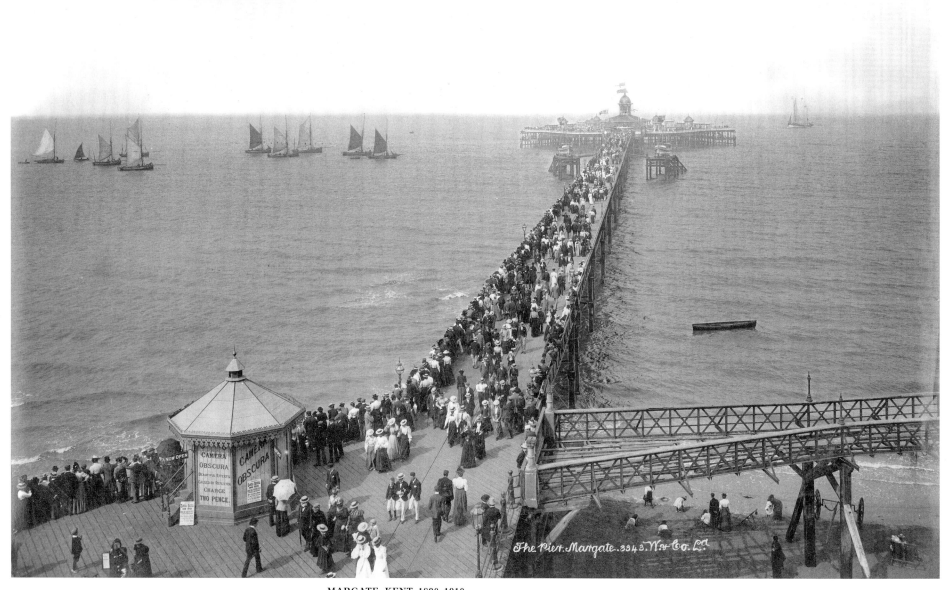

MARGATE, KENT, 1890–1910

Margate Pier, erected in 1853–6, was the first to be designed by Eugenius Birch. Between 1875 and 1877 the pier was extended and a pavilion was added in 1877. The kiosk at the landward end of the pier housed a camera obscura: a series of mirrors and lenses that provided visitors with spectacular views of Margate, as well as opportunities to spy on other tourists. In this photograph the crowd appears to be watching a regatta. Sadly, the pier was severely damaged by a storm in January 1978. [W & Co, OP00650]

SOUTHPORT, LANCASHIRE, 1890–1910

Southport Pier, built in 1859–60, was one of the longest in the country at over 3,600ft; it was later extended to 4,380ft. This was necessary to cross the wide expanse of sand in order to provide steamer access at low tide. It had a long promenade deck with a tramway to carry steamer passengers and their luggage. Waiting and refreshment rooms were built at the pier head and more facilities were constructed at the pier entrance. In 1868 the tariff of tolls was complex: admission was free for steamer passengers and 6d (2½p) for anyone else, but luggage was charged by weight and an extra charge was levied on prams. [W & Co, OP00595]

NORTH PIER, BLACKPOOL, LANCASHIRE, MAY 1977

This was the earliest of Blackpool's three piers. Built to Eugenius Birch's design, it was opened in 1863. This view along the deck shows its exotic domed shelters. Birch's Indian Pavilion of 1874 was destroyed by fire in 1921, as was its replacement in 1938. The pavilion shown in this image was built in 1939. Deck chairs are set out for hire, while the ornate iron benches that run along its length are part of the original design and incorporate the monogram for the Blackpool Pier Co. [BB77/07920; BB77/07924]

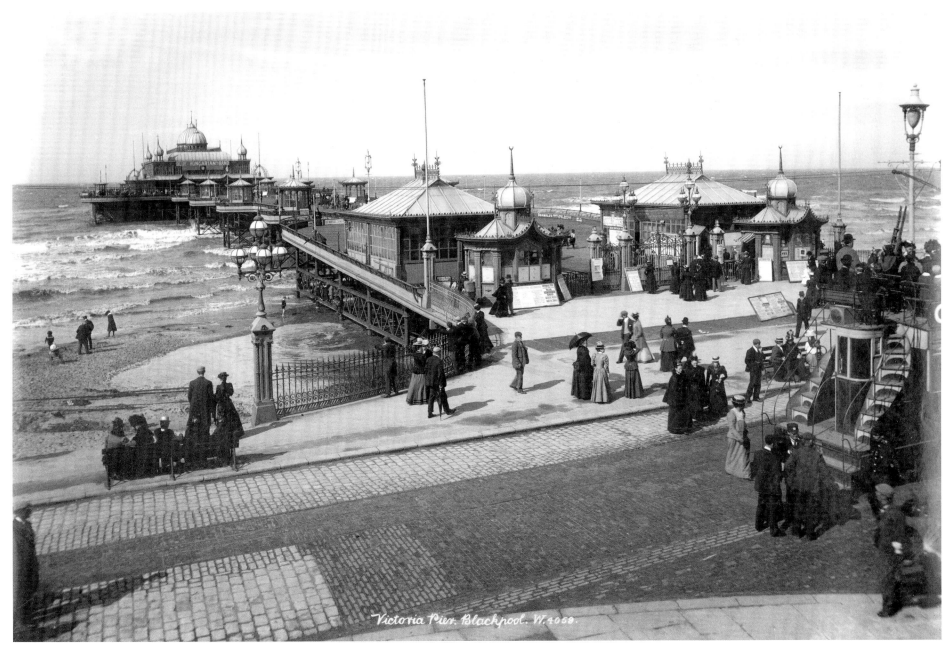

Victoria Pier. Blackpool. W.4059.

VICTORIA PIER, BLACKPOOL, LANCASHIRE, 1890–1910
The Victoria Pier (now known as the South Pier), which opened in 1893, was the last of Blackpool's three piers to be built. Shelters for promenaders were provided along its length and it boasted a magnificent pier-head pavilion. A horse bus has stopped opposite the pier entrance and tourists mill around. [W & Co, OP00487]

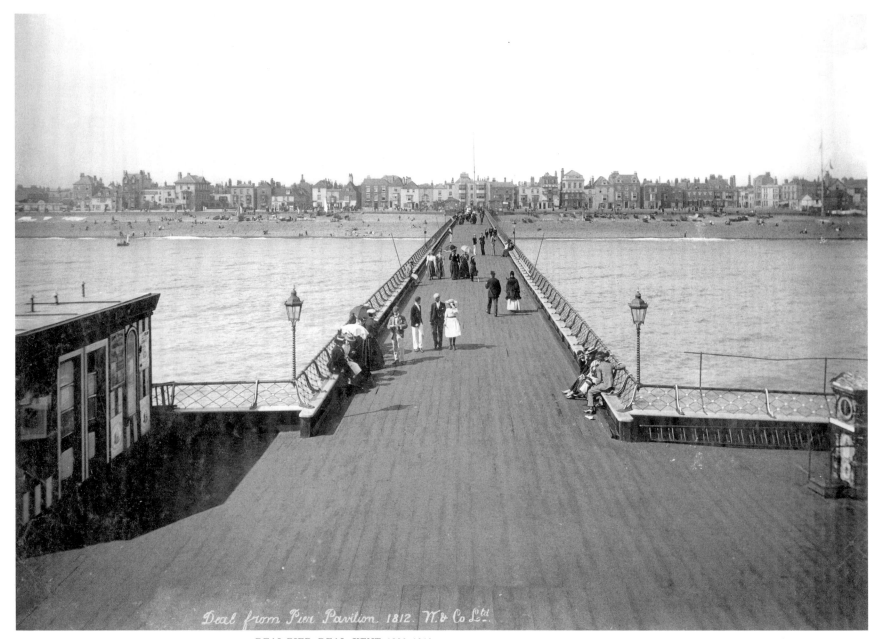

Deal from Pier Pavilion. 1812. W & Co Ltd.

DEAL PIER, DEAL, KENT, 1890–1910
This view looks back towards Deal from the pier-head pavilion on Deal's second pier, which was 1,100ft in length. A bench has been built into the rail along each side of the deck to provide ample seating, while a kiosk and weighing machine stand at the pier head, with the pavilion behind the photographer. This pier, another designed by Eugenius Birch and opened in 1864, was demolished after being damaged by a ship in 1940. A reinforced concrete replacement was built in 1954–7. [W & Co, OP00527]

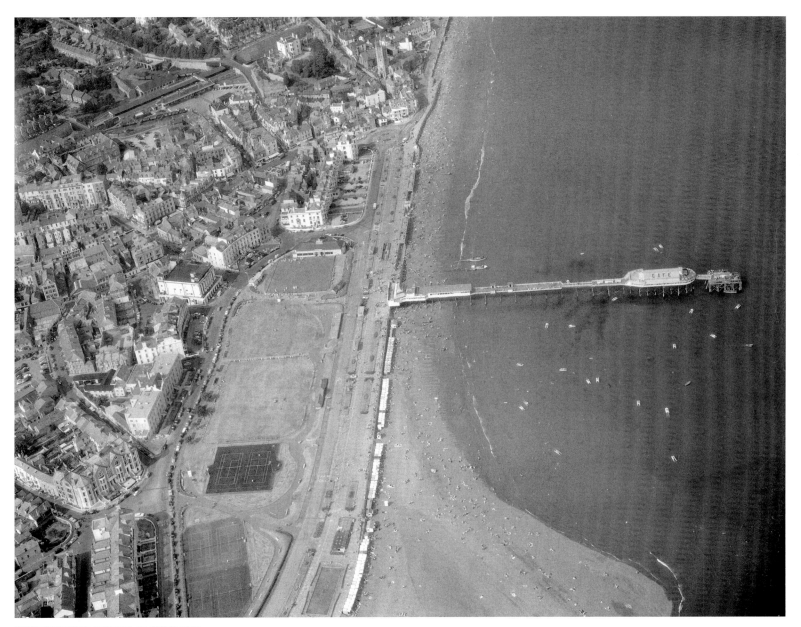

TEIGNMOUTH, DEVON, 22 JULY 1959

With its sandy beach and safe bathing, Teignmouth is a popular south coast resort. This aerial view records the seafront on a busy summer day. The beach is packed with holidaymakers, hire boats dot the bay and two launches offer sea trips. The pier, designed by J W Wilson and opened in 1867, has both a shore-end and a pier-head pavilion. The latter, the Castle Pavilion dating from 1890, was burned down in the 1960s. A separate landing stage, joined to the main pier by a bridge, is a reminder of the function of piers as a calling point for steamers. Behind the promenade is The Den – 6 acres of gardens, tennis courts and bowling greens – which is popular with visitors. Facing the pier is the Georgian Den Crescent (*see* p 20). [Harold Wingham, HAW 9394/4]

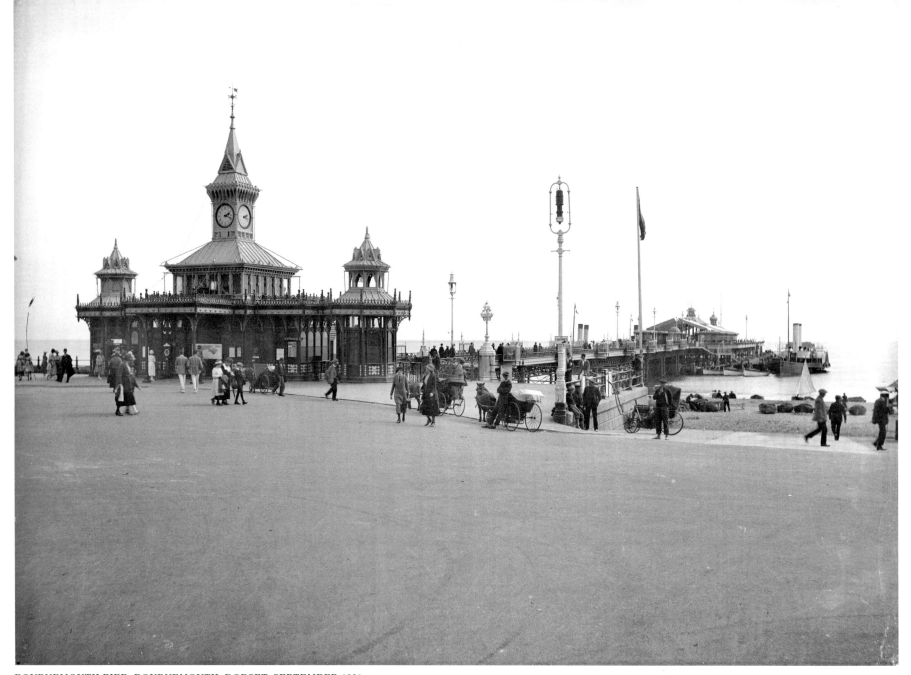

BOURNEMOUTH PIER, BOURNEMOUTH, DORSET, SEPTEMBER 1921

Opened in 1880, this was another pier designed by Eugenius Birch. Its elegant entrance building is shown here, together with the more functional shelters at the pier head. In 1921 admission to the pier was 2d (1p). At this date it seems to have served primarily as a deck for promenading. A paddle steamer is disembarking at the end of the pier and a second steamer is moored on the far side, underlining the important role of many pleasure piers as landing jetties. Donkey carts wait for fares in front of the pier, while boats can be hired on the beach. [LMS, CC76/00293]

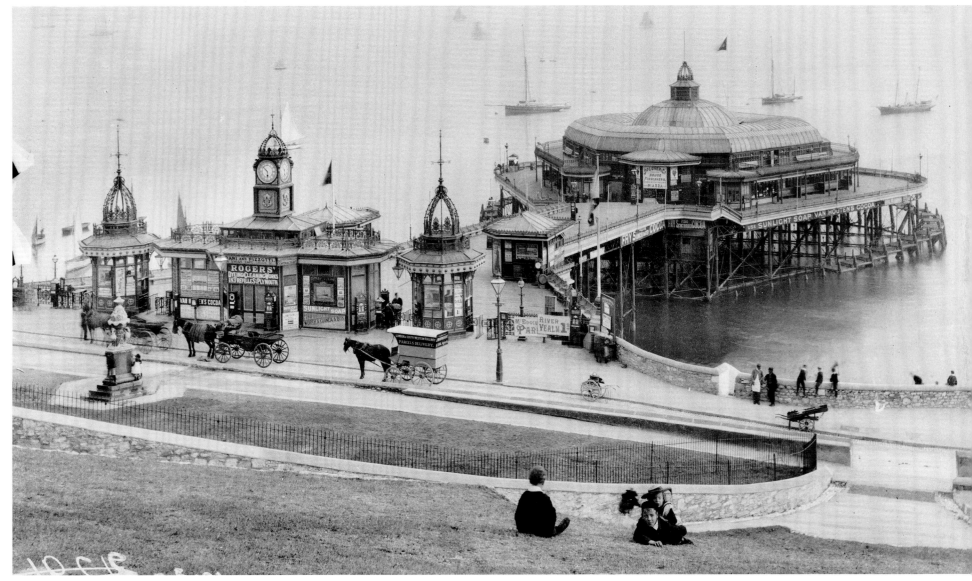

PLYMOUTH PIER, PLYMOUTH, DEVON, 5 JULY 1893
Carriages wait in front of Plymouth Pier. This pier, designed by Eugenius Birch in 1884, is strangely short, being only 465ft in length.
It was demolished in 1954. The pier pavilion was erected in 1891. The pier is covered in advertising for such non-holiday products and
services as Sunlight Soap, Fry's Cocoa, van Houten's Cocoa, S P Conner House Furnishers and Roger's Dyeing and Cleaning Works.
An admission toll of 1d (½p) was charged. [LMS, CC76/00445]

SALTBURN-BY-THE-SEA, NORTH YORKSHIRE, SEPTEMBER 1994

The inclined tramway links the town of Saltburn with the pier and beach approximately 130ft below. It operates using water power: a tank beneath the top carriage fills with water until it is heavier than the bottom one and, as it descends, it hauls the lighter carriage up the incline. Opened in 1884, it was only the third such cliff lift in England; both of the earlier ones were at Scarborough. Many of the houses that command the view from the top of the cliff were built as guest houses, their dormer windows showing that the roof space has been designed for accommodation. The pier, which opened in 1869, is now sadly truncated by storm and accident. [K Findlater, BB94/17385]

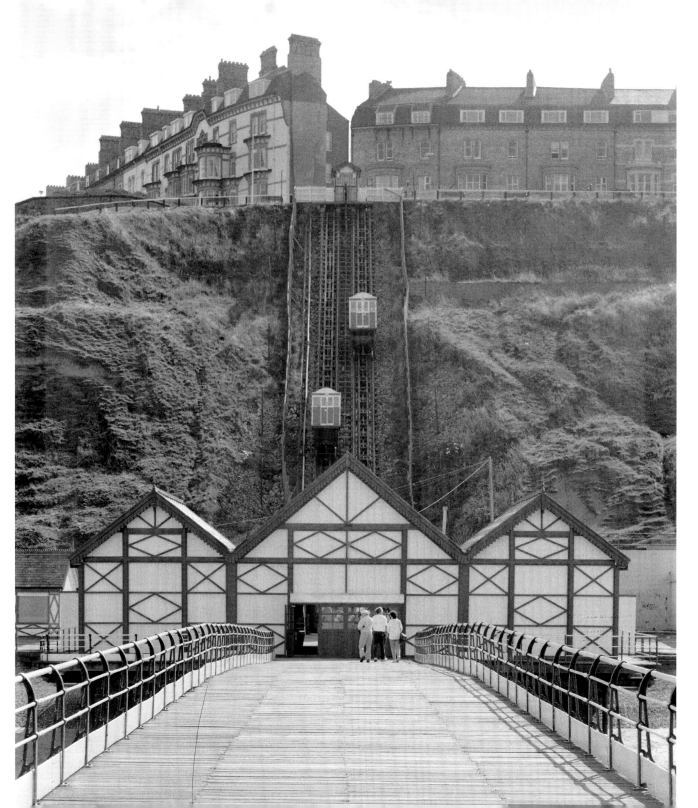

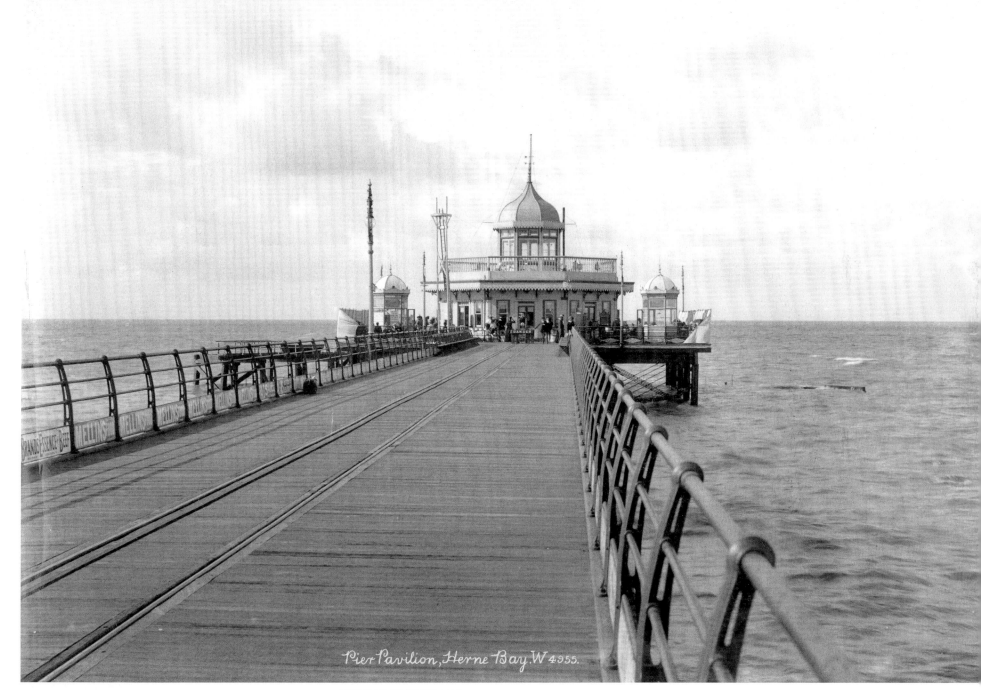

Pier Pavilion, Herne Bay. W 4955.

HERNE BAY, KENT, 1910
Herne Bay's third pier opened in 1899 and incorporated elements of the previous structure. The tram tracks laid along the deck
were very necessary as it extended to a length of over 3,700ft, making it one of the longest piers in the country. The ornate pier pavilion,
erected in 1910, was destroyed by fire in 1970 and was replaced by a sports and leisure centre in 1976. [W & Co, OP00563]

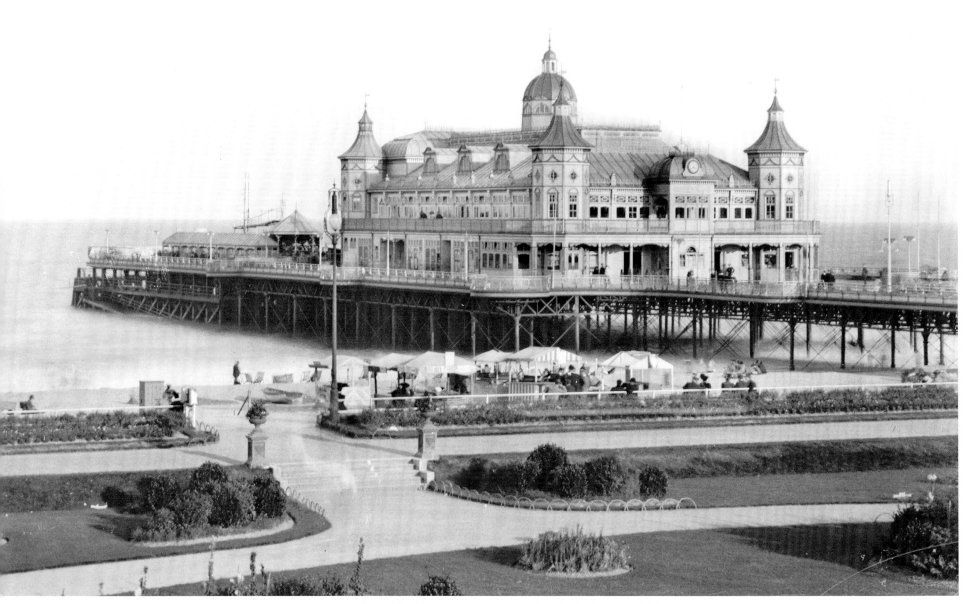

BRITANNIA PIER, GREAT YARMOUTH, NORFOLK, SEPTEMBER 1904
Great Yarmouth has two pleasure piers. The 810ft-long Britannia Pier, which opened in 1902, is dominated by a prefabricated pavilion.
This pavilion was burned down in 1909 and its site is currently occupied by a theatre. A row of stalls on the promenade sell ice cream and
other seaside essentials. [LMS, CC76/00348]

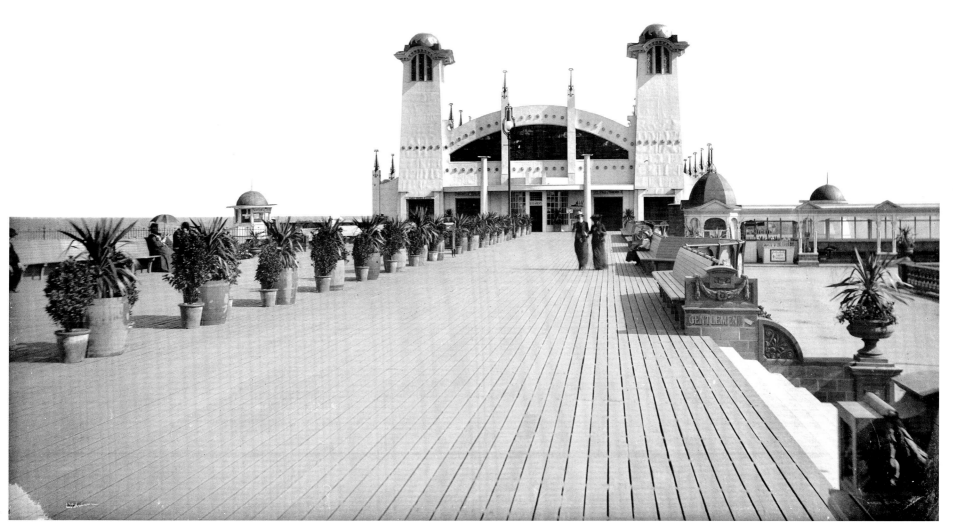

WELLINGTON PIER, GREAT YARMOUTH, NORFOLK, SEPTEMBER 1904

Wellington Pier – a complete contrast to Britannia Pier, although of similar date – was largely rebuilt in 1900–3 following its purchase by the local authority. J W Cockrill designed the distinctive Art Deco pavilion, faced in decorative ceramic panels, at the landward end. The Wellington Gardens with their sheltered cloisters are to the right. Subtropical potted plants add an air of the exotic to the pier approach. [CC76/00474]

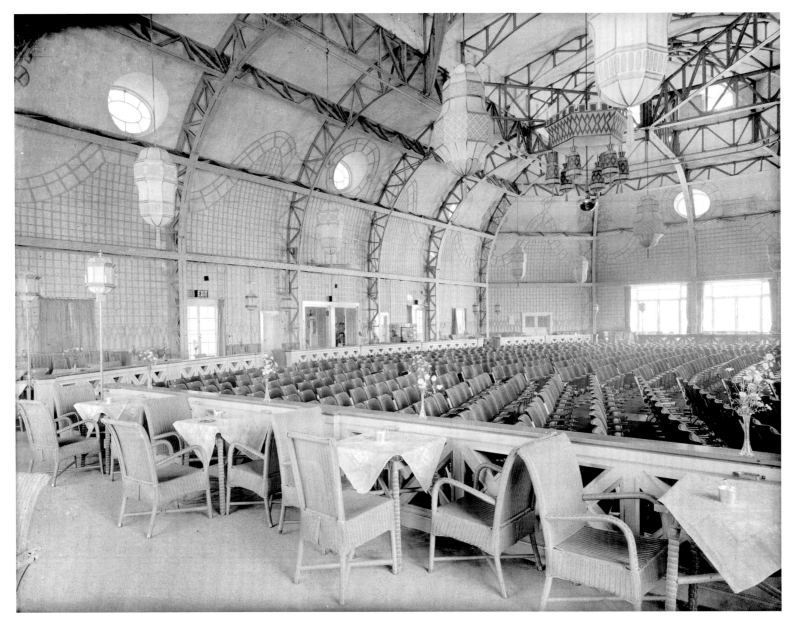

PIER PAVILION, WORTHING, WEST SUSSEX

Worthing Pier was built in 1861–2 to designs by Robert Rawlinson and was later extended. The pier-head pavilion burned down in 1933 but was quickly replaced. When Worthing Corporation bought the pier in 1920, they decided to build a second pavilion at the shore end. It was opened in 1926 and was the home of the municipal orchestra. Constructed on a prefabricated steel frame, it was given porthole windows to match its pier-head partner. This view of the interior shows that it had fixed cinema-style seating but also offered a terrace with tables where food and drinks could be served. The decor rather incongruously takes up a Moorish theme. [H Felton, CC47/02805]

HUNSTANTON, NORFOLK, 1945–59

Several piers included a tramway or railway as an attraction, often making use of tracks laid to service the pier-head pavilion or steamer landing stage. Here a miniature railway takes visitors along the length of the pier, which extends to over 800ft. The pier keeper, dressed in a naval-looking uniform of white jacket and cap to continue the maritime theme, is standing behind the train having just collected the fares. The pier was built in 1870 to designs by J W Wilson. The buildings at the shoreward end (seen here) were replaced with an amusement arcade in the 1960s, itself destroyed by fire in 2002; the majority of the pier structure was destroyed by a storm in 1978. [Hallam Ashley, AA98/18171]

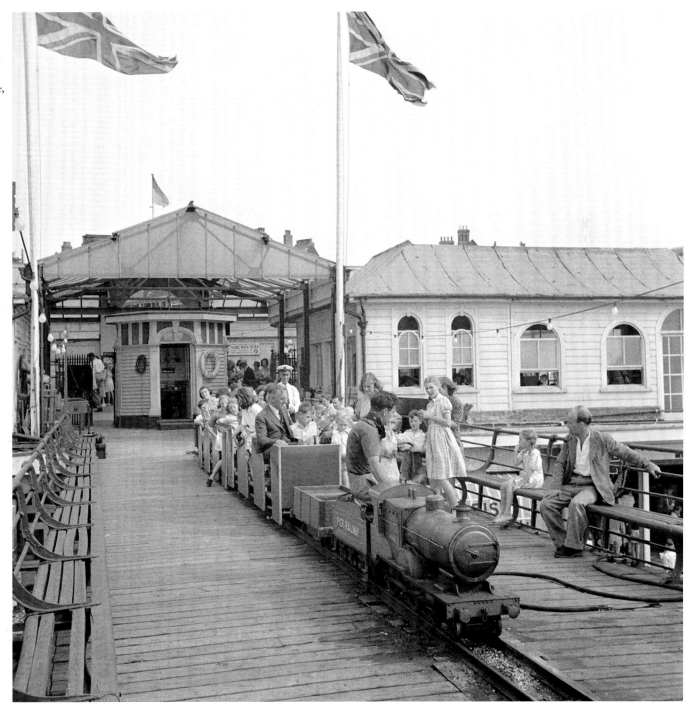

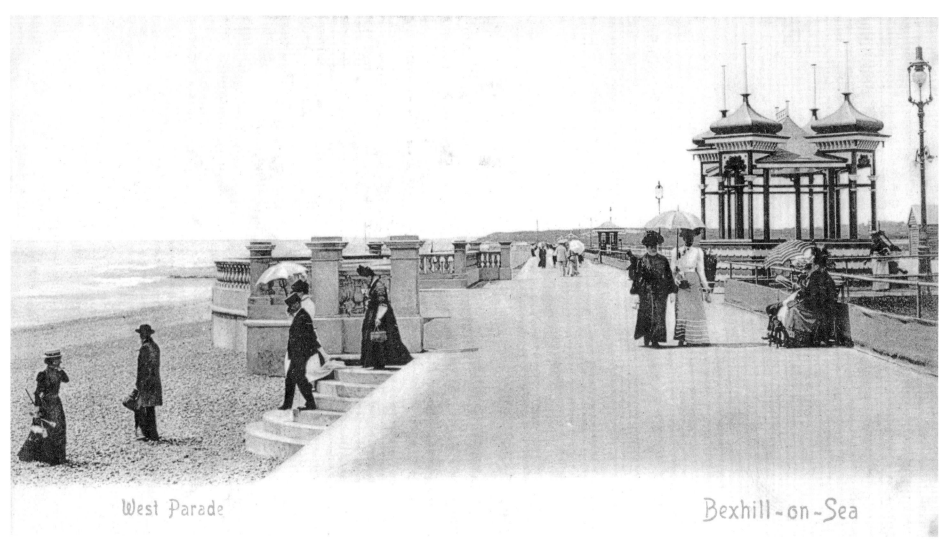

West Parade

Bexhill-on-Sea

WEST PARADE, BEXHILL-ON-SEA, EAST SUSSEX, 1900–14
The promenade was originally designed for taking a sociable walk, as these people are doing. This elegant example at Bexhill, which looks rather like a garden terrace, has not yet been cluttered with 'attractions'. The ornate structure is a bandstand. [Nigel Temple, PC09396]

Stroll along the prom

The gay world also mingle here with the croud [sic], in order to take an airing; to exercise the limbs;
to display external charms; to attract, persuade, and captivate by various ways and motions.
In doing all which there is a mutual and innocent satisfaction enjoyed by both parties; for,
as the passions of love, pride, ambition and vanity are in action, unaccountable sensations ensue.

James Rymer, *A Sketch of Great Yarmouth, in the County of Norfolk: with some Reflections on Cold Bathing*, 1777

The act of promenading – going for a leisurely, sociable walk – as with many other aspects of the English seaside, was borrowed from the inland health spas. The first seafront promenades were the beaches themselves, with the firm, fine sands recommended for walking, riding and carriage drives. Harbour piers also acted as social promenades, some of which were subject to tolls to limit access. By the end of the 18th century, providing a formal seafront promenade was considered to be important if a resort was to be successful.

The creation of a seafront promenade transformed the look of a settlement. The levelling of dunes and the construction of sea walls, pavements and roadways ended the natural connection between the sea, the shore and the land. Promenades were also important structurally: a raised one with an accompanying sea wall limited damage to seafront buildings and could act as a major thoroughfare.

Promenades were expensive to build, involving a great deal of investment by wealthy individuals, private companies and local authorities. However, the rewards could be high, as a well-built promenade, like a pier, could attract visitors and extend development along the shoreline. Promenades were often embellished with gardens and decorative street furniture such as shelters, benches and beach huts.

Today promenades have often been the focus of attempts to regenerate seaside resorts. New facilities and public art schemes have created stimulating, modern public spaces for visitors to enjoy.

ESPLANADE, VENTNOR, ISLE OF WIGHT

The old town of Ventnor was set back on top of the cliff. Tourism encouraged a resort development towards the sea and the Esplanade was only created around the cove in 1848. Behind it a number of houses with wrought-iron balconies rise up the cliff in terraces, each with a glorious sea view. At the time of this photograph the seaside was a very formal place. These ladies are fashionably dressed. A family with a small child is also out for a stroll. On the beach, bathing machines and boats compete for space. A pier was added in 1872.

[Howarth-Loomes, BB81/03277A]

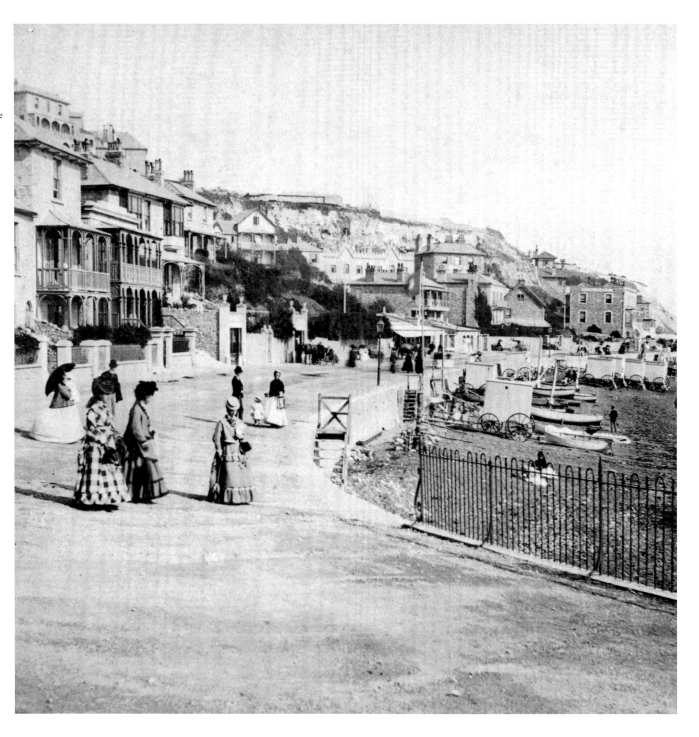

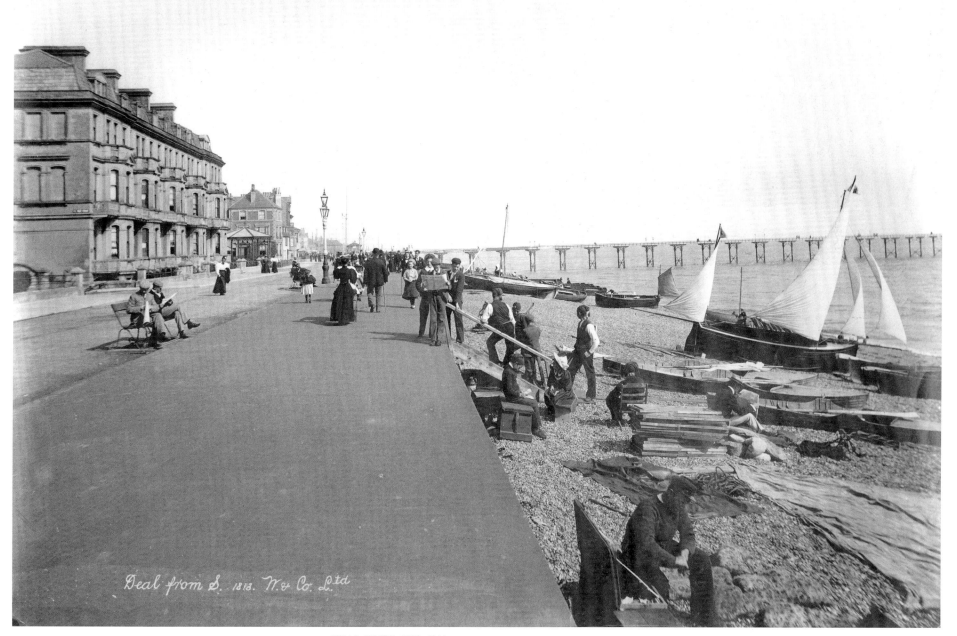

Deal from S. 1818. W. & Co. Ltd

DEAL, KENT, 1890–1910

This view along Victoria Parade towards the old pier seems to have captured a mix of leisure and work activities, which added interest and local colour for visitors. While holidaymakers stroll on the promenade or sit on the benches, a fisherman dries his nets on the shingle. People sit on the beach among the fishing boats and there appears to be a pile of deck chairs for hire. [W & Co, OP00540]

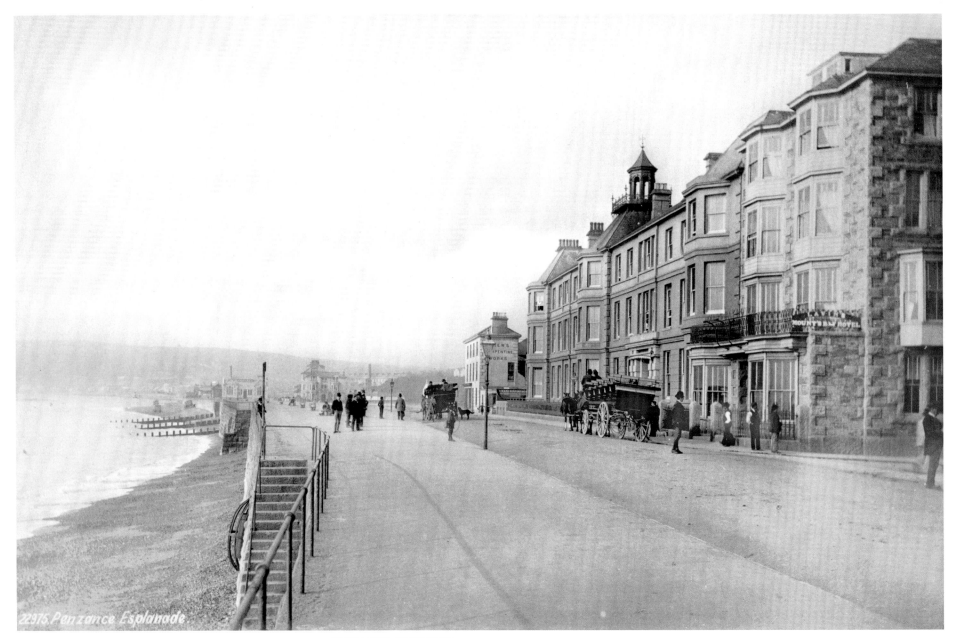

PENZANCE, CORNWALL

Penzance was remote from the main centres of population so did not develop as a mass holiday attraction. A horse-drawn coach outside the Mount's Bay Hotel on the Esplanade may be waiting to take a group of guests on an excursion to one of the fishing villages, St Michael's Mount or perhaps inland. A boy holds up his hoop as he watches proceedings. Further along the street another coach is loading up and a few forlorn bathing machines are on the beach. [BB82/10547]

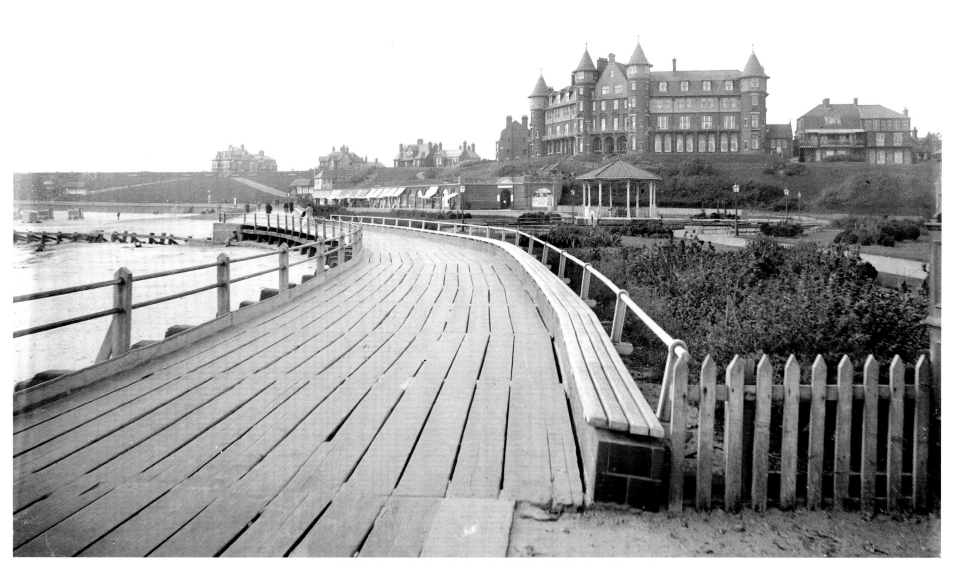

GORLESTON-ON-SEA, NEAR GREAT YARMOUTH, NORFOLK, 1904

This section of boardwalk extends the promenade towards the pier at the mouth of the River Yare. A bandstand is in a small garden adjacent to the promenade and a parade includes shops and refreshment rooms, including the Oasis Tea Rooms. Dominating the scene is the Cliff Hotel of 1898, which was destroyed by fire in 1915. [LMS, CC78/00229]

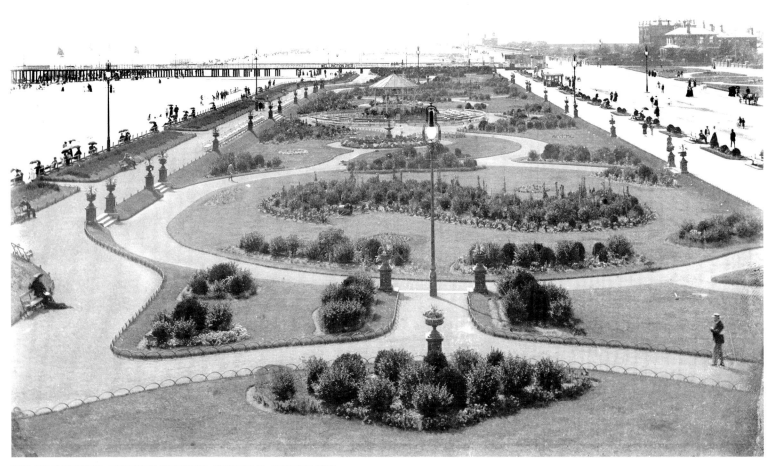

BEACH GARDENS, GREAT YARMOUTH, NORFOLK, AUGUST 1896

At some resorts a narrow promenade separates the town from the beach, while at others a desire to improve the seafront has resulted in a band of reclaimed land and stabilised sand, which advanced seaward and could become quite a wide strip. This 'new' land was often owned by the local corporation who saw it as an asset for tourism. It was often developed as an entertainment venue and included a promenade and areas laid out formally as public gardens. The Beach Gardens at Great Yarmouth are an example of this, photographed here before either the pavilion was built on the Wellington Pier or the Winter Gardens were erected. In common with many promenade gardens, they include a bandstand. [LMS, CC76/00455]

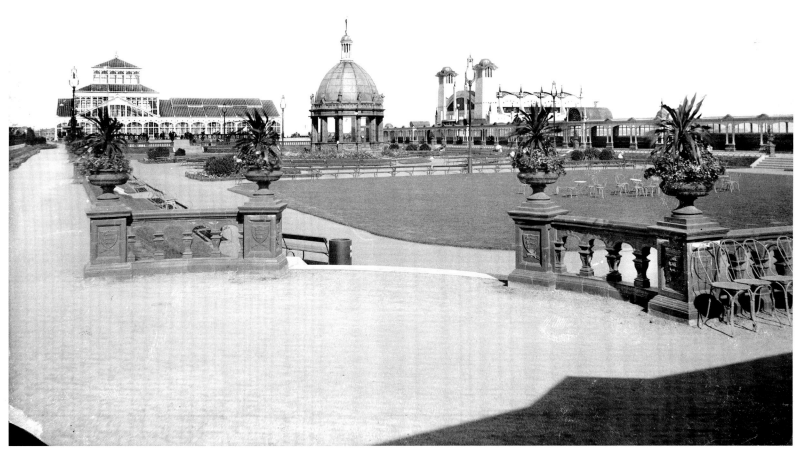

WELLINGTON GARDENS, GREAT YARMOUTH, NORFOLK, SEPTEMBER 1904

The Wellington Gardens, created on reclaimed land, adjoin the Wellington Pier. They were laid out for cultured recreation, with a bandstand in the centre and a cloister serving as a windbreak on the seaward side. Tables and chairs on the lawn suggest that tea is served. The Winter Gardens face the entrance to the pier. Originally from Torquay, the Winter Gardens were purchased by the town council in 1903 and moved here to serve as an arts venue. They were particularly used for concerts. [LMS, CC76/00335]

HASTINGS, EAST SUSSEX

Open-air music has long been a popular entertainment at the seaside. A small crowd has gathered on the promenade adjacent to Eversfield Place to hear a uniformed brass band perform. The men in the audience wear tall 'stovepipe' hats. The members have set up their music stands and pose for the camera. Eversfield Place contained a large number of lodging houses and continues to offer a variety of holiday accommodation today. [Howarth-Loomes, BB85/02203]

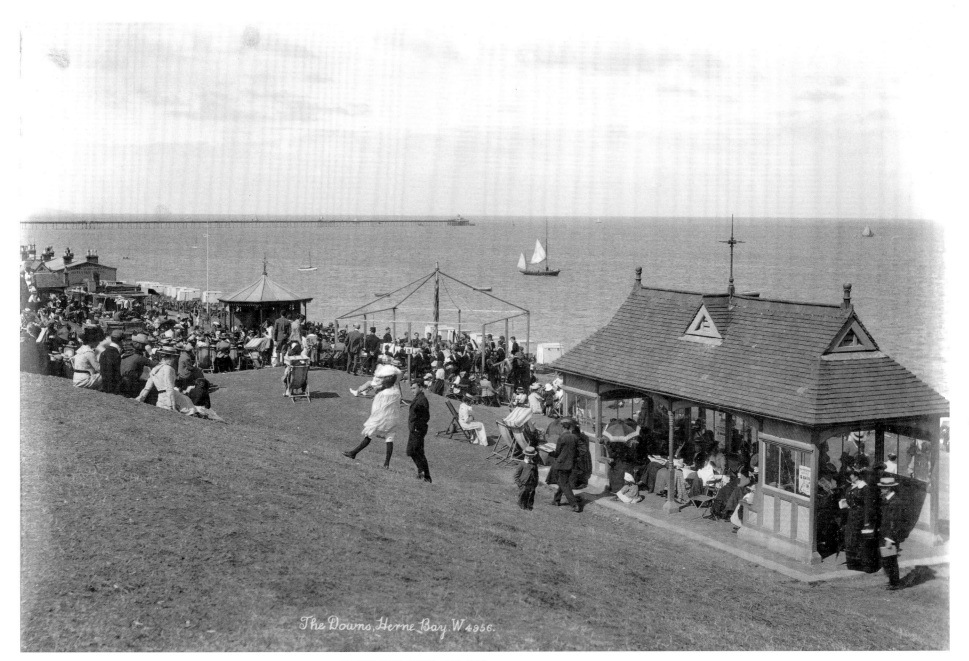

The Downs, Herne Bay. W 4956.

HERNE BAY, KENT, 1899–1910

Holidaymakers on the Downs at Herne Bay enjoy a band concert, while others squeeze into a shelter to escape the sun or perhaps the wind. Shelters were provided almost universally at seaside resorts in recognition of the English weather. In the distance is Herne Bay's third pier, which was over 3,700ft long; it was built by E Mathieson in 1896–9. A pavilion was added in 1910 near the shoreward end. [W & Co, OP00568]

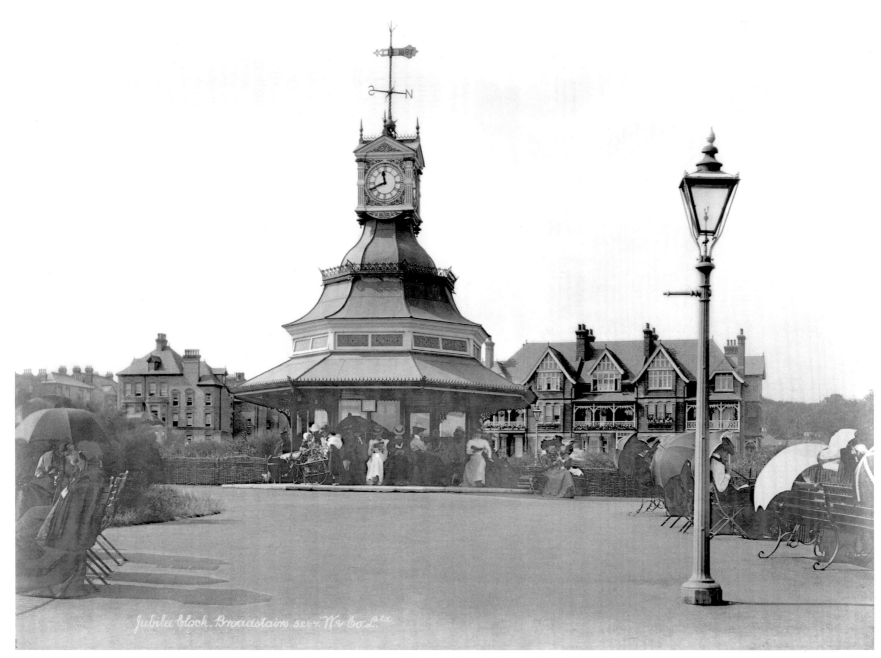

Jubilee Clock. Broadstairs. 3264. W & Co. L.

JUBILEE CLOCK, VICTORIA GARDENS, BROADSTAIRS, KENT, 1890–1910
Victoria Gardens, designed by J Cheal & Sons in 1892, formed part of the clifftop promenade at the southern end of Viking Bay. The Jubilee Clock was
built to commemorate Queen Victoria's Golden Jubilee of 1887. It was more than just a clock, serving as a shelter and being a monument to civic ambition.
These holidaymakers are seeking shelter from the late morning sun, either under sun umbrellas or in the shade of the clock. [W & Co, OP00515]

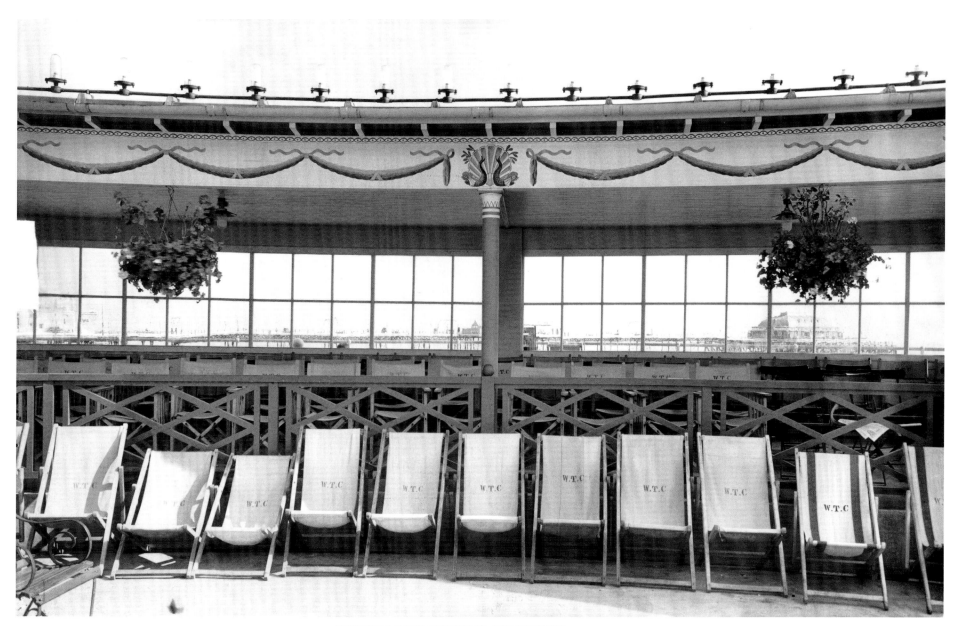

MARINE PARADE, WORTHING, WEST SUSSEX

The bandstand on the esplanade is a little to the west of the pier, which can be seen through the window. Worthing boasts a 'genial climate', but the bandstand is enclosed by windscreens where the audience can sun themselves in Town Council deck chairs, sheltered from the sea breezes. [H Felton, CC47/02807]

NORTH TERRACE, WHITBY, NORTH YORKSHIRE, AUGUST 1992

These shelters at Whitby date from the Edwardian period. They are a ubiquitous feature of the English seaside promenade, providing holidaymakers with protection from the wind, sun or rain as well as being somewhere to sit and think. Despite their functional design they often carry interesting decorative details and follow contemporary stylistic fashions. [R Skingle, AA94/04057]

BLACKPOOL, LANCASHIRE, 27 OCTOBER 1999

Coastal resorts look very different by night, when the lights add an atmosphere of mystery and glamour. Blackpool has turned its lights into a major attraction and the Blackpool Illuminations draw large crowds, extending the season into the autumn. The Tower is picked out in lights – in the process becoming a huge advertising hoarding – and the miles of shops and amusement arcades are alluring in their finery. [P Williams, MF99/0622/32]

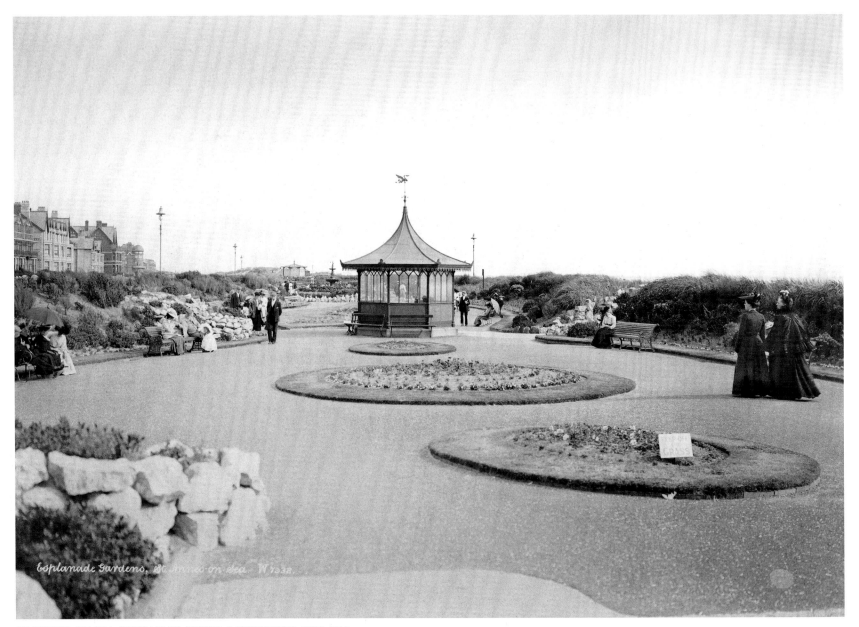

Esplanade Gardens, St Anned-on-sea W.1332.

ST ANNE'S-ON-SEA, LYTHAM ST ANNE'S, LANCASHIRE, 1890–1910

The wide beach along this part of the coast allowed a broad strip of land to be reclaimed between the town of St Anne's and the sea and this was laid out formally as a public garden. In this view people stroll in the Esplanade Gardens, which were created in the 1880s at about the time the pier was built. A shelter offers protection from the weather and raised beds at either side of the garden act as windbreaks. [W & Co, OP00443]

Parks and gardens

Opposite the crescent are spacious Gardens, well laid out, affording an agreeable private promenade,
and a welcome inhalation of fresh breezes, from the open sea, to the occupations of that building;
and immediately below, on the brow of the cliff, or rather extending halfway down to the beach,
is a newly planted copse wood, with shady plinths and seats, and a public walk through it to the sands.

Edward William Pritchard MD, MRCS, *Observations on Filey as a Watering Place; or a Guide for Visitors,* 1853

Parks and gardens have been important features at English seaside resorts for over 200 years. Initially they were the preserves of the privileged and wealthy but later developed into public open spaces. The first enclosed parks were the private communal gardens accessible only to those who were living in the surrounding residences.

Public health debates led to the recommendation that public parks should be made available to the 'humbler classes' to improve their moral and physical health. The 1848 Public Health Act finally gave local authorities the means to implement plans for public parks and as a result municipal gardens began to spring up all over the country. Resorts were quick to realise the benefit of parks, which served as new attractions. Seafront gardens added colour and formality to the linear promenades, and enclosed parks – usually some distance from the seafront – offered more informal, secluded havens away from the bustle of the sands and promenades.

Parks at seaside resorts are more that just open spaces full of trees and shrubs. They are venues for a multitude of activities, particularly concerts and theatrical performances and therefore many have bandstands and stages. Some areas are dedicated to sporting activities or a leisured pursuit such as boating. Gardens also demonstrated horticultural techniques and changing fashions to interest visitors, and themed gardens, such as Italian and Japanese, could add an exotic flavour to a resort.

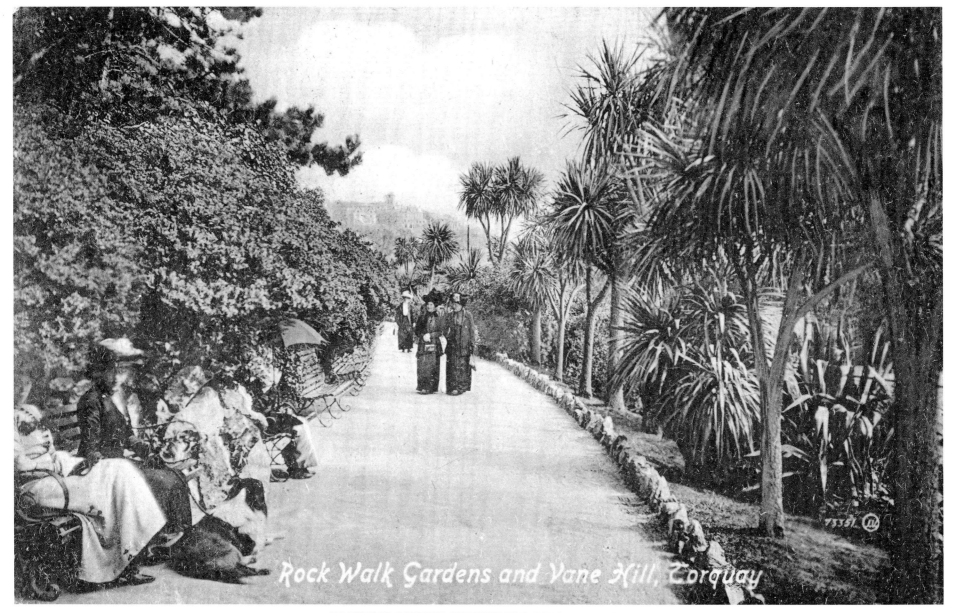

Rock Walk Gardens and Vane Hill, Torquay

ROCK WALK GARDENS AND VANE HILL, TORQUAY, DEVON

Well laid out walks provided with regularly spaced benches allowed the less energetic to take the air and while away a pleasant afternoon. Many subtropical plants, such as these palms, flourish in the mild climate of Torquay, adding interest and contributing an exotic element to the atmosphere. The fashionable ladies in this postcard view are all well covered up against the sun and one even has a sun umbrella.

[Nigel Temple (manufacturer: J Valentine), PC08917]

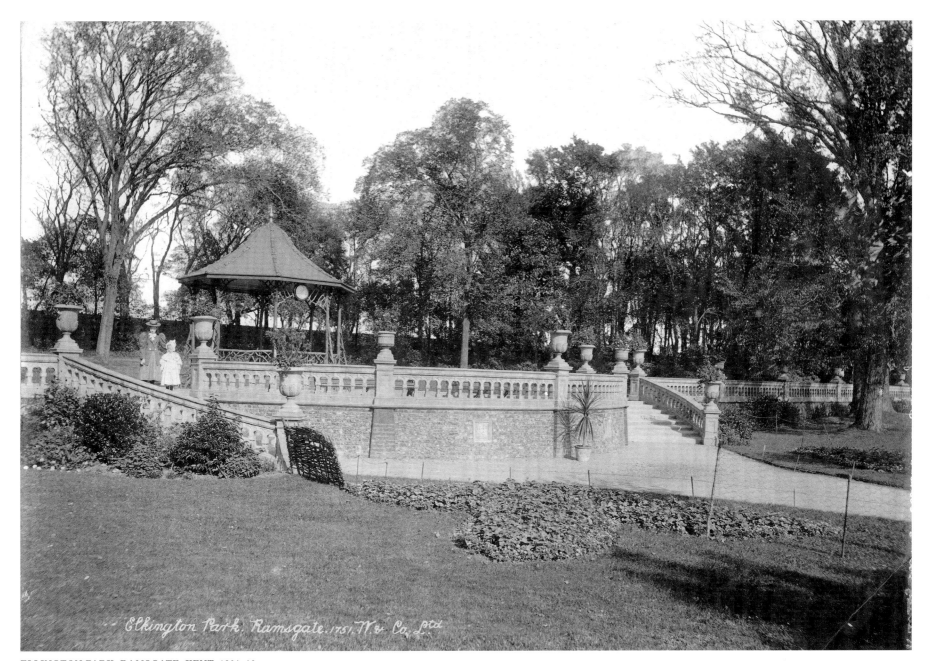

Elkington Park, Ramsgate. 1751. W & Co, Ltd

ELLINGTON PARK, RAMSGATE, KENT, 1901–10

Ellington Park (Elkington Park is a misprint on the part of the postcard manufacturer) was created on 12 acres of land purchased by the Corporation and opened in 1893. The park, located away from the seafront, provided a valuable public space for visitors and townspeople alike and included landscaped gardens, fishpond and lake. The building with the pointed roof is an aviary not a bandstand. The steps and path in front of it lead to an ornamental fountain. [W & Co, OP00668]

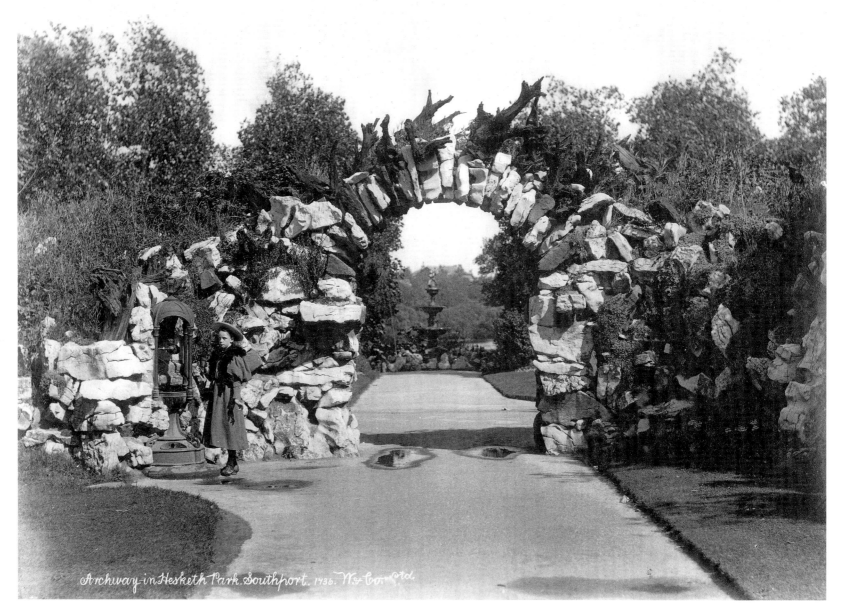

Archway in Hesketh Park. Southport. 1736. W & Co. Ltd.

HESKETH PARK, SOUTHPORT, LANCASHIRE, 1901–10

Hesketh Park was given to the town by Rev Charles Hesketh, lord of the manor. Intended to attract a superior class of visitor, it was soon circled by exclusive villas. Laid out on 30 acres of reclaimed sand dunes by Edward Kemp, the park was opened in 1868. Hesketh Park contained a 4½ acre lake, croquet grounds, rustic summer houses, an aviary, and meteorological and astrological stations. Subtropical gardens were added in 1882 and herbaceous gardens in 1904. Here a girl stands next to a drinking fountain; a decorative fountain is framed by a rustic arch topped with stump work. [W & Co, OP00593]

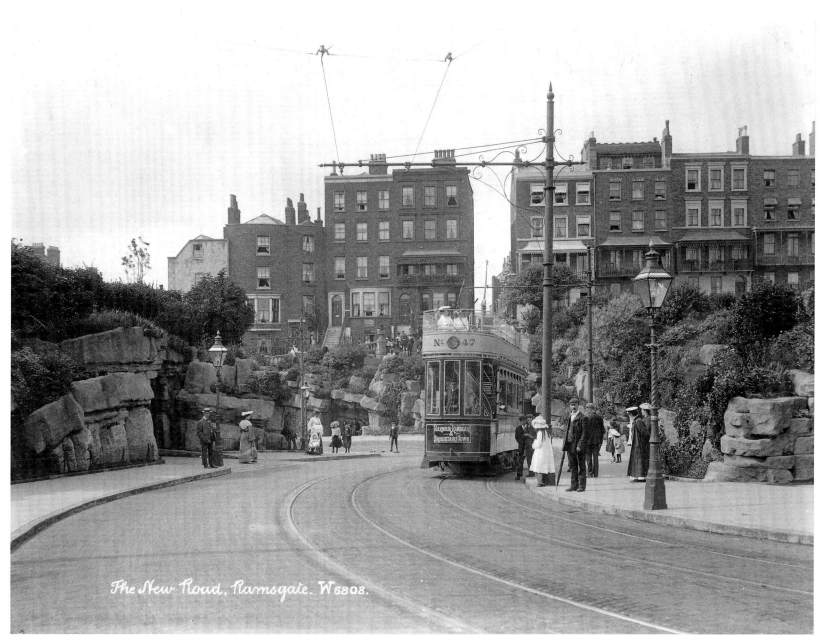

The New Road, Ramsgate. W5808.

NEW ROAD, RAMSGATE, KENT, 1901–10

Passengers wait to board a Number 47 tram in New Road (now Madeira Walk). The route was operated by the Isle of Thanet Electric
Tramways & Lighting Co Ltd, which ran trams between Westbrooke, Broadstairs and Ramsgate from 1901–37. This serpentine road cuts
through a newly laid out rock garden at the top of the cliff at Ramsgate. This was a steep ascent and, following an accident on 3 August 1905
when a tram ran out of control and fell 30ft over the cliff, the steep curves were altered at a cost of £2,019 11s 4d. [W & Co, OP00654]

FLORAL CLOCK, WESTON-SUPER-MARE, SOMERSET, 1913
By the late 19th century carpet bedding had been widely adopted in public parks and, as gardeners sought new ways to demonstrate their artistic ingenuity, it came to be viewed as a benchmark of their excellence. A development of this was the floral clock, combining planting with moving hands, a feature which became popular at the start of the 20th century. This postcard of the floral clock in Clarence Park is postmarked 17 September 1913. A gardener uses a small push mower to cut the huge lawn, indicating how labour-intensive public parks could be. [Nigel Temple, PC09271]

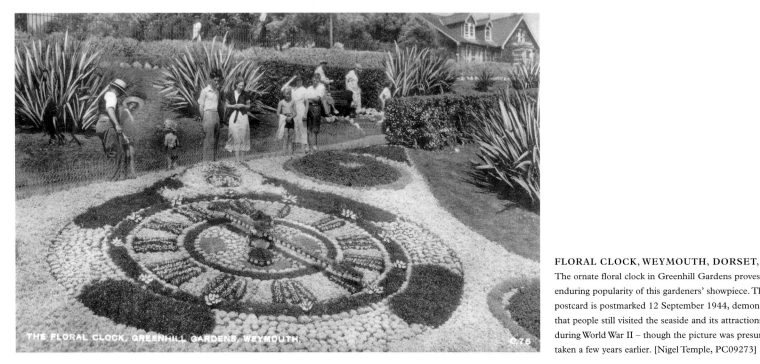

THE FLORAL CLOCK, GREENHILL GARDENS, WEYMOUTH.

FLORAL CLOCK, WEYMOUTH, DORSET, 1930s
The ornate floral clock in Greenhill Gardens proves the enduring popularity of this gardeners' showpiece. This postcard is postmarked 12 September 1944, demonstrating that people still visited the seaside and its attractions – even during World War II – though the picture was presumably taken a few years earlier. [Nigel Temple, PC09273]

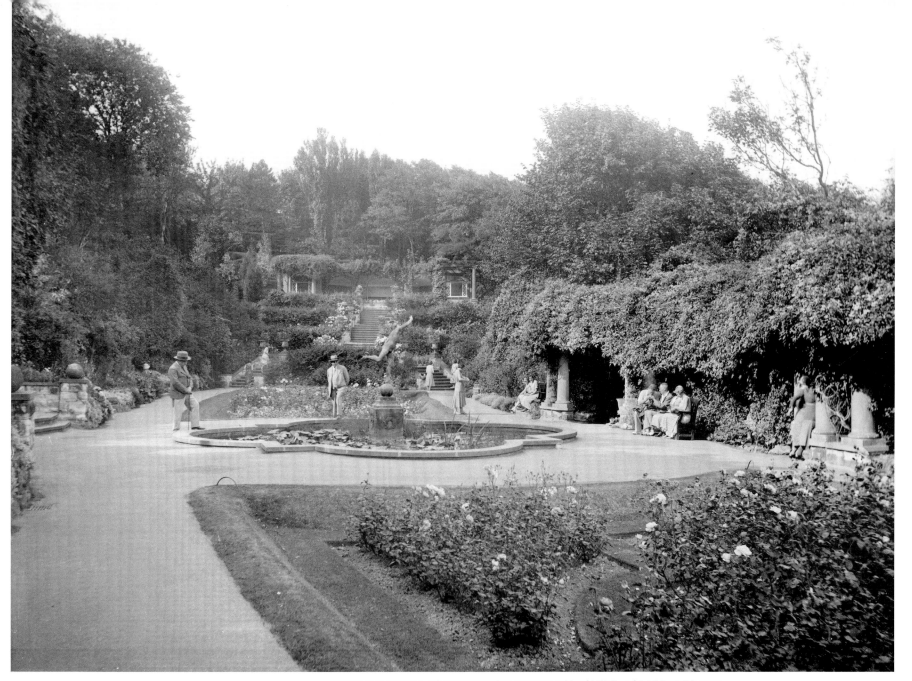

ITALIAN GARDEN, SCARBOROUGH, NORTH YORKSHIRE, 4 SEPTEMBER 1933
Gardens could provide a restful retreat away from the sea and the holiday crowds. The South Cliff Gardens overlooking the
South Bay were laid out as public gardens from about 1910. The Italian Garden, complete with leafy arbours, was created in
1912. It is dominated by the formal terraces and the central lily pool with a statue of Mercury. The Italian Garden was enclosed
and, in contrast to other parts of the South Cliff Gardens, views of the sea were deliberately restricted. [CC80/00406]

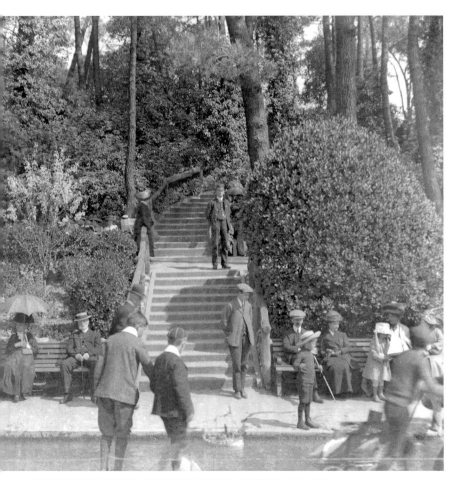

PLEASURE GARDENS, BOURNEMOUTH, DORSET, 1894–1920

For part of its course the Bourne Brook was canalised to create a formal walk along both banks. This section was known as the Children's Corner, where they were permitted to sail yachts, as the small boy with the stick is doing. A uniformed park keeper looks on from the steps to spot any infringement of the park rules. Behind him the steps lead on to a woodland walk. [Alfred Newton & Son, BB98/10745]

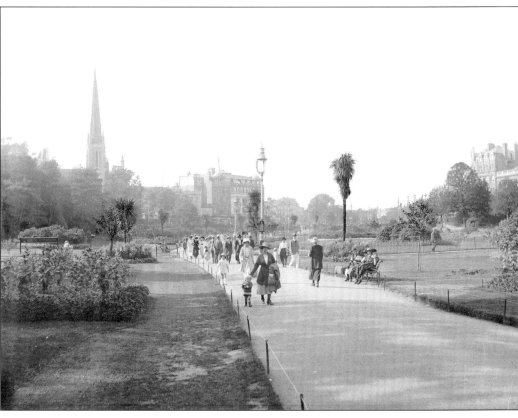

PLEASURE GARDENS, BOURNEMOUTH, DORSET, SEPTEMBER 1921

The Pleasure Gardens follow the Bourne Brook for approximately 1½ miles through Bournemouth, providing a leisurely walking route between the town and the Pier Approach. The Lower Pleasure Gardens are a busy thoroughfare to and from the sea. The spire of St Andrew's Presbyterian Church, Exeter Road, is a landmark and the Tea Lounge at Bobby & Co department store advertises its innocent pleasures to families wearily returning from the beach. The gardens were acquired and laid out by the town in the 1870s. They contain a variety of features and styles of design, and include a bandstand, tennis courts and a putting green. [LMS, CC76/00313]

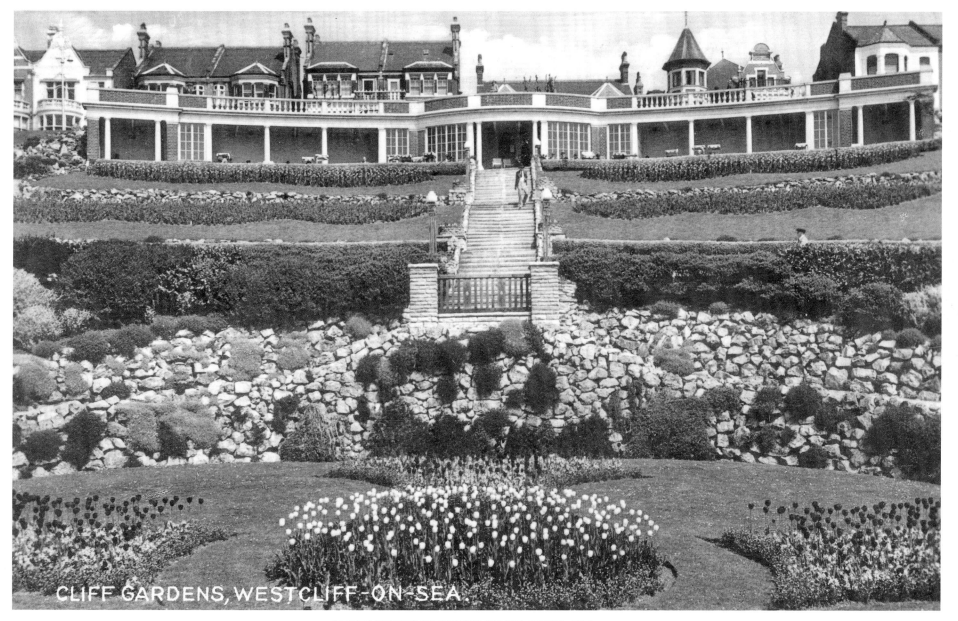

CLIFF GARDENS, WESTCLIFF-ON-SEA.

CLIFF GARDENS, WESTCLIFF-ON-SEA, ESSEX, 1930s

This postcard, postmarked 12 June 1938, is an example of the type of garden laid out at seaside resorts in the inter-war years. Good use has been made of the topography. A single-storey shelter with a roof terrace provides panoramic views to the sea and has been set down so as not to obscure the sea view from the houses behind. The glazed central portion of the shelter may have been a tearoom with tables on the front terrace. A flight of steps lead down through a series of terraces to an area of planting and onto the Western Esplanade. Facilities such as these show that the town was more interested in the genteel visitor than the day tripper. [Nigel Temple, PC09122]

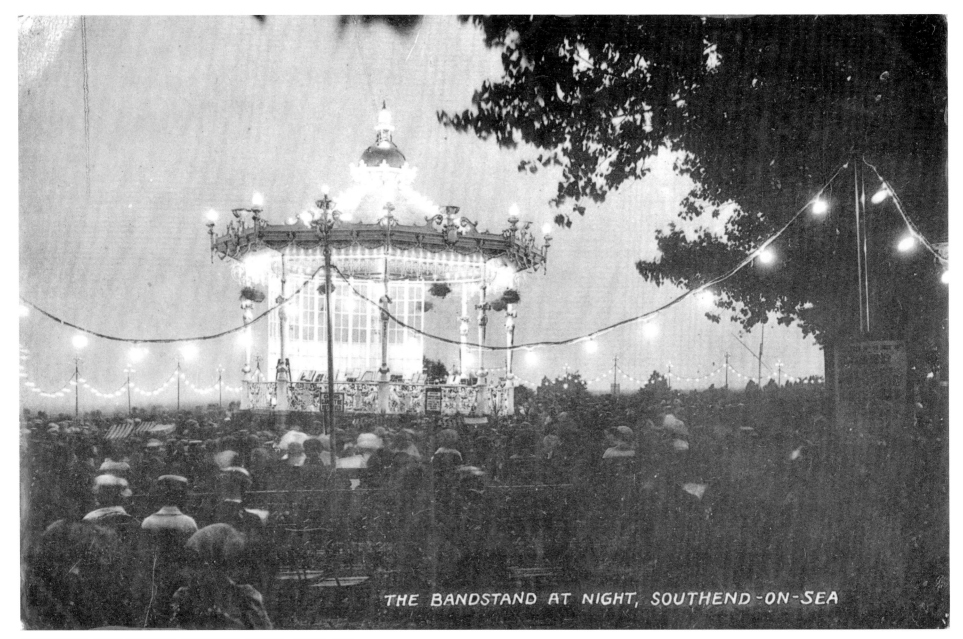

THE BANDSTAND AT NIGHT, SOUTHEND-ON-SEA

BANDSTAND, CLIFF GARDENS, SOUTHEND-ON-SEA, ESSEX, 1922

Public concerts were an important opportunity to hear music in the days before radio brought it into every home at the touch of a button. By the late 19th century a bandstand could be found in nearly every town park in England and they were an important component of the seaside landscape. Town councils often maintained a band or orchestra and concerts would be advertised at fixed times throughout the day. This postcard, postmarked 7 July 1922, shows the ornate bandstand at Southend. It is attractively lit for an evening concert, which has drawn a large audience. [Nigel Temple, PC08823]

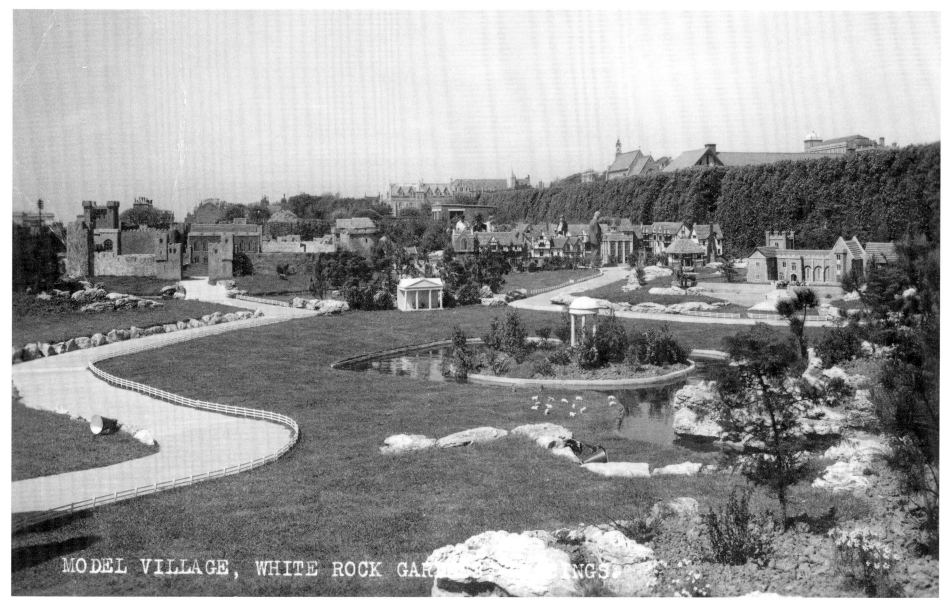

MODEL VILLAGE, WHITE ROCK GARDENS, HASTINGS

MODEL VILLAGE, HASTINGS, EAST SUSSEX, 1950s

A model village can turn a garden into a paying attraction. People are fascinated by the skill involved and are amused by playing with scale. This example in White Rock Gardens includes buildings from many periods of English history: a Norman castle, a medieval manor house, half-timbered houses and 18th-century garden temples in the classical style. A flock of miniature sheep lend added realism. [Nigel Temple, PC07834]

ROBIN HOOD'S BAY, NORTH YORKSHIRE, 1950s

'Messing about in boats' is not the sole prerogative of adults. These five boys have been playing with a rowing boat in Robin Hood's Bay – shades of Enid Blyton and Arthur Ransome. This adventure may have been the highlight of their holiday. [Hallam Ashley, AA98/09806]

Fresh air and fun

Approaching, at dusk, the fair-field from the beach, we scorched and
gritty boys heard above the belabouring of the batherless sea
the siren voices of the noisy, raucous, horsy barkers ... Round galleries and
shies and stalls, pennies were burning holes in a hundred pockets.

Dylan Thomas, *Holiday Memory*, 1952

On the open spaces between the sea and the town many resorts offer various amusements that developed in the 19th and 20th centuries. If the sea proved too cold there were often large open-air pools, which were known as lidos. Originating before World War I, but particularly popular in the 1930s, hundreds of people could enjoy the water though they were usually too crowded for any serious swimming.

If swimming was too energetic visitors could enjoy a game of bowls, pitch and putt and crazy golf. Some resorts have boating lakes in the area between the sea and land, and boat trips out to sea cater for visitors wishing to recreate some of the adventures of Lord Nelson. However, for those wishing to enjoy a lazy afternoon of music, most seafronts have bandstands, which date from the 19th and early 20th centuries.

Victorian visitors to resorts were able to enjoy the thrills of new technology. Amusement parks began to appear in the early 20th century and, since their creation, rollercoasters and ferris wheels have grown in size as has the adrenalin rush they provide. Colourful carousels, log flumes and helter-skelters offered more sedate alternatives and some resorts had tall towers with revolving observatories. Static towers were also built to exploit the views. At Blackpool, an echo of the Eiffel Tower in Paris was built. It is the most famous of these towers and the only survivor today, though an even taller one was built at New Brighton.

LIDO, WESTON-SUPER-MARE, SOMERSET, 1937
Bathing in the sea was a major attraction at the seaside, but many holidaymakers preferred the safe and perhaps more ordered environment of the lido. A new pool opened on the seafront at Weston-super-Mare in 1937 and included this very elaborate diving board. This pool was built at a time when swimming was being popularised by Busby Berkeley's movies.
[H Felton, BB81/08505]

BLACKPOOL, LANCASHIRE, 1946–55

Blackpool Lido was opened in 1923. It was a huge pool, as befitted the busiest resort in England, and was claimed to accommodate 1,500 bathers with seating for 8,000 spectators. Although designed primarily for leisure bathers, it incorporated a section laid out for championship swimming and a diving area. Refreshment bars were also provided for bathers. Here, children are being entertained with an exercise class on the side of the pool while their parents look on. The distinctive roofline of the South Pier theatre is visible behind the lido. [John Gay, AA047936]

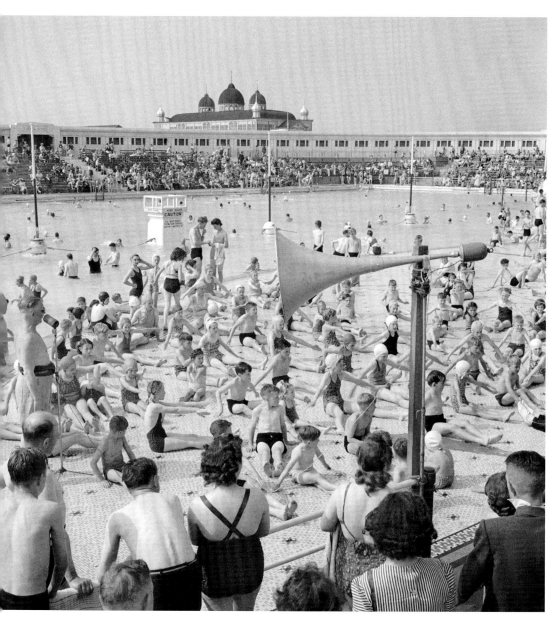

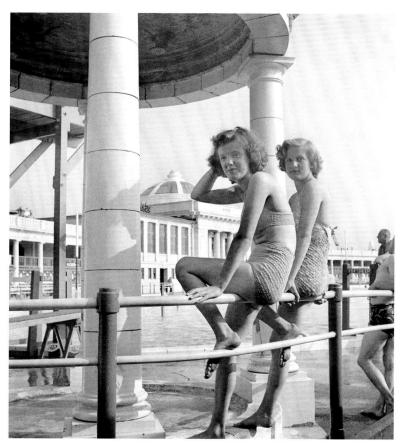

LIDO, BLACKPOOL, LANCASHIRE, 1946–55

Two bathing beauties pose for the camera in Blackpool Lido. The Classical influence on the architecture of the Lido – with its Greek and Roman pillars – is evident. [John Gay, AA047938]

GORLESTON-ON-SEA, NEAR GREAT YARMOUTH, NORFOLK, 28 JULY 1961

This open-air swimming pool is right on the seafront – the beach with its bathing huts can be seen over the wall. A row of changing cubicles runs around the outside of the pool: men on one side, ladies on the other. The site also includes the Floral Hall (to the left). Posters advertise Eddie Gates on the electric organ and the Gorleston Bach Festival.
[Hallam Ashley, AA99/00327]

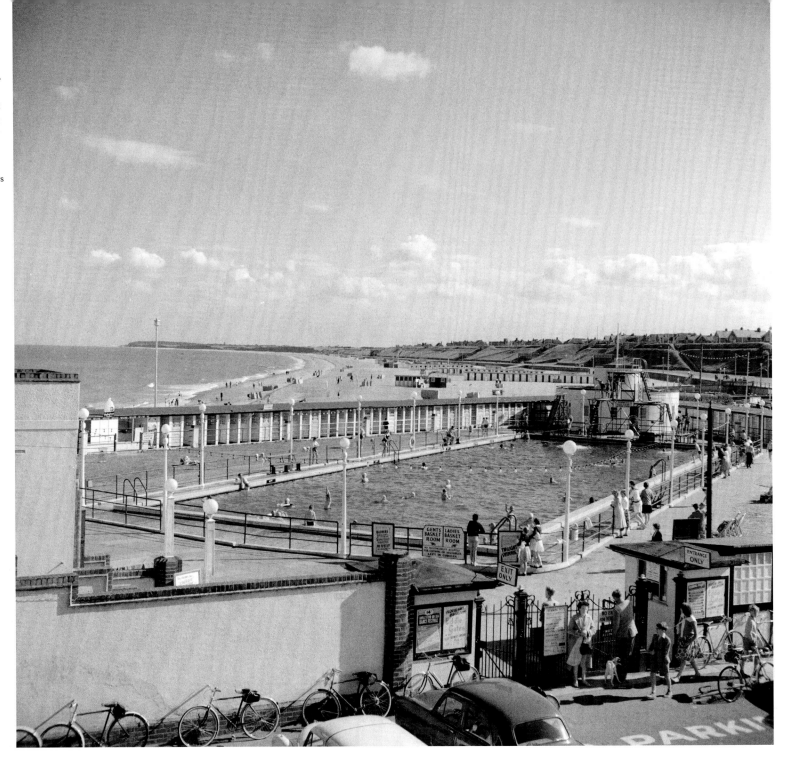

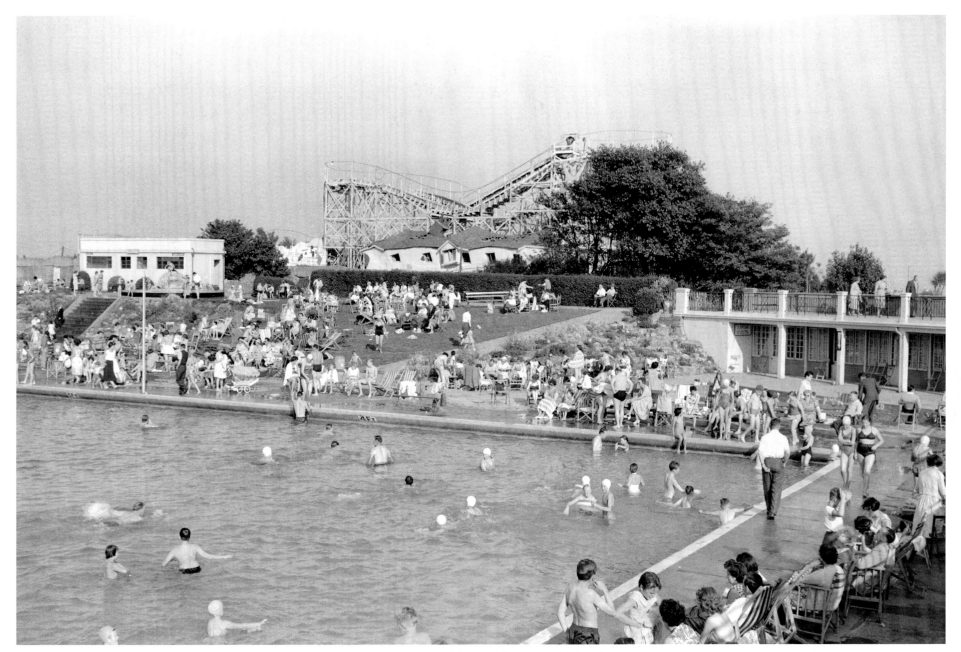

LIDO, SKEGNESS, LINCOLNSHIRE, SEPTEMBER 1960
Skegness Lido opened in 1932 but was built on a rather less ambitious scale than its Blackpool cousin. This pool is designed purely for leisure swimmers and seating for spectators is provided by deck chairs and a grassy bank, while refreshments are served from a temporary cabin. The rollercoaster in the next door fairground towers over the Lido. [Hallam Ashley, AA99/00322]

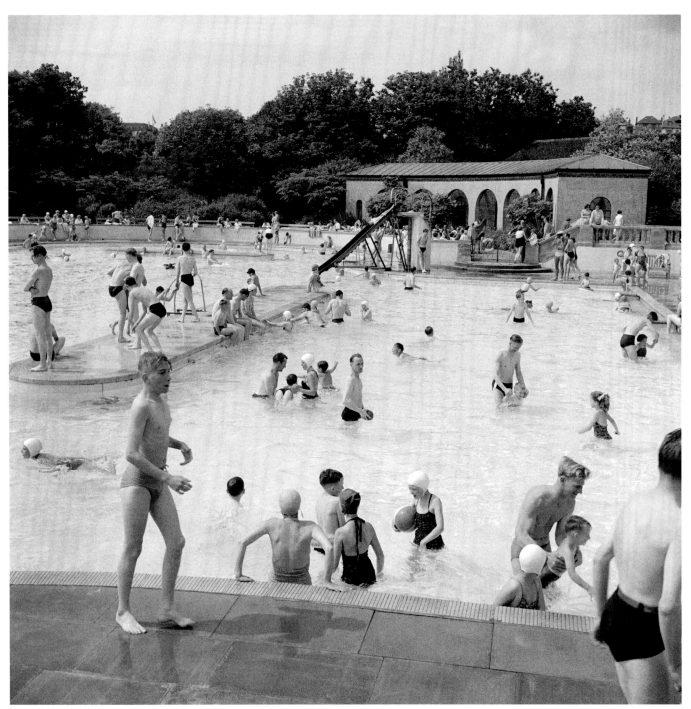

NORTHSTEAD LIDO, SCARBOROUGH, NORTH YORKSHIRE, 1950s
This lido on Scarborough's North Bay was opened in 1938 as a pleasure pool. It was rounded at the ends rather than being rectangular and incorporated a number of 'islands'. Refreshment facilities and an area for spectators were also provided. It was clearly popular with families and several parents supervise small children in this view.
[Hallam Ashley, AA98/18187]

BOATING POND, FELIXSTOWE, SUFFOLK, 1953

Children gather round the boating pond, which provides a safe and predictable environment for 'messing about'. While the adults try their hand in pedal boats, the children sail their model yachts. Surprisingly, some appear to be catching crabs. The Pier Pavilion and other entertainment venues are visible in the background, with the beach to the right.
[Hallam Ashley, AA98/17450]

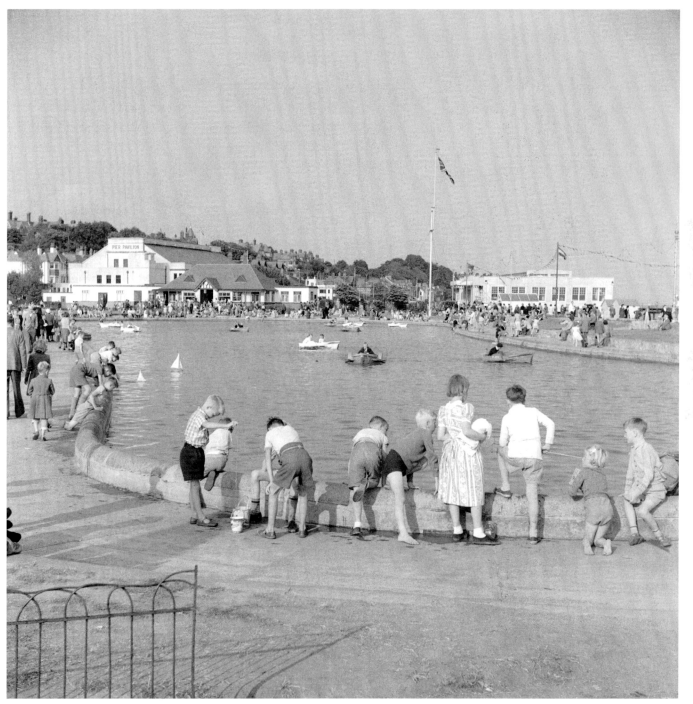

NORTHSTEAD MANOR GARDENS, SCARBOROUGH, NORTH YORKSHIRE, 1950s

A keeper in a vaguely naval uniform is in charge of this boating pond in Northstead Manor Gardens. Visitors have a choice of pedalos or rowing boats. The tiered seating of the open-air theatre is just visible beyond the trees on the right, separated from the stage by the lake. [Hallam Ashley, AA98/18192]

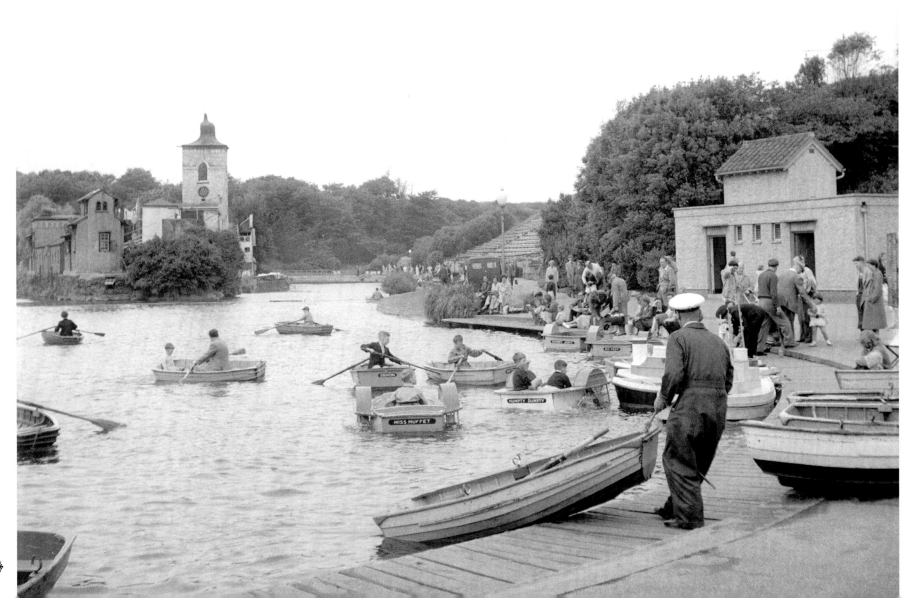

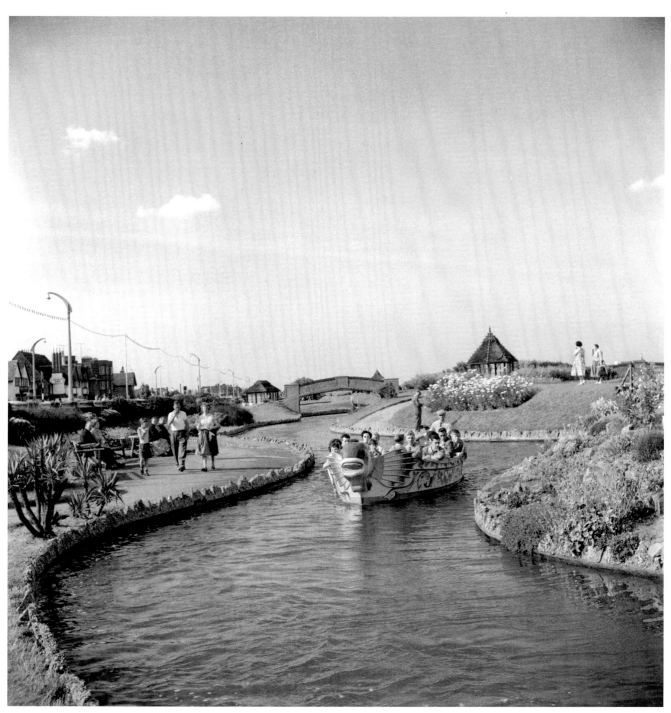

GREAT YARMOUTH, NORFOLK, *c* 1947
Visitors enjoy a trip on a dragon boat as it meanders along the Venetian Waterways on the North Beach at Great Yarmouth. In the 1920s the town council built a new sea wall and much of the reclaimed land between the promenade and beach was laid out as pleasure gardens. The Venetian Waterways opened in 1928, providing a boating lake and a serpentine watercourse. The grounds were landscaped with flower beds and rockeries, thatched shelters and picturesque bridges, providing a pleasant place to walk and sit. [Hallam Ashley, AA99/00344]

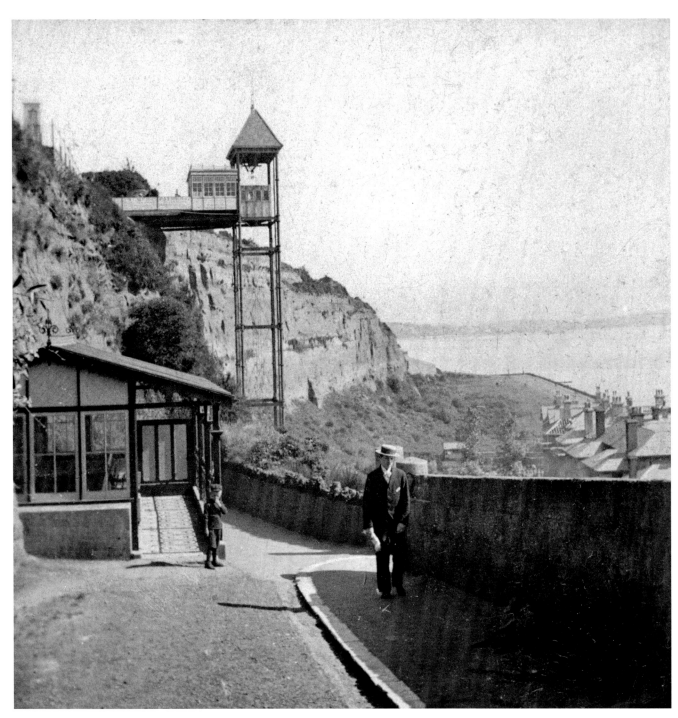

HYDRAULIC LIFT, SHANKLIN, ISLE OF WIGHT

Most of the town of Shanklin stands on top of a sea cliff 100–150ft high. The route to the sea is down a zigzag path with strategically positioned shelters where pedestrians could rest and admire the view. The hydraulic lift was both a practical alternative and a novelty ride. In 1900–1 the fare per journey was 1d (½p). A guide book of that date listed the attractions of Shanklin as bathing, boating, various sports including golf and tennis, the Esplanade, the pier (admission 2d), the Chine (a valley garden, admission 3d), the Old Village (for sightseeing) and local excursions. [Howarth-Loomes, BB82/13476B]

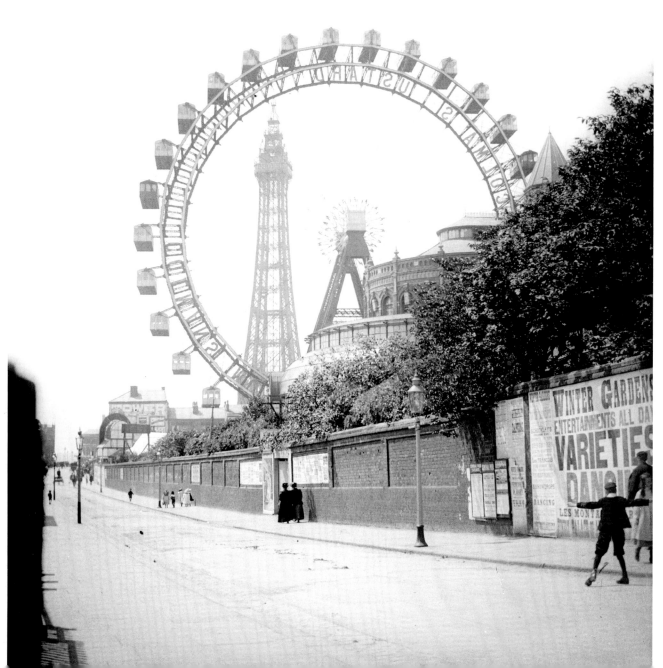

BLACKPOOL, LANCASHIRE

Blackpool Tower opened in 1894 and the huge ferris wheel in the Winter Gardens was completed two years later. The wheel was intended as a rival attraction to the neighbouring Tower and was an impressive feat of engineering. However, it was not a commercial success and was finally dismantled in 1928. One of the cars was reused as a cabin in the nearby Abingdon Street market. Oddly, the wheel appears to be advertising Colman's Mustard – the letters are in reverse around the rim. [AA84/00148]

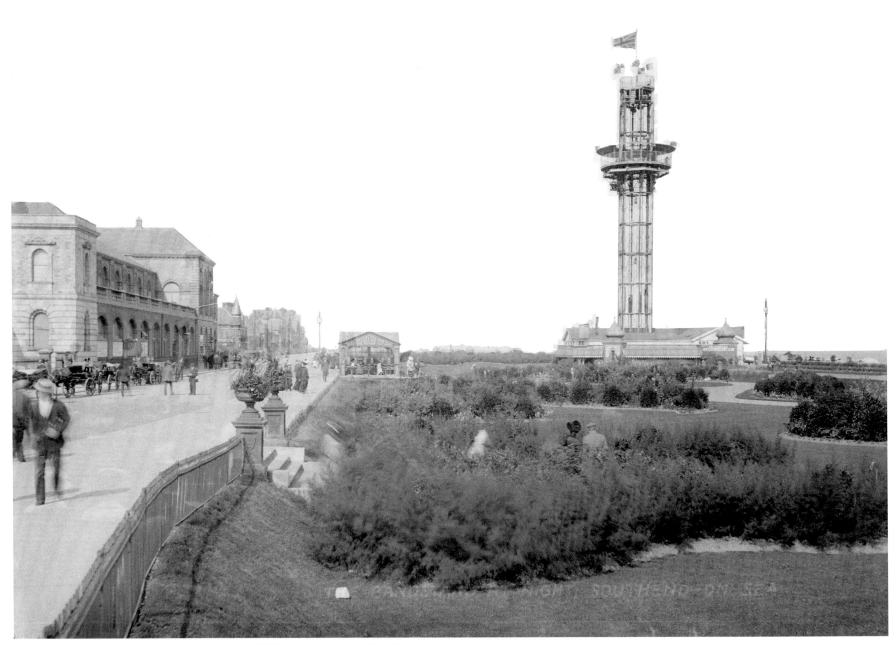

WARWICK'S REVOLVING TOWER, GREAT YARMOUTH, NORFOLK, SEPTEMBER 1904

Less monumental than the Blackpool Tower, the Revolving Tower was invented by Thomas Warwick, an engineer from London. This example was one of five in England and was built in North Beach Gardens in 1897. Customers travelled in a ring-shaped carriage that rotated as it rose up the Tower, which was about 150ft high and gave panoramic views over the town and seafront. The Revolving Tower continued in use until 1939. [LMS, CC76/00473]

**GREAT YARMOUTH, NORFOLK,
AUGUST 1949**
Most resorts had their funfair and Great
Yarmouth was no exception. This view of
the amusement park includes a crowd of
people gathered around a stall, a traditional
helter-skelter and a less traditional flying
gondola ride. [Hallam Ashley, AA98/14647]

PLEASURE BEACH, BLACKPOOL, LANCASHIRE, 1946–55
Blackpool Pleasure Beach is a large fairground and amusement park and is one of the most popular attractions in England. From the top of the double ferris wheel there was a wonderful view over the promenade and beach. Rides along the promenade in a horse-drawn carriage offer a more sedate form of entertainment. A horse enjoys its nosebag while the carriage waits for a fare.
[John Gay, AA047934]

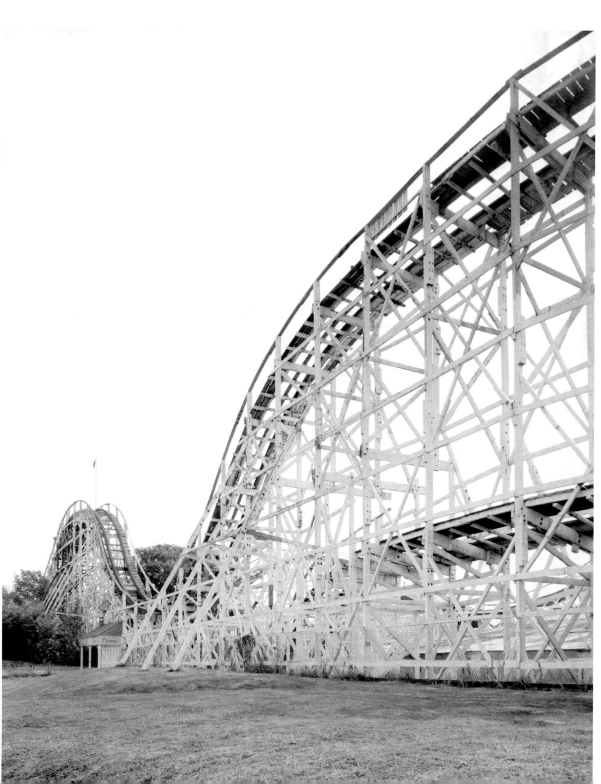

PLEASURELAND AMUSEMENT PARK, SOUTHPORT, LANCASHIRE, SEPTEMBER 1993
Big dippers are a popular feature of funfairs. Wooden rollercoasters can never rival more modern steel ones in terms of height and speed, but the shake, rattle and roll of the car on a 'woody' is a unique experience. [P Williams, BB93/33601]

MORECAMBE, LANCASHIRE, OCTOBER 1978

This travelling fairground has found a temporary home behind the Winter Gardens. The centrepiece is a traditional carousel, accompanied by a few other children's rides. The Winter Gardens date from 1878 and were extended with a theatre block in 1896. The earlier part, with the arched roof (nearer the camera), was demolished in 1982. [BB81/05837]

NORTHSTEAD MANOR GARDENS, SCARBOROUGH, NORTH YORKSHIRE, 1959
Miniature railways continue to hold a fascination for many people and, even in the age of steam, every little boy wanted to be an engine driver. They are advertised as being 'for the children', though their parents are often just as enthusiastic to ride on them. The North Bay Railway was opened in 1931, running through the gardens from Peasholme to Scalby Mills with an intermediate station for the beach. [Hallam Ashley, AA99/00256]

REDOUBT BOWLING GREEN, EASTBOURNE 54

EASTBOURNE, EAST SUSSEX, 1920–35

The south coast resorts have long been a haven for retired people. Bowls, which has unfairly gained a reputation as a sport exclusively for older people, is a very popular pastime for all ages. This match at the Redoubt Bowling Green has drawn a small crowd of spectators. [Nigel Temple, PC08310]

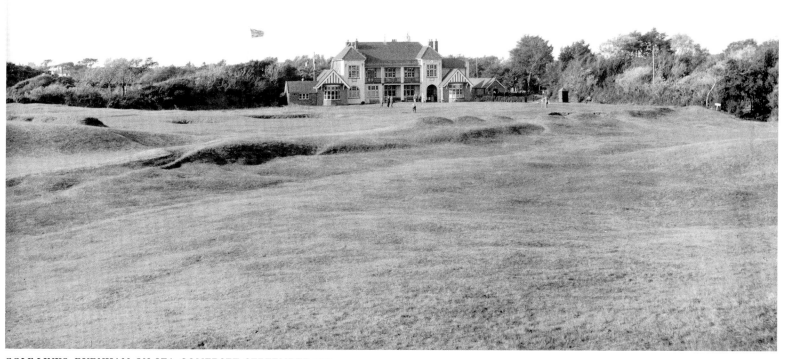

GOLF LINKS, BURNHAM-ON-SEA, SOMERSET, SEPTEMBER 1921

Golf is a popular pastime and many seaside resorts have at least one course open to visitors. A golf course needs a large area of land and is an ideal use for reclaimed sand dunes. Many of Britain's most prestigious golf links are in coastal situations. The Burnham & Berrow Golf Club was founded in 1890 and the club house is of that date. [LMS, CC76/00402]

NEAR SIDMOUTH, DEVON, 18 AUGUST 1950
The 1930s saw the rising popularity of healthy outdoor
pursuits such as swimming and hiking as people looked
for a physical and spiritual escape from city life. The
famous 'mass trespass' on Kinder Scout, Derbyshire, took
place in April 1932 and the Ramblers' Association was
founded in 1935. The fashion for active outdoor holidays
continued after World War II. Here a family walks along
the cliff path from Seaton to Sidmouth. Walking continues
to be a popular pastime and several sections of path
around the coast have been established as National Trails:
the South West Coast Path alone is 630 miles long.
[Hallam Ashley, AA98/16080]

NEAR RAMSGATE, KENT, 1890–1910
Holidaymakers are often drawn by the romance of
the sea, making 'trips around the bay' and fishing
trips both enduring popular pastimes at the seaside.
Here a sailing boat out from Ramsgate, the *New Moss
Rose*, takes passengers on the dead calm waters of the
English Channel. [W & Co, OP00655]

New Moss Rose, Ramsgate. W 6801.

BLAKENEY, NORFOLK

The sea is a magnet for visitors and sailing is a popular hobby. Some resorts offer marina facilities, while others are less formal. Along the Norfolk coast many boats are moored on the extensive sandbanks and among the creeks and inlets. Settlements such as Blakeney have little to offer the holidaymaker by way of traditional attractions and amusements, catering instead for the sailing fraternity and for people seeking a quiet holiday. [Hallam Ashley, AA99/02106]

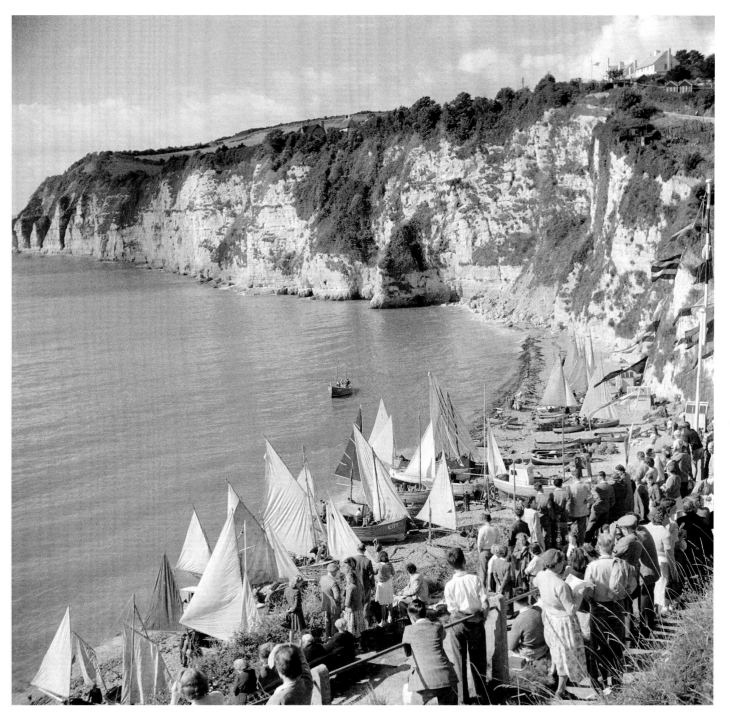

BEER, DEVON, AUGUST 1950

The enduring twin appeal of the sea and sailing is considerable. Here spectators gather by the shore to watch the annual regatta at Beer. The yachts are pulled up on the shore before the start of a race and the umpire's boat is the only one in the bay. [Hallam Ashley, AA98/12144]

THE PAVILION, TORQUAY, DEVON, NOVEMBER 1971
The Pavilion at Torquay stands on reclaimed land on the seafront next to the harbour. Built in 1912, it is a steel-framed building faced in cream Doulton stoneware panels and features copper domed roofs and Art Nouveau ironwork details. It originally housed a theatre/concert hall and a rooftop tea garden. The theatre was still functioning when this photograph was taken, but the building was under threat of demolition. It has since been reprieved and converted to retail use. [BB71/11311]

Pleasure palaces

Our True Intent is all for your Delight.

Slogan used by Butlins, based on a quote from *A Midsummer Night's Dream*, Act V, Scene I

Visitors have been drawn to seaside resorts by the beach and the sea, but once they arrived they needed to be entertained. Georgian visitors enjoyed visiting circulating libraries, theatres and assembly rooms. Their numbers were small and the facilities were usually fairly modest.

Their Victorian successors still enjoyed the theatre but the circulating library and assembly rooms declined in favour of music halls and winter gardens. Thousands of people were now visiting some resorts every week and therefore the entertainment facilities had to be rebuilt to accommodate them. Entertainment venues also served as somewhere for visitors to shelter when inclement weather drove them off the beach.

From the early 20th century cinemas begin to appear at the seaside. At first they were in adapted buildings, but small purpose-built cinemas began to appear before World War I. By the 1930s large modernist-style cinemas were being built all over the country.

Seaside resorts have to cater for people with a wide range of tastes. Aquaria amuse children as well as appealing to people with an interest in natural history. Cultural venues like museums, art galleries, theatres and even opera houses have also appeared at some resorts. Today no seafront is complete without amusement arcades, often occupying the ground floors of houses that were built for a quieter era.

Resorts were busy during the summer but quiet during the winter. However, by investing in winter gardens, and now conference centres, resorts have been able to attract visitors all year round.

ROTUNDA MUSEUM, SCARBOROUGH, NORTH YORKSHIRE, AUGUST 1945

Among the genteel cultural attractions found at some early resorts was a museum or cabinet of curiosities. The Rotunda Museum was built for the Scarborough Philosophical Society in 1828 to a design suggested by William Smith – the 'father of English geology' – who believed that a circular space best showed off the exhibits. Originally just consisting of the rotunda with its external pilasters and domed roof, two wings were added in 1861 to provide additional facilities. A spiral staircase leads to the first-floor exhibition area. [G B Wood, A45/6210]

MUSEUM & ART GALLERY, CHURCH STREET, BRIGHTON, EAST SUSSEX, 1998
Royal interest in the Pavilion at Brighton ended in 1850 when it was sold to the town to help finance alterations to Buckingham Palace. The Pavilion was purchased to serve as a Winter Garden and, since 1873, Brighton Museum & Art Gallery has occupied part of the former stables. This range was originally designed in 1804 by William Porden in an Indian style that was later used for the Pavilion, but much of the interior decoration seen here dates from the 1901 remodelling. Today this important collection includes fashion, 20th-century design and world art as well as local archaeology and history. [P Payne, BB98/10534]

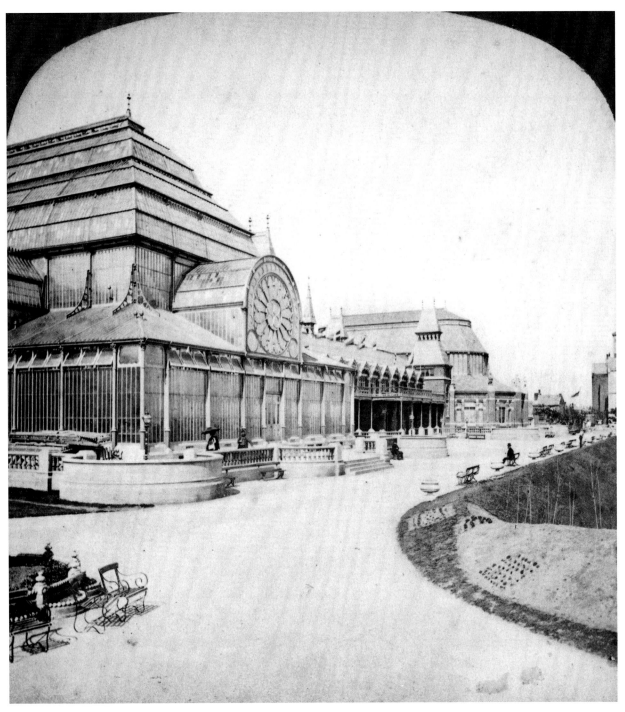

WINTER GARDEN, SOUTHPORT, LANCASHIRE, SEPTEMBER 1878

In a country like England where the climate is notoriously unpredictable, a seaside resort cannot rely on sea, sun and sand to entertain its visitors; therefore indoor entertainment complexes are also necessary. Many winter gardens were based on the design of iron and glass conservatories made popular by the success of the Crystal Palace at Sydenham, London. They were used for concerts and other cultural activities, as well as for housing tender plants. The Southport Winter Garden, built in 1874 by the Manchester architects Maxwell & Tuke, was one of the largest. Its concert pavilion could hold an audience of 2,000; there was also a conservatory near the camera and the linking corridor housed an aquarium. The Winter Garden was finally demolished in 1962. [Howarth-Loomes (H Sampson), BB83/05801]

WINTER GARDENS, GREAT YARMOUTH, NORFOLK, SEPTEMBER 1904

The Winter Gardens were originally erected in Torquay but were moved to Great Yarmouth in 1903. The building that houses them is like a large conservatory, measuring 170ft long and 83ft high. It was re-erected opposite the entrance to Wellington Pier and used for concert performances. The main body of the building is filled with rather unforgiving benches facing a small stage with music stands. Flags and banners hang from the ceiling to add an air of festivity. [LMS, CC76/00337]

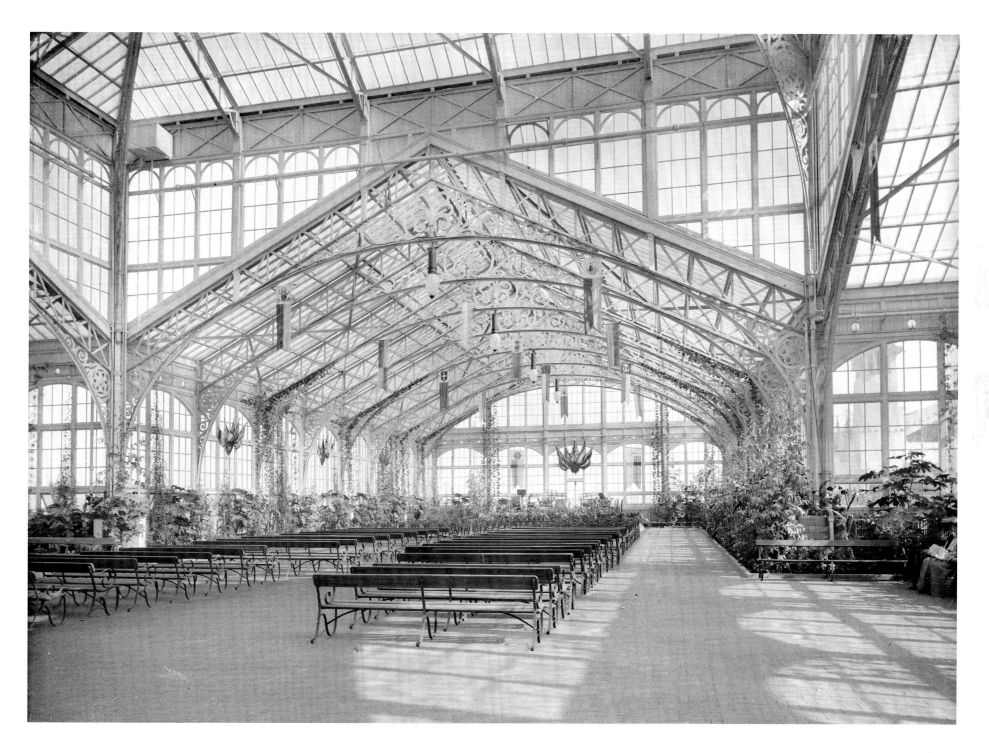

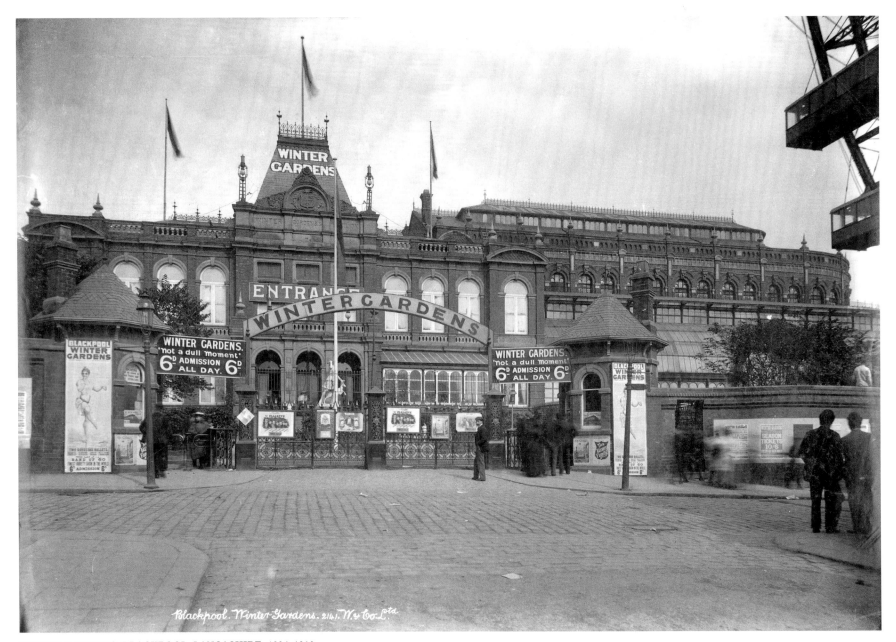

WINTER GARDENS, BLACKPOOL, LANCASHIRE, 1896–1910

The rising popularity of Blackpool as a resort created commercial opportunities that entrepreneurs were quick to seize. The North Pier was opened in 1863 and the Central Pier in 1868, followed in 1872 by Raikes Hall Park, an amusement park. The Winter Gardens, which opened in 1878, provided an indoor alternative to Raikes Hall Park, and the Empress Ballroom was added in 1896–7. Under the motto 'Not a dull moment', an admission of 6d (2½p) was charged. Direct competition was felt when the large and very similar entertainment complex at the base of Blackpool Tower was opened in 1894. [W & Co, OP00478]

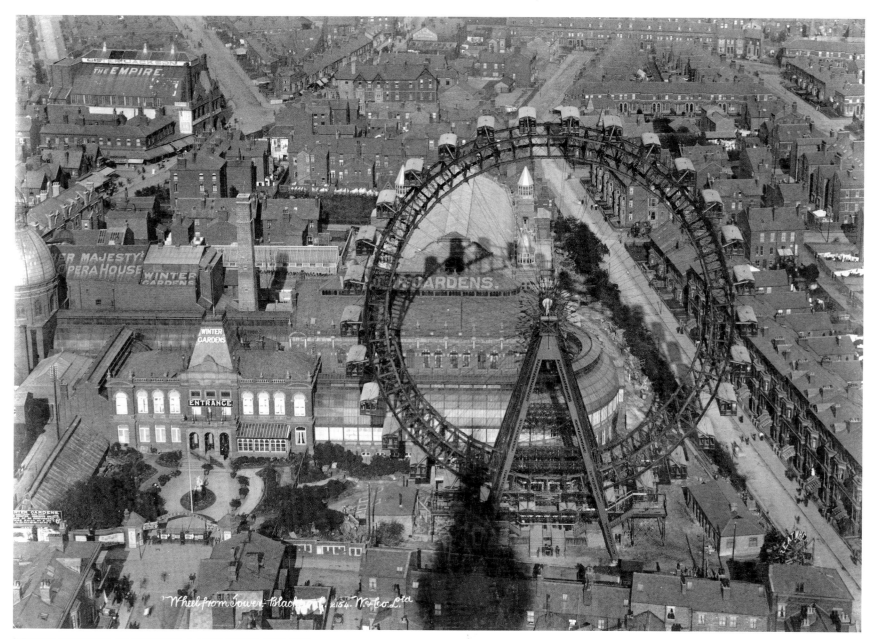

Wheel from Tower-Blackpool. 2154. N & Co. Ltd

WINTER GARDENS, BLACKPOOL, LANCASHIRE, 1897–1910

This view of the Winter Gardens is from the vantage of their great rival, Blackpool Tower. The Winter Gardens enjoyed 16 years unchallenged as Blackpool's largest attraction. Following the opening of the Tower in 1894, competition between the two neighbours was intense. New attractions were developed at the Winter Gardens, including Her Majesty's Opera House, opened in 1889; the ferris wheel (not originally owned by the Winter Gardens), completed in 1896; and the Empress Ballroom, opened in 1897. In 1929 the entrance, seen here, was dramatically remodelled in white ceramic tile. [W & Co, OP00473]

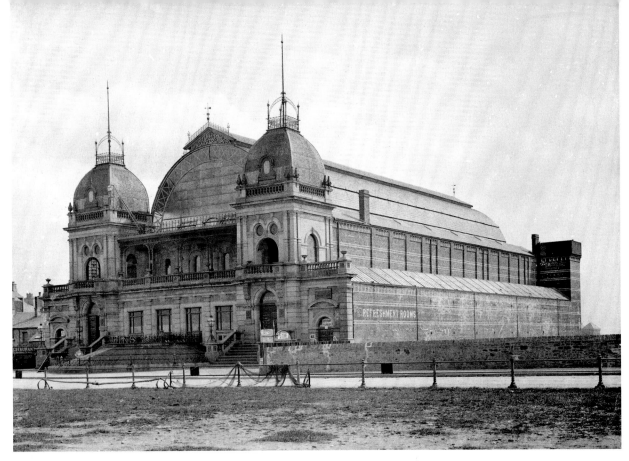

WINTER GARDENS, MORECAMBE, LANCASHIRE, 1886 AND OCTOBER 1978

Originally called the People's Palace, the earliest part of the Winter Gardens was built in 1878 with a more ornate extension added in 1896. These two photographs illustrate the change in English culture over a century. The 19th-century view shows a very restrained façade with little signage and the refreshment rooms quite discreetly advertised. By the late 20th century every notice is very prominent. Shops have been inserted into the frontage of the 1896 extension, though behind them the theatre still operates. Just visible at the right-hand edge of the second picture, the earlier building is still in use as a bingo hall; it was demolished four years later. [LMS, CC76/00212; BB81/05833]

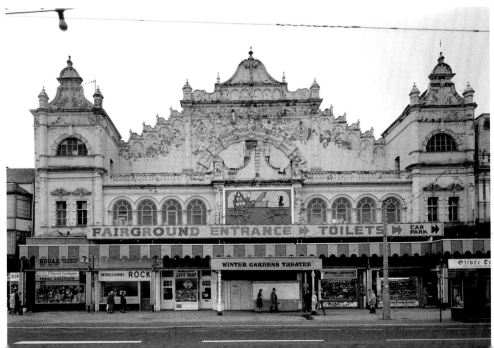

FLORAL PAVILION, BRIDLINGTON, EAST YORKSHIRE

Music was widely provided for public entertainment at most resorts from an early date. In the 20th century the organ established itself as a seaside attraction, most notably the famous Wurlitzer in the Tower Ballroom, Blackpool. Hammond organs were also widely favoured; here Bobby Fisher on the organ shares top billing with Edwin Harper and his orchestra. The Floral Pavilion dates from 1904–6 and, like many winter gardens, is constructed of delicate ironwork filled in with glazing (and later wooden panels). [Hallam Ashley, BB98/16307]

NEW BRIGHTON, MERSEYSIDE, 1898–1910 AND AUGUST 1933

A rival to Blackpool Tower quickly emerged only 50 miles along the coast at New Brighton on the Wirral. Shamelessly copying its competitor and boasting that it was 120ft taller, the New Brighton Tower was opened in 1898, just four years after the Blackpool Tower. As at Blackpool its base was surrounded by an amusement complex, which included a theatre, ballroom, restaurant and roof garden. It drew its visitors mainly from Liverpool and the Mersey ferry made day trips attractive. Despite its success, the Tower only had a short life and was demolished by 1921, though the amusement complex survived until 1969. [W & Co, OP00587; LMS, CC80/00453]

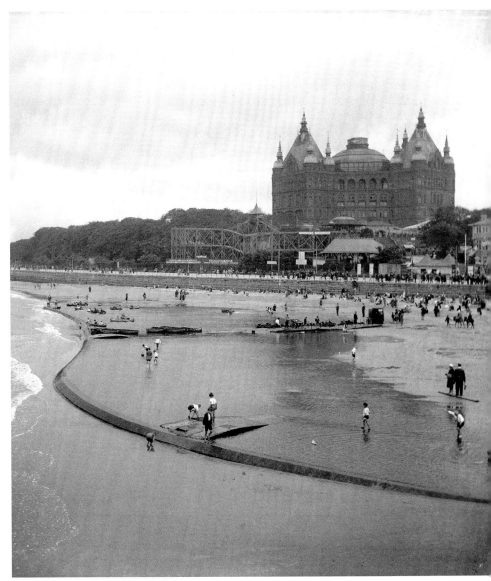

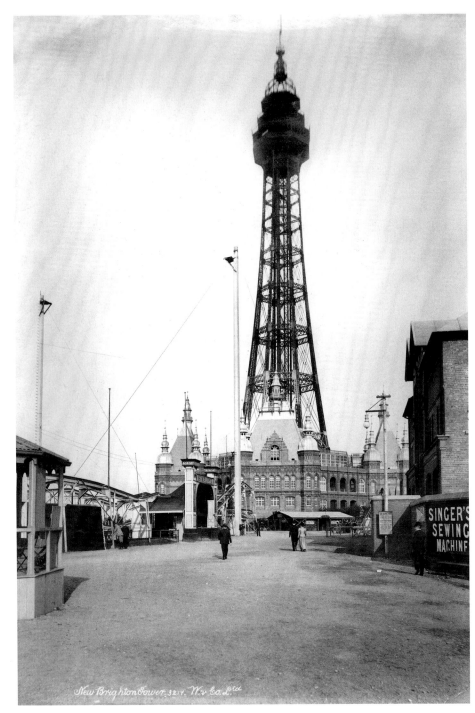

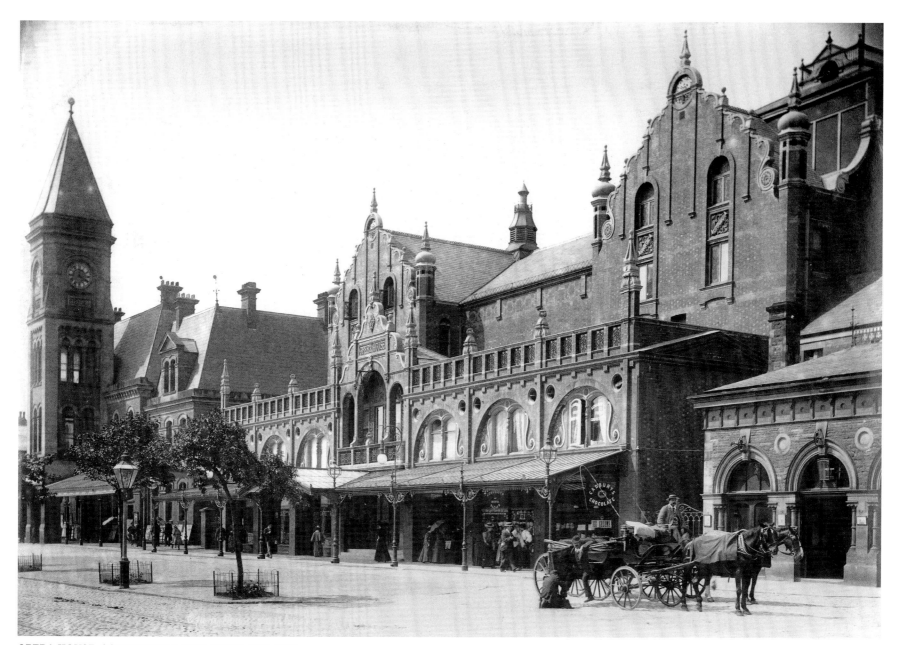

OPERA HOUSE, SOUTHPORT, LANCASHIRE, 1891–1910

In the late 19th century Southport tried to raise its status and attract a better class of visitor, though this resulted in the town declining as a resort. Lord Street, which runs parallel to the promenade, was remodelled as a leafy boulevard with public gardens laid out on its east side. A free library and art gallery were created in the 1870s and the Winter Garden Opera House, with a capacity for 2,000, opened in 1891. The Opera House was not a success and, when it burned down in 1929, was replaced with a theatre. [W & Co, OP00592]

GRAND THEATRE, BLACKPOOL, LANCASHIRE, OCTOBER 1972
The Grand Theatre, near the Winter Gardens in Church Street, was opened in 1894 just after Blackpool Tower. With its striking corner entrance and ornate auditorium, the theatre – designed by Frank Matcham – was a major addition to Blackpool's nightlife. The galleries, boxes, ceiling and proscenium arch are of gilded plasterwork. [BB72/05758; BB72/05769]

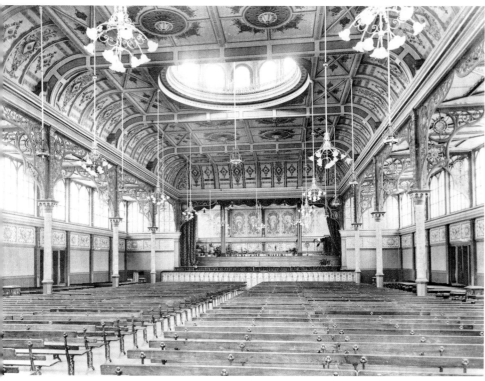

THEATRE, SOUTH PIER, BLACKPOOL, LANCASHIRE, 24 MARCH 1896
Pier entertainments were (and still are) an important feature of resorts and most pier pavilions housed a concert hall or theatre. Victoria Pier (renamed the South Pier) was opened in 1893 with a theatre at the pier head. It was designed for a single class of patron: seating was on hard wooden benches throughout and there were no galleries. The theatre was demolished in 1998 to make way for a fairground ride. [LMS, BB93/22796]

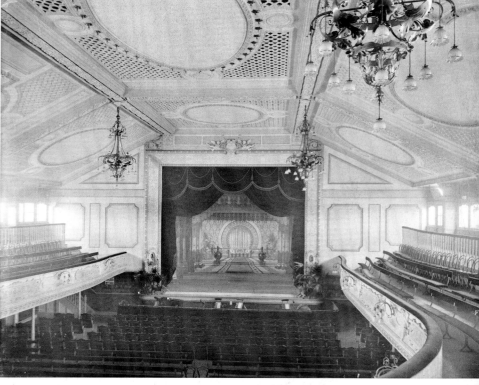

THEATRE, BRITANNIA PIER, GREAT YARMOUTH, NORFOLK, SEPTEMBER 1904
The theatre in the pier-head pavilion on the Britannia Pier contrasts markedly with that on Blackpool South Pier. There is room for an orchestra in a small pit in front of the stage, which appears to be set out for a vaguely Oriental performance. The seating in the stalls is upholstered, as are the benches on the gallery; only the bentwood chairs are not. The auditorium is also more highly decorated. [LMS, CC76/00343]

PLAY BILLS, BRIXHAM, DEVON, 2000

Theatre, music hall and other stage acts have always been an important element in seaside entertainment. Three framed posters advertise plays by the Brixham Amateur Operatic Society staged in the Town Hall Theatre between 1925 and 1934. They were all performed out of season, for the enjoyment of residents rather than visitors. During the summer season the theatre was probably home to professional acts and touring repertory companies. [J O Davies, BB001100]

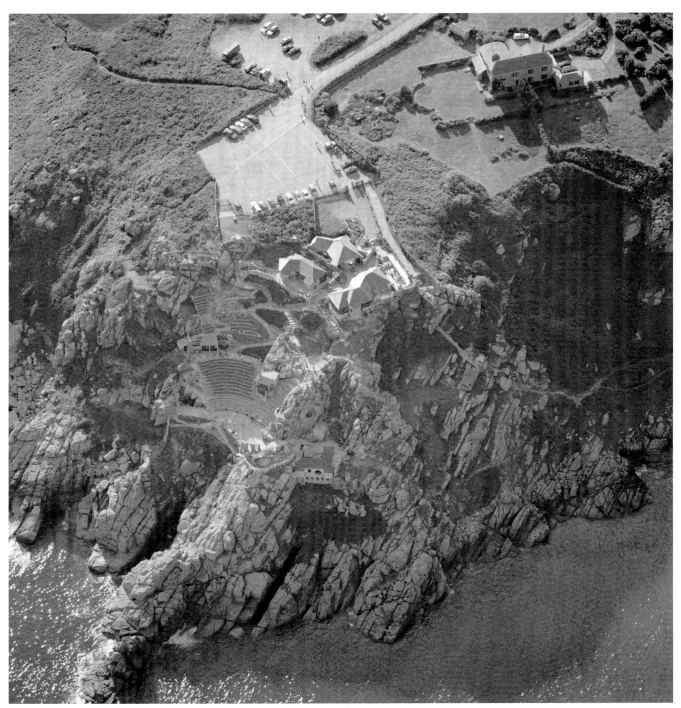

MINACK THEATRE, NEAR PORTHCURNO, CORNWALL, 10 AUGUST 1999
The Minack Theatre stands out on the tip of Cornwall and plays to audiences of holidaymakers all summer. The theatre was created by Rowena Cade in the 1930s, though the more recent ticket office and other facilities can be seen at the clifftop. It is carved out of a sea cliff, with tiered seating like some Classical Greek theatre beside the Mediterranean. The sea and the setting sun form a stunning backdrop to performances. [R Featherstone, NMR 18484/09]

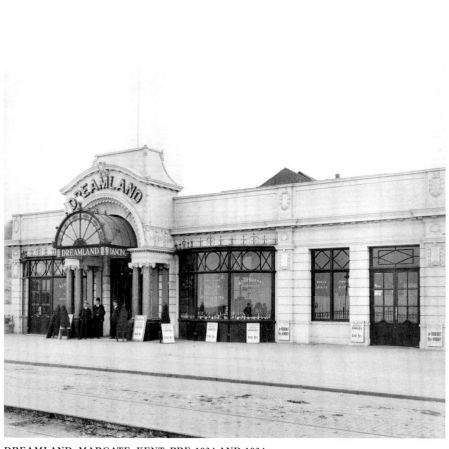

DREAMLAND, MARGATE, KENT, PRE-1934 AND 1934

The original Dreamland was an entertainment complex offering restaurants, bars and an auditorium, which could stage such diverse activities as dancing and boxing; its cinema was converted from a music hall. This site burned down in 1931 and was replaced by a new complex which offered a restaurant and café, bar, cinema and ballroom with an amusement park to the rear. Architecturally it pioneered some of the design features soon to be taken up by the Odeon cinemas, such as the fin-shaped tower. Internally it was fitted out in the International Modern style. When photographed in 1934 it was still under construction although it had already opened for business.
[BB97/00001; H Felton, CC47/00761]

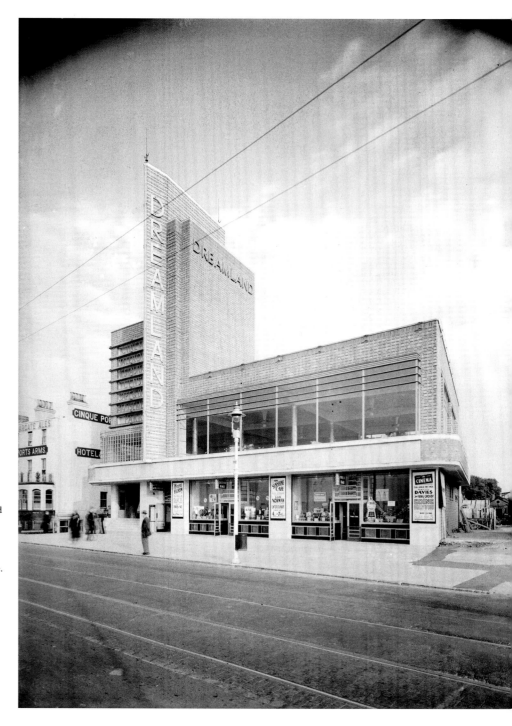

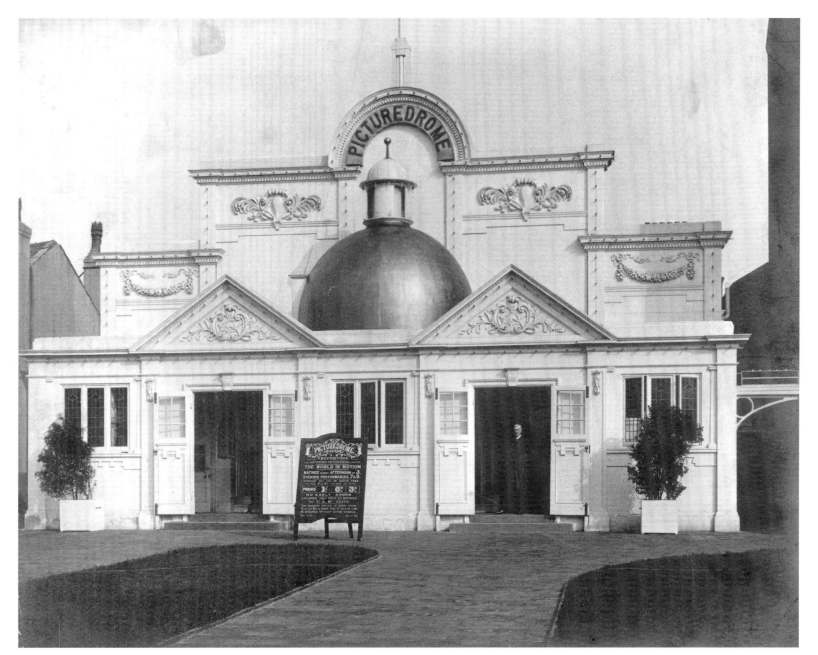

PICTUREDROME, SOUTHPORT, LANCASHIRE

This early purpose-built cinema was designed by Campbell & Fairhurst. It was a local venture predating the large cinema chains and was owned by Southport Picturedrome Ltd. The tariff of admission charges is clearly advertised outside with three performances given daily. The proprietor stands in the doorway waiting for custom. [Gough of Southport, OP03552]

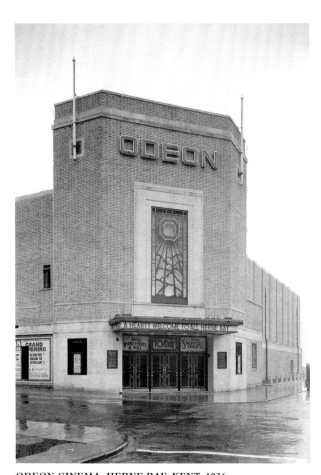

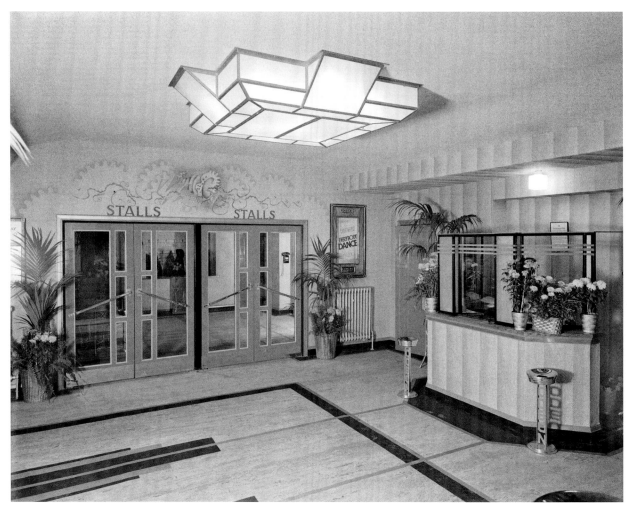

ODEON CINEMA, HERNE BAY, KENT, 1936

This cinema opened on 2 November 1936. The grim autumn weather makes the 'hearty welcome to all Herne Bay' over the entrance sound a little hollow, though palms and flowers in the foyer help to create a better atmosphere. The Odeon cinema chain is famous for its trademark architectural style though this building is not a typical example. However, the Odeon name is prominently displayed and the architect, Andrew Mather, has used the 'O' of Odeon as a rising sun in a panel over the main door. The light fittings in the foyer are typical and the free-standing ash trays by the booth also feature the Odeon name.
[John Maltby, BB87/03295, BB87/03298]

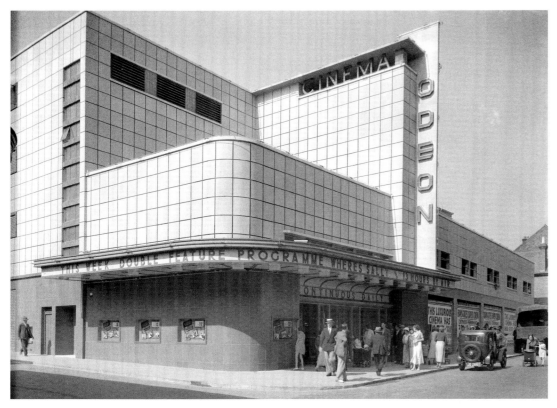

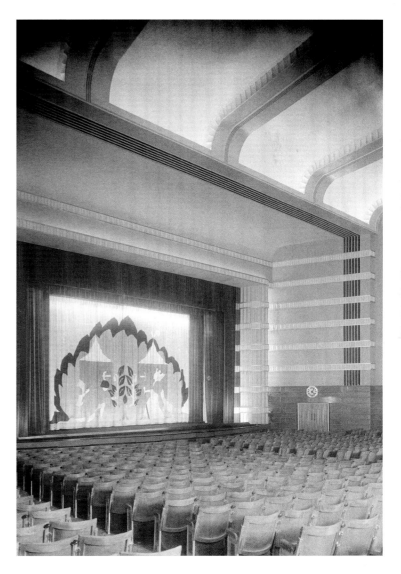

ODEON CINEMA, RAMSGATE, KENT, 1930s

The Odeon in King Street opened on 22 August 1936 and advertises itself as 'luxurious'. This cinema is a classic example of the Odeon style, with its fin-shaped tower, cream glazed facing panels and curved projecting canopy. Holidaymakers take an interest in the programme as they walk past. The auditorium is also typical of Odeon and, like the window of the Herne Bay cinema, the shape of the letter 'O' of Odeon is repeated in the clock. Again, Andrew Mather was the architect of this cinema. [John Maltby, BB87/03160, BB87/03162]

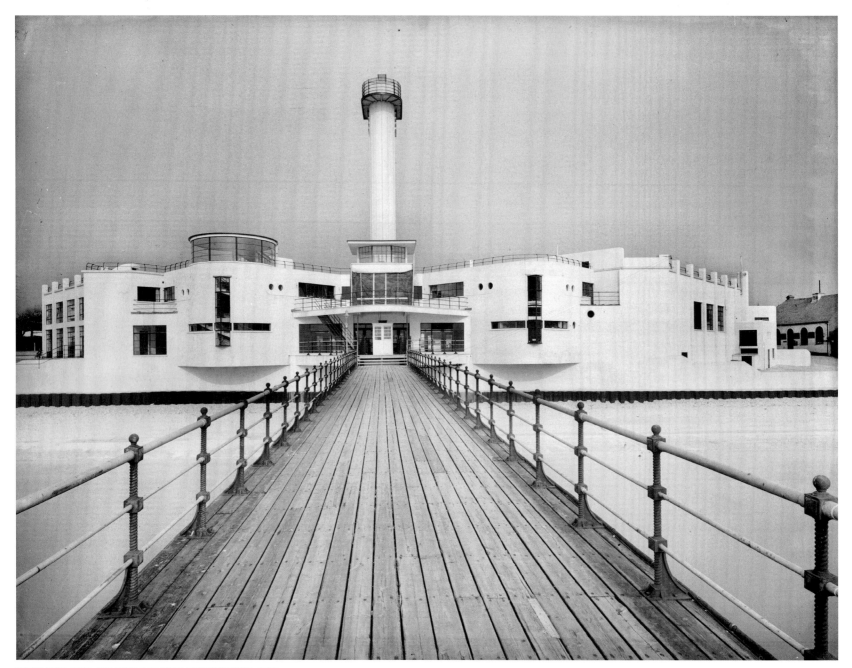

PAVILION, LEE-ON-THE-SOLENT, HAMPSHIRE, 1936

During the 1930s a number of new pavilions in the Winter Garden tradition were built at resorts, using the clean-cut Modernist style. Unlike the iconic De La Warr Pavilion at Bexhill, this impressive building at Lee-on-the-Solent near Gosport has not survived. [H Felton, CC47/00937]

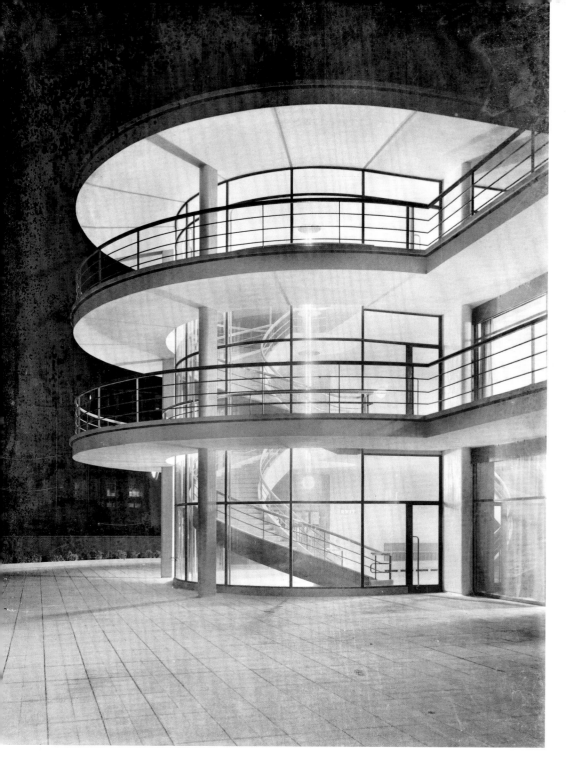

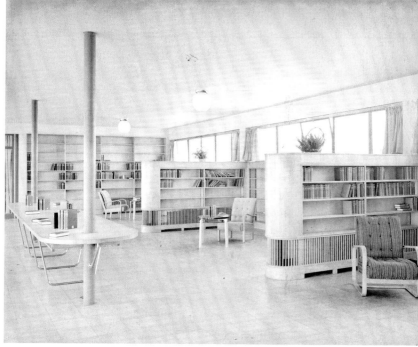

DE LA WARR PAVILION, BEXHILL-ON-SEA, EAST SUSSEX, 1935 AND 1937

The De La Warr Pavilion was part of the development of Bexhill as a seaside resort by Earl De La Warr, though the controversy it generated ended the Earl's period as mayor. Completed in 1936, the Pavilion provided a theatre, ballroom, restaurant and reading room. The first photograph shows a bay which contains a spiral staircase. Visitors could sit on the terrace or balconies and enjoy the sea view. The second shows the newly opened reading room where there is still plenty of space on the shelves for expansion.

[H Felton, CC47/02767, CC47/02395]

CASINO, BLACKPOOL, LANCASHIRE, 1946–55

A resort like Blackpool caters for a wide range of visitors' tastes. The casino, which replaced an earlier one, is on the South Shore beside the Pleasure Beach. It was built in 1937–40 by Joseph Emberton in the International Modern style. The thin tower with its spiral staircase echoes the fairground rides next door. The casino is circular in plan and, in addition to gaming rooms, there were a number of bars and restaurants. Viewed here from the top of the ferris wheel in the Pleasure Beach, it faces the lido across the Promenade. Blackpool Tower is visible in the distance. [John Gay, AA047940]

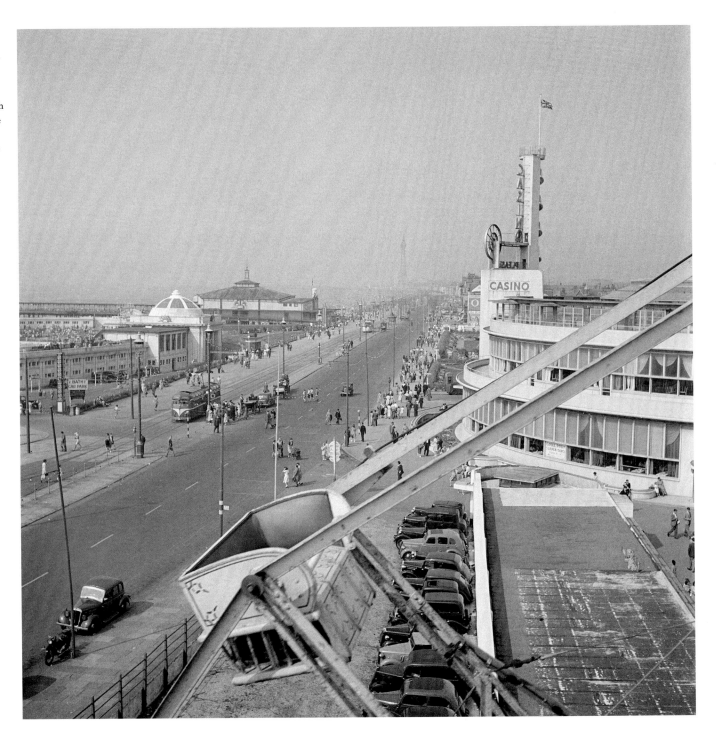

WORTHING PIER, WORTHING, WEST SUSSEX, NOVEMBER 1993

Gambling machines have been a feature of amusement arcades at holiday resorts throughout the 20th century. The fruit machine or 'one-armed bandit' was perhaps the most traditional form, though it has now largely been replaced by electronic versions. [S Barker, BB93/36300]

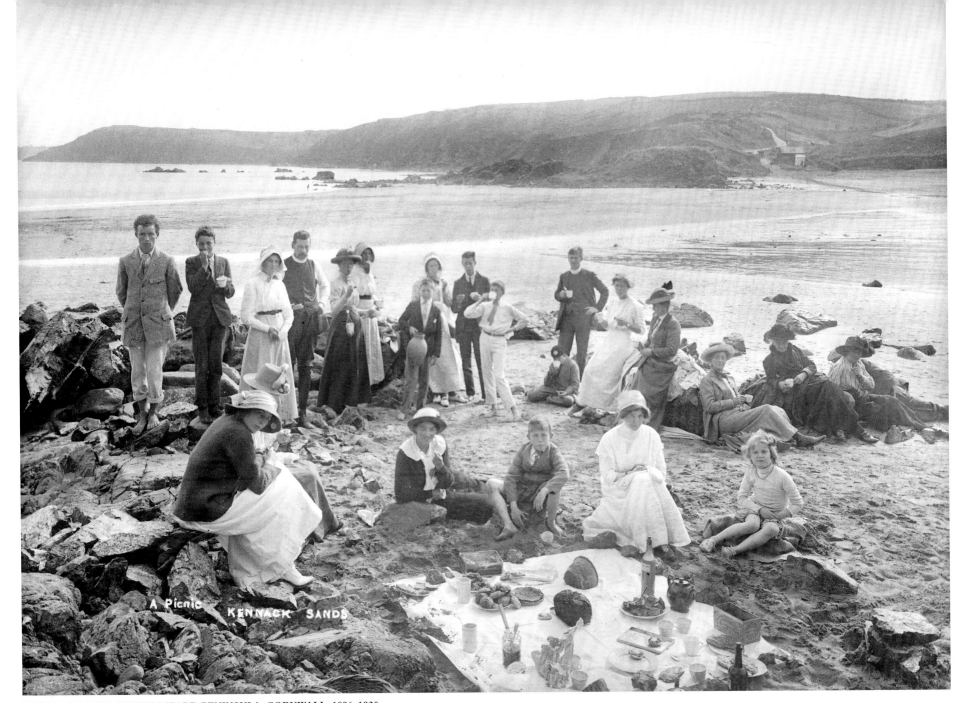

A Picnic KENNACK SANDS

KENNACK SANDS ON THE LIZARD PENINSULA, CORNWALL, 1896–1920

Picnicking has long been a popular seaside activity. This picnic on the east beach at Kennack Sands may be a church outing as there are two clergymen present, one of whom has daringly removed his jacket. At this date even an informal occasion such as this required the ladies to wear their hats. Today the area is designated an Area of Outstanding Natural Beauty and the beaches are part of a National Nature Reserve. [Alfred Newton & Son, BB98/02415]

Tea and ices

It's like those sticks of rock: bite it all the way down, you'll still read Brighton.

Ida Arnold in Graham Greene's *Brighton Rock*, 1938

It was the drinking of mineral water and seawater that first drew the upper echelons of society to the English seaside for health and pleasure. However, the consumption of food at the seaside has never been particularly different to any other regional dietary custom, except that the fish might be that bit fresher. Early visitors to the English seaside either had their meals provided for them or they purchased the food themselves, which was then cooked by their own staff or by the landlady of the lodgings in which they stayed. Many early visitors, who resided at a resort for several months, complained at the expense of local foodstuffs, particularly when the resort was busy.

Restaurant provision at the early seaside resorts was not extensive, although the assembly room – often the hub of a socially respectable Georgian resort – held social events that coincided with meals. Improved communications led not only to increased numbers of visitors but also opened up food markets that could support a growing catering industry. Cheap food and drink were needed for those visitors whose landladies operated strict residential policies, effectively barring guests from their lodgings after breakfast time until the evening meal. Local businesses supplied the restaurants, tearooms, ice cream parlours and fast-food booths found on the seafronts, promenades, piers and beaches.

As well as providing the obvious refreshments, seaside restaurants function as shelters from which customers can observe the seascape in comfort. Today a restaurant can also be a central feature of a resort with the ability to attract a local and visitor clientele because of the quality of its food or because of its unique location. A bar or restaurant may have taken up a particular theme associated with the sea or with holidays, such as a pirate ship or a Hawaiian paradise, adding to the sense of holiday escapism.

The foods that we associate with the seaside – fish and chips, shellfish, ice cream, candyfloss, sticks of rock and the like – have never been exclusive to resorts. Shellfish have been eaten for thousands of years and the 'fun' foods often either predate resort culture or were originally developed independently of the seaside experience. The pleasure in their consumption comes from the way they are eaten, where they are eaten and the establishments they are purchased from. They are small treats to be enjoyed informally, on the move and out of doors in relaxed social surroundings, or perhaps to be taken home as gifts or edible souvenirs.

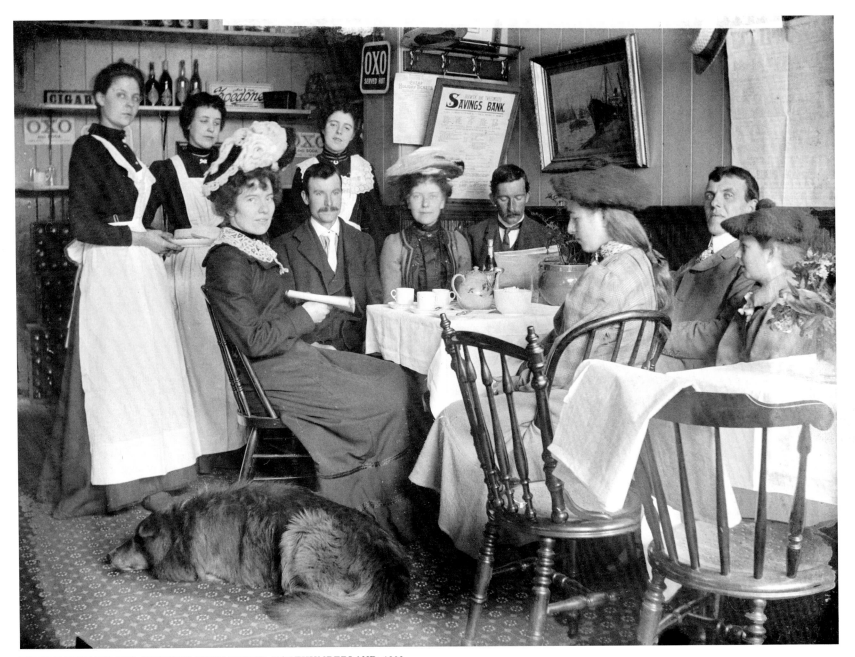

WOOD'S RESTAURANT, BERWICK-UPON-TWEED, NORTHUMBERLAND, 1902

Waitresses serve afternoon tea to a group of holidaymakers who have brought their dog into the restaurant with them. One of the party ignores his friends and reads the newspaper. Posters promote the Berwick and Tweedmouth Savings Bank and cheap holiday tickets from the North Eastern Railway, while OXO is heavily advertised. [Alfred Newton & Son, AA97/05220]

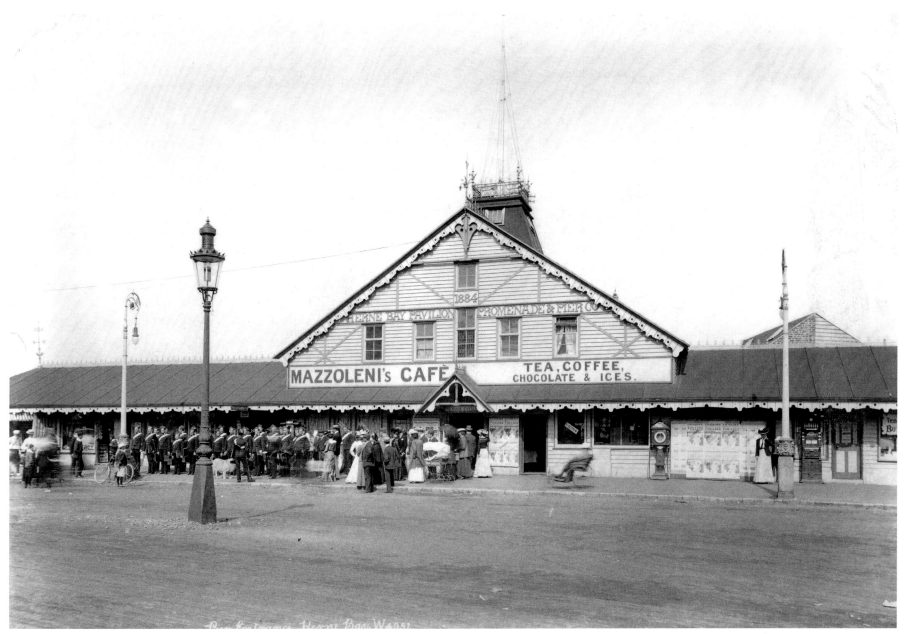

MAZZOLENI'S CAFÉ, HERNE BAY, KENT, 1890s
A small crowd has gathered to watch a uniformed band parade in front of the entrance to the pier at Herne Bay.
The pier entrance building comprises a theatre and shops and includes Mazzoleni's Café, which advertises tea,
coffee, chocolate and ices. The building was erected in 1884 and was destroyed by fire in 1928. [W & Co, OP00564]

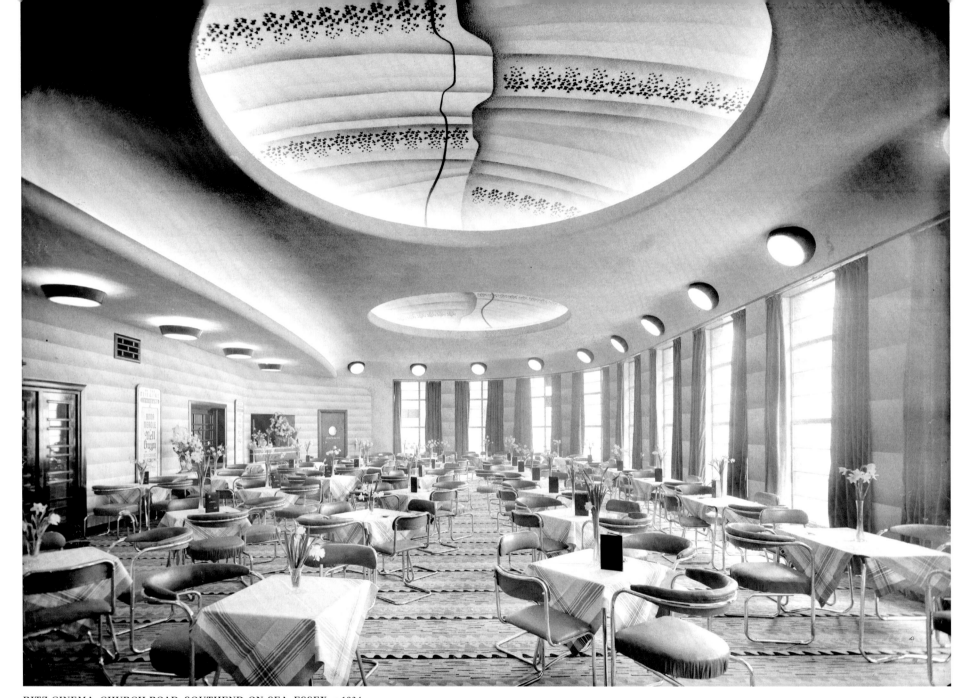

RITZ CINEMA, CHURCH ROAD, SOUTHEND-ON-SEA, ESSEX, *c* 1934

Diversification made commercial sense, so in the 1930s many new cinemas included a café or restaurant for their patrons. The Ritz in Southend was built in 1934. The architectural detail and lighting in the café was very modern – even the furniture has tubular steel legs – looking clean and efficient. The tables have cloths and flowers, and the upholstery on the chairs is leather, creating an air of quality. Undoubtedly there was waitress service. [H Felton, CC75/00074]

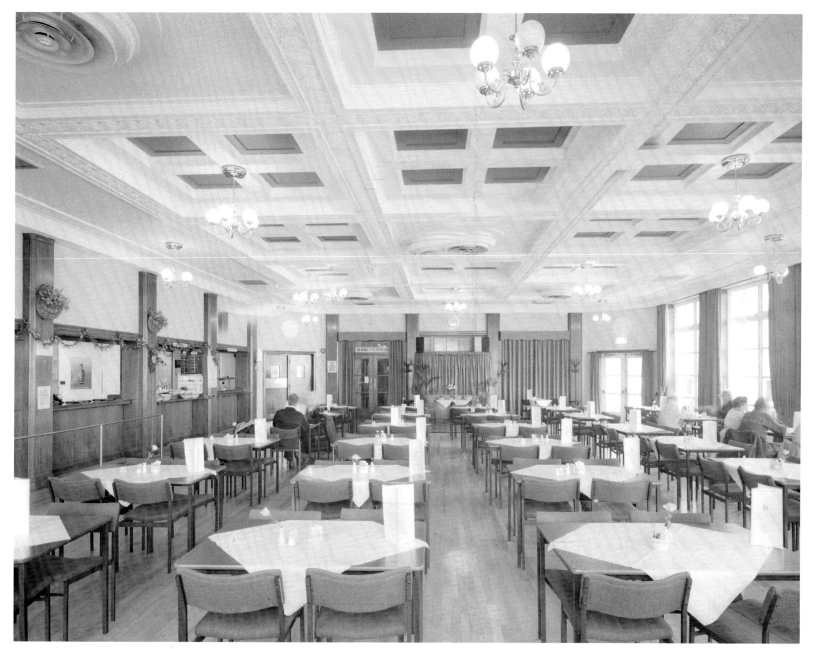

THE DENTON RESTAURANT, WORTHING, WEST SUSSEX, NOVEMBER 1993

Pier pavilions offer a range of facilities from amusement arcades to theatres. Chief among these are places to eat. The Denton Restaurant is in the shoreward-end pavilion of Worthing Pier, which was upgraded in 1958–9. Even out of season the tables are laid with a cloth, flowers and a menu, and a number of patrons have come in from the cold. [S Barker, BB93/36292]

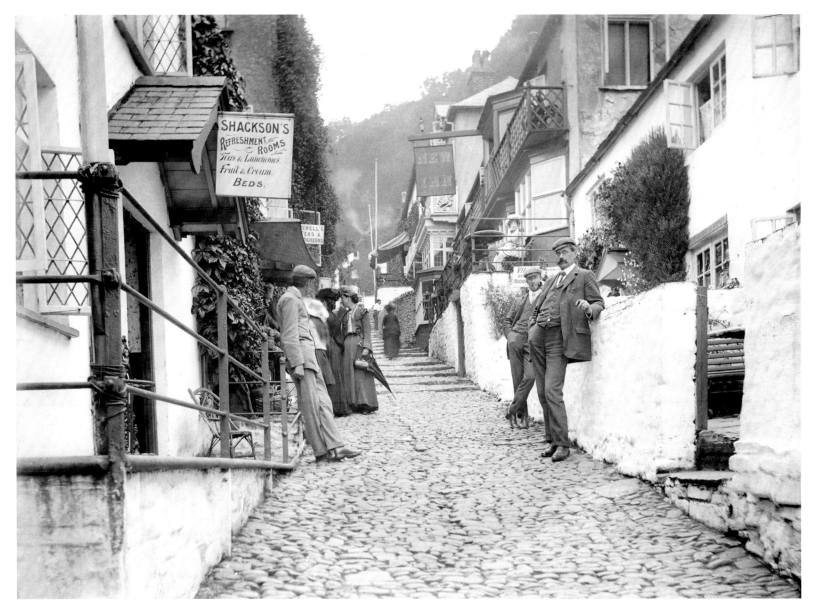

CLOVELLY, DEVON

Many visitors to the seaside were looking for picturesque fishing villages that offered a contrast with modern town life. This was perhaps especially true of those who made the long trek to Devon and Cornwall, and at Clovelly they found a wonderful example of a traditional working village. The narrow cobbled street rising steeply up a flight of steps between vernacular houses enforces pedestrian access, although donkeys and sledges were used to carry luggage. The village quickly adapted to the commercial benefits of this type of tourism. Refreshment rooms serve luncheon and tea – no doubt Devon cream tea. Shackson's Refreshment Rooms also offer accommodation. Today this scene has barely changed: the village is privately owned by the Clovelly Estate, ensuring its preservation. [Campbell's Press Studio, BB73/07823]

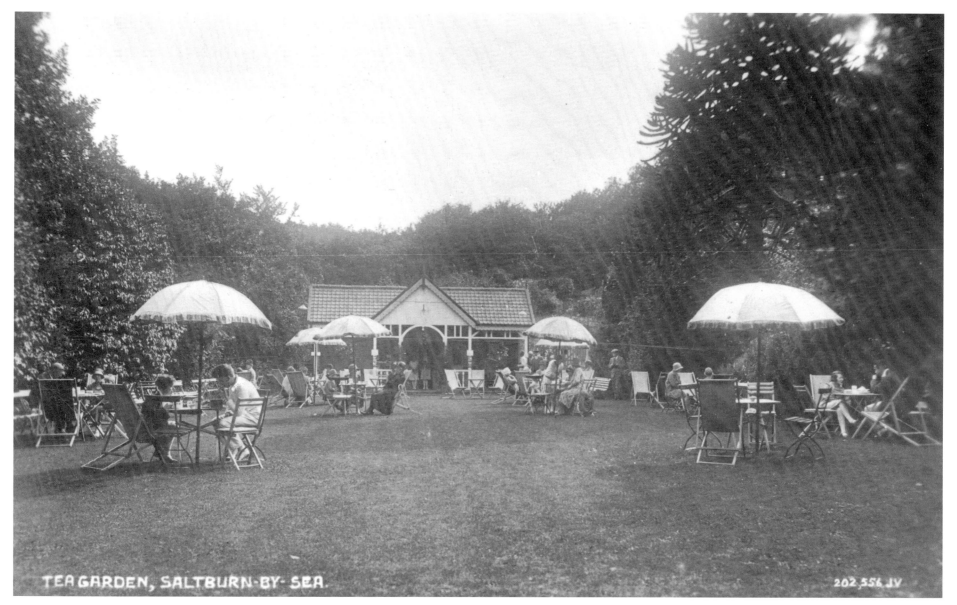

TEA GARDEN, SALTBURN-BY-SEA.

202,556 JV

TEA GARDEN, SALTBURN-BY-THE-SEA, NORTH YORKSHIRE, 1920–35
Tea gardens were particularly popular in the early 20th century, allowing visitors to combine the current fashion for the outdoors with a formal setting for refreshment. They could offer a secluded and sheltered retreat, frequently with a sea view. The servery was often a temporary chalet, as here, and umbrellas sheltered patrons from both sun and rain. [Nigel Temple (manufacturer: J Valentine?), PC09282]

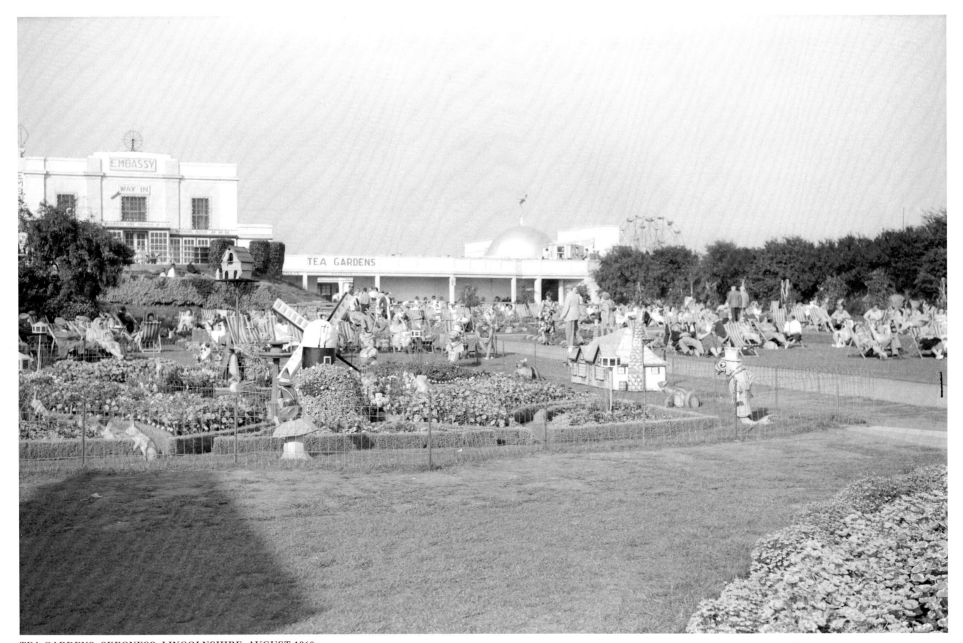

TEA GARDENS, SKEGNESS, LINCOLNSHIRE, AUGUST 1960

Deck chairs are for hire in the Tea Gardens at Skegness and the patrons enjoy the sun in the knowledge that refreshments are close at hand.
A novelty garden provides a light-hearted focus. The ferris wheel of the funfair is just visible above the trees. [Hallam Ashley, AA99/00323]

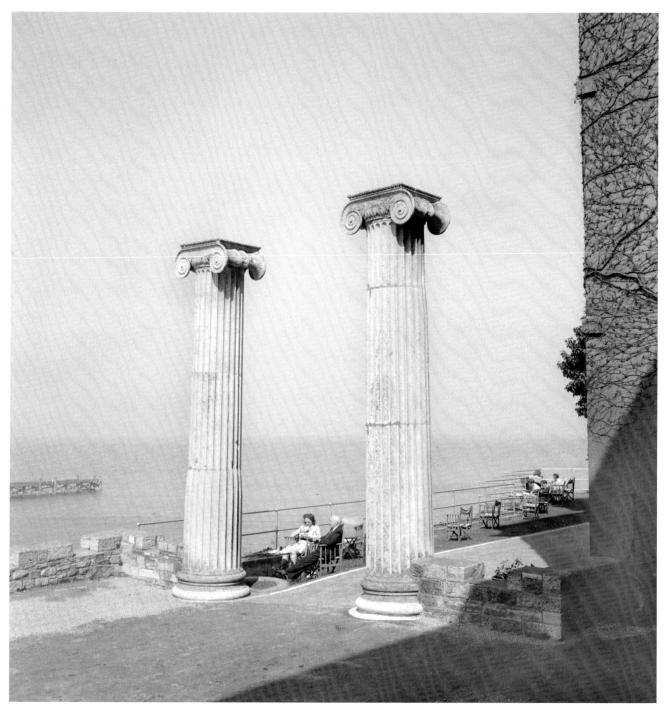

SWANAGE, DORSET, WINTER 1943–4
This pair of early 19th-century Ionic columns on the forecourt of the Grosvenor Hotel was brought from London. They are of the local Portland stone, a high-quality building stone used in many of London's public buildings. This restful scene, with hotel patrons taking tea on the terrace overlooking the bay, has an out-of-season feel. Perhaps surprisingly, it was photographed during World War II and before D-Day. People continued to take seaside holidays during wartime, though in smaller numbers and in a more subdued manner. Swanage seafront was defended against invasion by a scaffolding barricade and concrete blocks.
[O G S Crawford, AA53/06085]

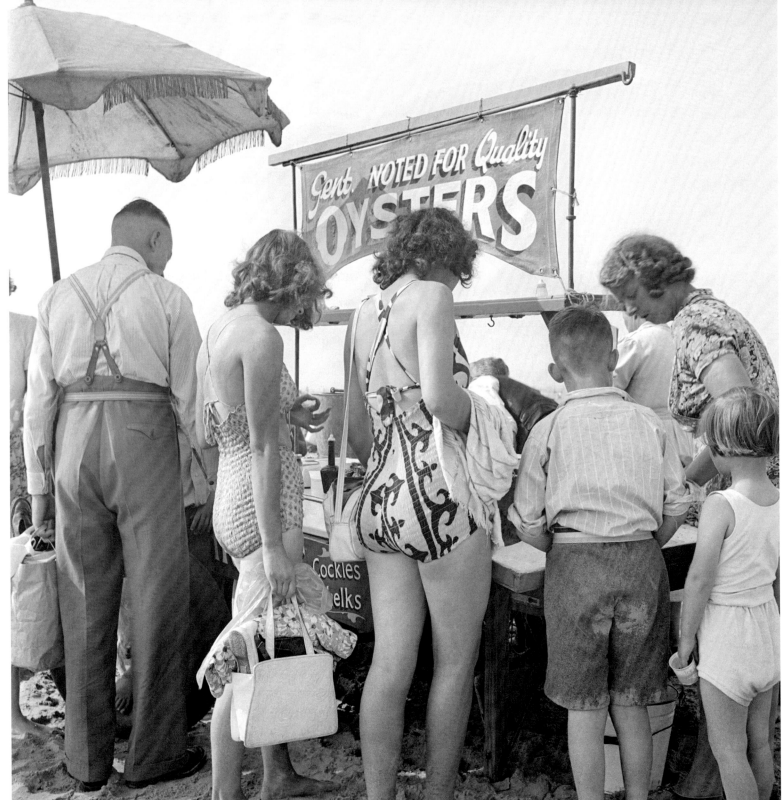

BLACKPOOL, LANCASHIRE, 1946–55
Stalls selling ready-to-eat local seafood, such as shrimps or shellfish, were a feature of many promenades. Here a group of people cluster around a stall on the beach, tempted by the prospect of a treat of cockles, whelks or oysters. [John Gay, AA047923]

PIER ROAD, WHITBY, NORTH YORKSHIRE, JUNE 1978

Whitby has a long association with the sea and was a resort from the early 18th century. West Cliff was planned as a seaside resort development in the mid-19th century and contrasts to the irregularity of the town on the eastern bank of the River Esk. Captain James Cook's ships *Endeavour* and *Resolution* were both built here and it was here that Bram Stoker's Count Dracula landed in England. Pier Road runs alongside the harbour of what is still a fishing port. It offers a choice of refreshments: a pub, a café and a stall selling locally caught fish. The Magpie is still a popular fish restaurant. A chandler's shop supplies the needs of the sailing community, while Gypsy Rose Lee offers her unique skills. [BB78/05370]

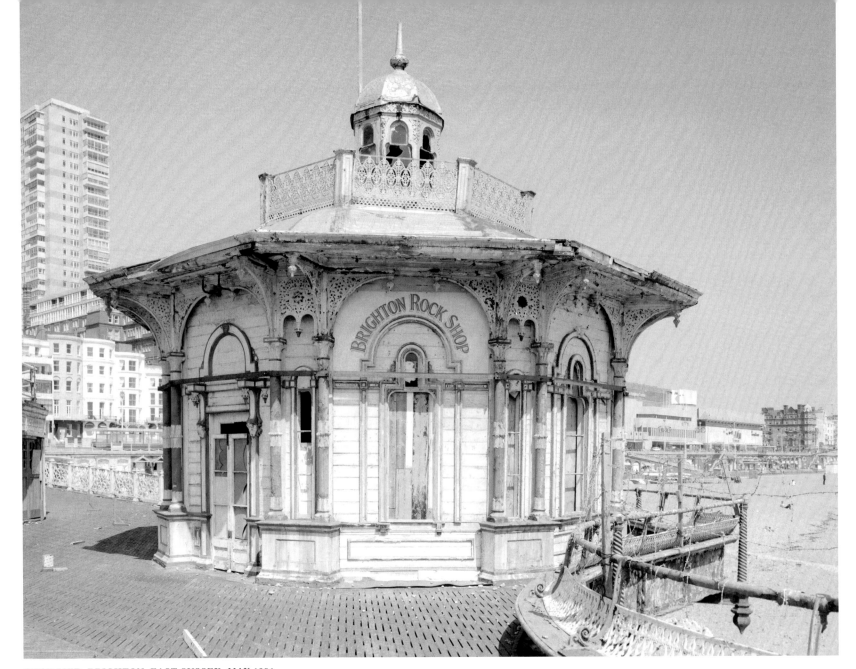

WEST PIER, BRIGHTON, EAST SUSSEX, MAY 1986

Souvenirs and refreshments of all kinds are sold on piers. Rock is a typical seaside confectionery, usually with the name of the resort running through it, making it ideal both for eating on the spot and as a gift. This highly ornate 'oriental' kiosk of 1866 specialised in rock, but at the time of photographing it was derelict. West Pier was an important early iron pier, designed by Eugenius Birch and opened in 1866. It has had an unfortunate recent history, including partial and complete closure, fire and storm damage, and consent to demolish was given and withdrawn; its future is currently uncertain.

[J P Hutchins, BB97/10888]

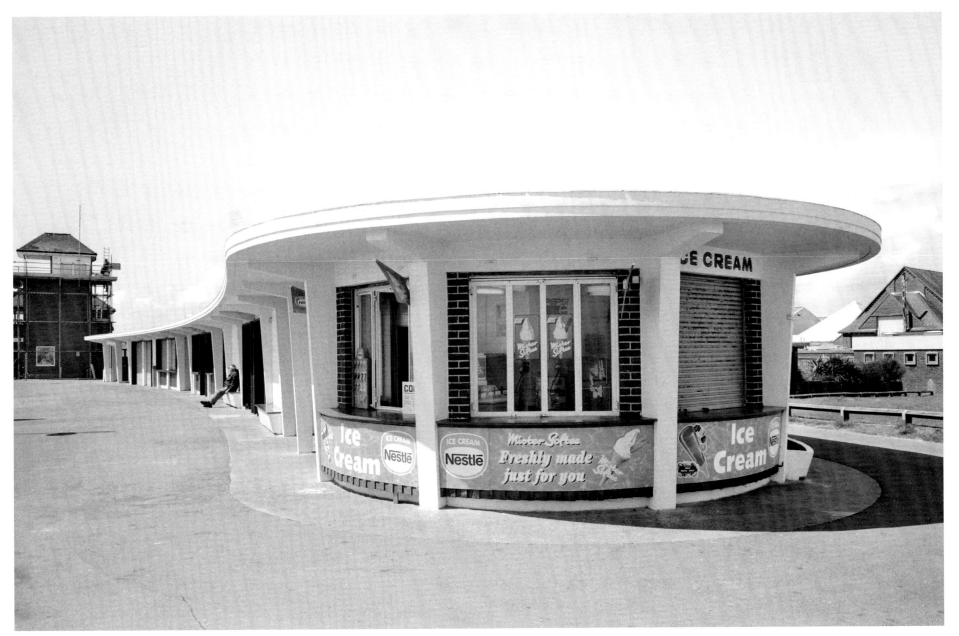

KIOSK, EAST PIER, LITTLEHAMPTON, WEST SUSSEX, 1999

Littlehampton has been a port since the medieval period and developed as a holiday resort from the late 18th century. It has a sandy beach with safe bathing and a wide strip between the town and the beach is laid out as gardens. However, it never had a pleasure pier: the East Pier is part of the harbour installation at the mouth of the River Arun. In the absence of a pleasure pier, the East Pier serves as a focus for promenading. This modern shelter with its ice cream kiosk provides basic facilities for the holidaymaker. [P Williams, AA99/06828]

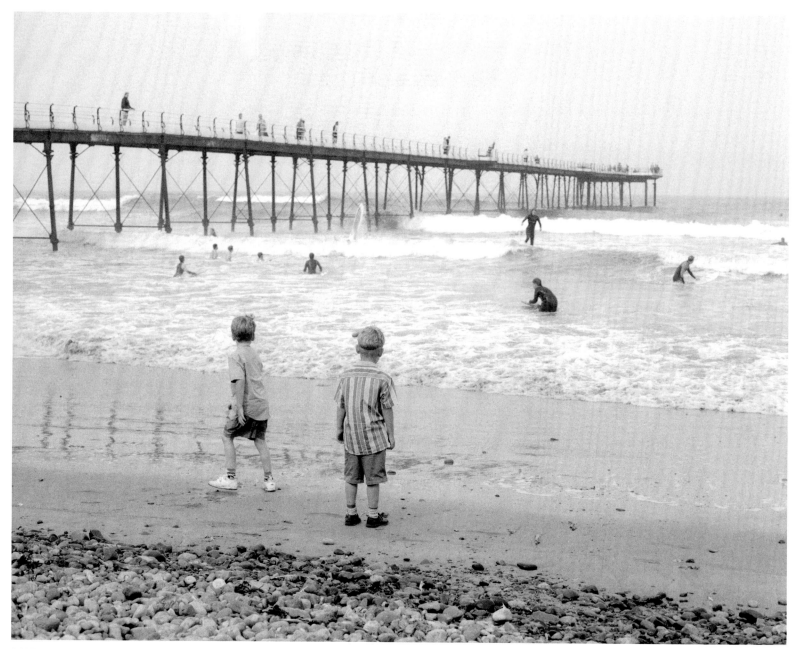

SALTBURN-BY-THE-SEA, NORTH YORKSHIRE, SEPTEMBER 1994

Surfing, which has a long tradition in this country, continues to be a popular recreation around the English coast, even though the waves do not match the breakers of the Pacific seaboard of the USA. The Cornish coast is perhaps best known for surfing, but enthusiasts can be found almost anywhere. Here spectators have gathered on the pier and two small boys watch in admiration (or disbelief) as surfers brave the chilly North Sea in September. [K Findlater, AA94/04672]

The seaside today

Every British bulge is different and every mile has its own mood. I said Blackpool and people said, 'Naturally!'
I said Worthing and they said, 'Of all places!' The character was fixed, and though few coastal places
matched their reputation each one was unique. It made my circular tour a pleasure, because it was always
worth setting off in the morning. It might be bad ahead, but at least it was different; and the dreariest and
most defoliated harbour town might be five minutes from a green sweep of bay.

Paul Theroux, *The Kingdom by the Sea*, 1984

In recent years England's seaside has been criticised for being old-fashioned, shabby and expensive, and some resorts have to deal with considerable economic and social problems. Since the 1960s English seaside resorts have struggled to compete with affordable and accessible holidays overseas. Rural holiday parks, adventure holidays and city breaks offer desirable alternatives to wet weekends at run-down seaside resorts that cling hopelessly to bygone eras. Nostalgia is no longer enough of an incentive to attract the modern holidaymaker. Today's visitor is likely to have more discerning and varied tastes, and higher expectations with regard to comfort, cuisine and leisure activities.

Long holidays to the coast are not as popular as they once were. However, despite England's unpredictable climate, the seaside is still a popular place for short breaks and day trips. Some resorts have begun to establish themselves in distinctive niches within the holiday market by promoting their cultural facilities, their restaurants or specialised attractions like the heritage coast of Dorset or the Tate St Ives in Cornwall. While new iconic features, such as an art gallery or a museum, can act as the centrepiece of a renaissance, most resorts are also conscious that they are working towns with large residential populations all year round. A good place to work will be a good place to visit.

On the right day, England's seaside resorts can be a little slice of paradise. From the quietest, most remote fishing harbour facing the North Sea to the surfing beaches of the south-western peninsula, from the vibrant Channel coast city-by-the-sea to the nature reserves of the East Anglian coast, England's seaside can offer much more than the obligatory fish and chips and stroll along the prom.

FORE STREET, ST IVES, CORNWALL, AUGUST 1993

This wall in St Ives captures the eclectic mix that is the English seaside holiday today. Notices advertise a huge variety of activities and entertainments. Some are traditional while others reflect more recent tastes. Arts and crafts have been part of the attraction of Cornwall for centuries and particularly since the 1880s when artists began to settle in Newlyn. The Tate St Ives art gallery opened in 1993 and over 270,000 visits were made to the gallery in 2003/4. A single forlorn road sign points to the most traditional of attractions, the harbour and beach.
[P Williams, BB93/28651]

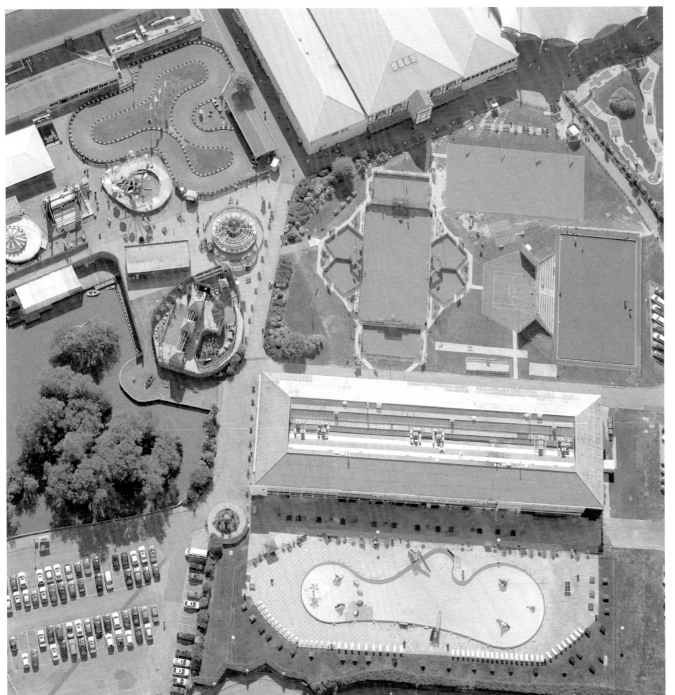

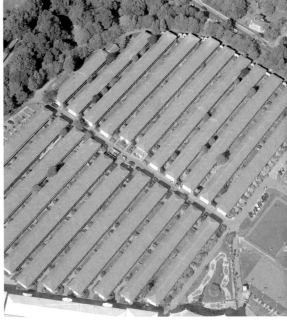

**BUTLINS, BOGNOR REGIS, WEST SUSSEX,
SEPTEMBER 2002**
Holiday camps increased in popularity after World War II,
providing inexpensive holidays for the masses. Butlins, a
leading operator of holiday camps, has recently focused its
efforts at three sites: Minehead, Ingoldmells (near
Skegness) and Bognor Regis. In order to compete, these
resorts now offer a wide range of leisure and recreational
facilities and a better quality of accommodation. These
detailed aerial photographs show some of the indoor and
outdoor attractions and accommodation blocks at Bognor.
[D Grady, NMR 21819/06, NMR 21819/08]

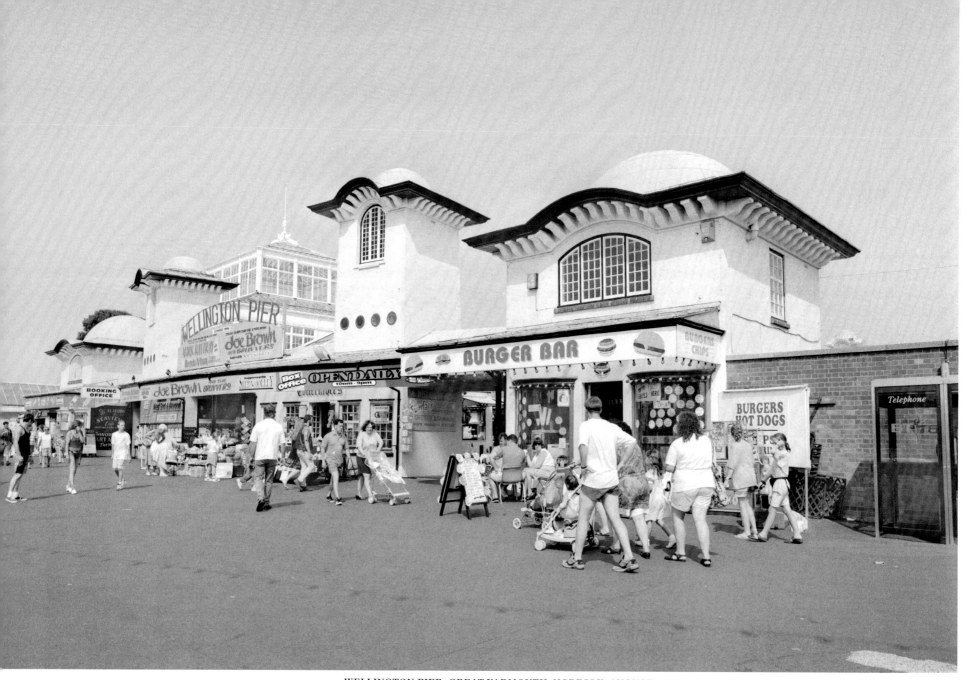

WELLINGTON PIER, GREAT YARMOUTH, NORFOLK, AUGUST 1994
The Wellington Pier was largely rebuilt in 1900–3. Today the distinctive Art Deco entrance building, designed by J W Cockrill, is largely masked by retail units though its unusual roofs have survived. Kiosks offer the holidaymaker a choice of fast foods and souvenirs, and the pier pavilion theatre, also by Cockrill, seems to be thriving: a poster advertises two acts, Joe Brown and the Bruvvers and Mark Rattray. The tiered roof of the Winter Gardens can be seen over the entrance of the buildings. [S W Cole, AA93/02278]

NIGHT CLUB, WORTHING, WEST SUSSEX, 1993

Holiday resorts must provide adult and evening entertainment as well as children's daytime activities. Restaurants, music halls, theatres and cinemas all fill this gap, but in the late 20th century night clubs attracted a different clientele. Pier pavilions offer an obvious venue, as is the case at Worthing. [S Barker, BB93/36312]

GOLDEN MILE, BLACKPOOL, LANCASHIRE, OCTOBER 1999
Today the draw of Blackpool is greater than that of just a seaside resort. As the year progresses, the focus moves from the beach to the promenade swathed in the magic of coloured lights. Blackpool Illuminations, which began officially in 1912, continue to be an attraction in their own right and have extended the season into November. Many of the people in this photograph are wearing coats against the chill, but even so business is brisk in the amusement arcades, kiosks and cafés along the Golden Mile. [P Williams, MF99/0622/009]

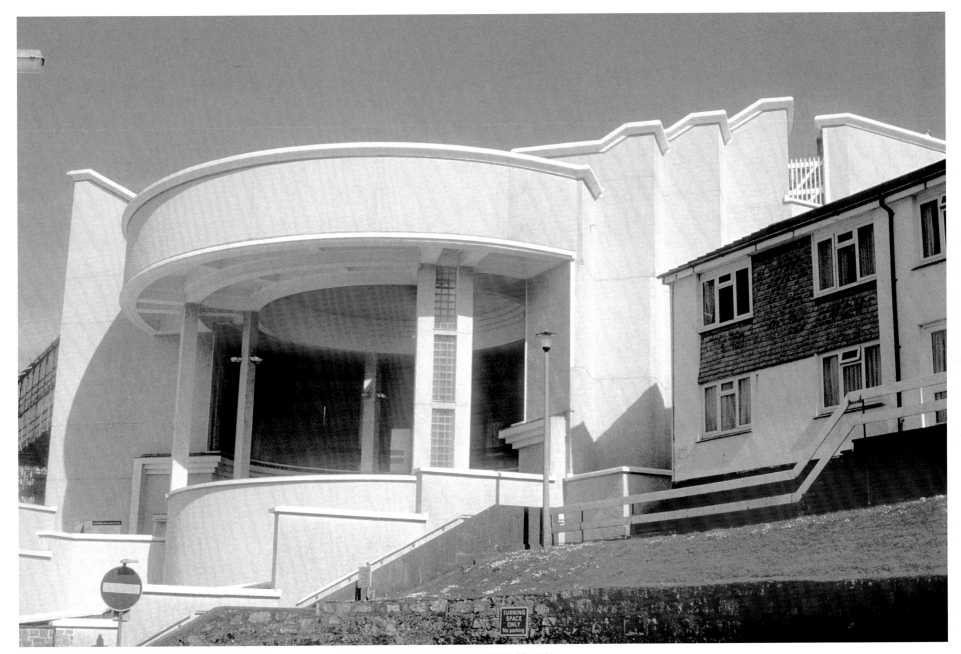

TATE GALLERY, ST IVES, CORNWALL, 2002
Artists have been drawn to St Ives since the 1920s and it soon gained a reputation as an artists' colony. Building on this tradition, the Tate St Ives was opened in June 1993. It was quickly established as a major focus for cultural tourism, adding an important new attraction to this remote Cornish fishing port. [G Winter]

Sidmouth in high season offers a very restful and
sedate picture. Small fishing boats have been pulled
up on the beach in the shelter of the cliffs and a few
well-dressed couples and family groups enjoy the
view of the sea. [Hallam Ashley, AA98/16084]

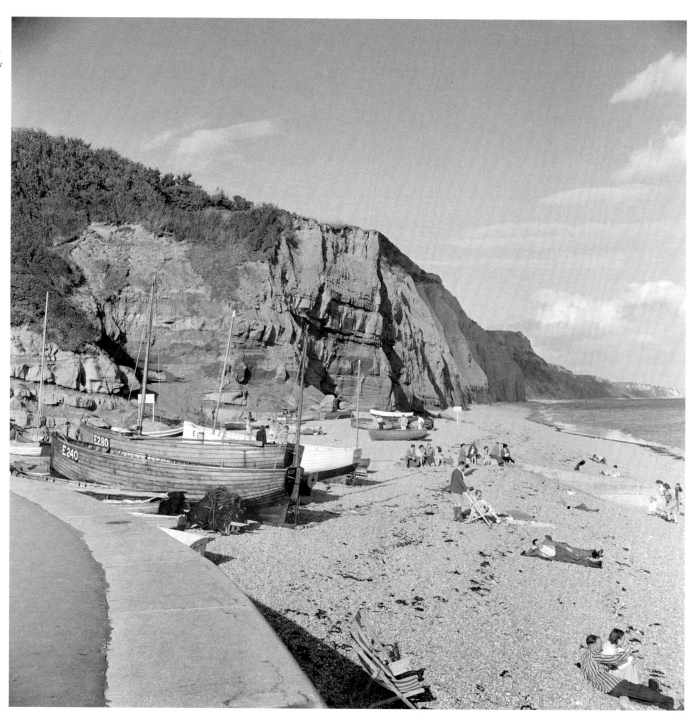

NMR collections and photographers

The photographs in this book all come from the collections of the National Monuments Record (NMR). The NMR is one of the largest publicly accessible archives in Britain and is the biggest dedicated to the historic environment. It is an unparalleled collection of images, old and new, which has been growing for over 60 years. Today the collection comprises more than eight million photographs and other archive items relating to England's architecture and archaeology. It continues to accept major collections of national importance and is a repository for material created by English Heritage's staff photographers. The collection may be consulted at the National Monuments Record office in Swindon (telephone 01793 414600 or email nmrinfo@english-heritage.org.uk for details).

The following collections and photographers are represented in this volume.

HALLAM ASHLEY COLLECTION

Hallam Ashley (1900–87) was a professional photographer and between 1945 and 1983 he carried out commissions for the National Buildings Record (NBR, later NMR). The NMR holds 19,700 negatives, colour transparencies and original prints. For much of his life Hallam Ashley lived in Norwich; over half of the collection covers Norfolk though most English counties are featured to some extent. His main interests were architecture, Norfolk landscapes and disappearing ways of life.

BEDFORD LEMERE COLLECTION

Bedford Lemere & Co (1870s–1950s) was a commercial photographic firm. It quickly built up a reputation for pre-eminent architectural photography: interiors and decorative schemes were the firm's speciality. A wide range of building types were recorded, including country houses, factories, department stores, railway stations and even cruise liners. The firm's work centred on London, with over 50% of the NMR's holding of 23,000 negatives depicting buildings in the capital.

CAMPBELL'S PRESS STUDIO COLLECTION

Campbell's Press Studio was a commercial picture library with close links with the photographer E J Farmer. The firm systematically removed reference to the photographer's name and date of photography from its holdings for its own commercial reasons.

JOHN GAY COLLECTION

Born Hans Gohler (1909–99), John Gay moved to England in 1933. His interests included architecture, landscape, villages and agriculture as well as portraiture. He illustrated several books including *London Observed* (1964), *London's Historic Railway Stations* (1972) and *Highgate Cemetery* (1984). A collection of over 5,000 photographs was bequeathed to the NMR.

HOWARTH-LOOMES COLLECTION

Bernard Howarth-Loomes was an important collector of stereoscopic equipment and stereo cards, predominantly from the 1850s and 1860s. He allowed the NMR to copy part of this nationally significant early collection, which covers much of the country.

LMS COLLECTION

The London, Midland & Scottish Railway (LMS) commissioned photographs of tourist attractions and other places of interest along their route. This collection covers most English counties. (Photographs of the rolling stock etc are held by the National Railway Museum, York.)

ERIC DE MARÉ COLLECTION

Eric de Maré (1910–2002) was a writer and architectural photographer and in 1943 he became acting editor of the *Architects Journal*. De Maré wrote or illustrated several books: for example, a 600-mile journey on England's canals in 1948 resulted in *The Canals of England*, while in 1956 he was commissioned to photograph early industrial sites for *The Functional Tradition in Early Industrial Buildings* (by J M Richards). The NMR holds over 2,800 photographs.

JOHN MALTBY (ODEON CINEMA) COLLECTION

John Maltby (1910–80) was a freelance architectural photographer. In 1935 he was commissioned to take four photographs of every cinema in the Odeon chain. The NMR holds over 1,100 photographs of 250 different cinemas.

ALFRED NEWTON & SON COLLECTION

Alfred Newton opened the Belvoir Photographic Studios in Leicester in 1882. His son Sydney Walter Alfred joined the firm in 1894. The NMR has 4,000 photographs taken by the company. The collection concentrates on the route of the Great Central Railway and is strong in town and village scenes. Coverage focuses on Northamptonshire and Buckinghamshire, with Cornwall, Devon and Warwickshire well represented. The firm ceased trading *c* 1950.

S W RAWLINGS COLLECTION

Stanley W Rawlings worked for the Port of London Authority, including a period as photographer in the Information Office. The collection of 1,500 photographs, broadly dated 1945–65, reflects this interest. It records life on and around the River Thames and its estuary, especially dock and harbour installations and shipping. Greater London accounts for 77% of the coverage, with Kent and Essex well represented.

NIGEL TEMPLE POSTCARD COLLECTION

Nigel Temple was a national authority on gardens and an important artist as well as an antiquary. This collection comprises *c* 8,500 postcards of public parks and gardens, mainly in England. Most of the cards date from around 1900 to 1910, though there are later examples. Many well-known photographers and manufacturers are represented, including Valentine & Sons, Francis Frith and George Washington Wilson. Both real photographs and printed halftone cards are present and many of the Edwardian examples are hand-tinted.

W & CO COLLECTION

The identity of W & Co is uncertain: they may have been Walker & Co based in Margate. The collection consists of *c* 260 original black-and-white prints. Dating from 1890–1910, they are primarily seaside views of the Lancashire and Kent coasts, though town and village scenes from elsewhere are also present.

HAROLD WINGHAM COLLECTION

Former Squadron Leader Harold Wingham was an important practitioner of aerial photography for archaeology. This significant collection of 2,000 negatives covers the south-west of England for the period 1951–63.

NMR STAFF PHOTOGRAPHERS

Herbert Felton (1888–1968) was the NBR's first photographer, appointed in 1941. Prior to that he had been a freelance architectural photographer and a regular contributor to architectural publications.

Margaret Tomlinson (1905–97) began her professional career as a photographer and investigator with the NBR. She later worked for the VCH and the Ministry of Housing & Local Government.

O G S Crawford (1886–1957) was the Ordnance Survey's Archaeology Officer and a pioneer in the use of aerial photography in archaeology. During World War II he undertook a photographic survey of southern towns for the NBR.

Other staff photographers represented in this volume are *S Barker, S W Cole, J O Davies, R Featherstone, K Findlater, D Grady, J P Hutchins, D Macleod, P Payne, R Skingle, P Williams* and *G Winter.*

The work of many other photographers is included in this volume, though sadly in many cases their names are not known. One who is well represented in the NMR collection is *George Bernard Wood* (1900–73). He was a photographer and journalist, based mainly in the north of England.

ST MARY'S LIGHTHOUSE, WHITLEY BAY, TYNE & WEAR, AUGUST 1994

Built in 1898, this lighthouse is a reminder that the sea is a workplace as well as a playground and that it can be dangerous.
However, at low tide on a warm August day a lighthouse makes a suitable goal for a pleasant afternoon's stroll, while rock pools
offer to our curiosity those 'hints of earlier and other creation' (T S Eliot, *The Dry Salvages*, 1941). [K Findlater, BB94/17387]

Index of places illustrated in text